REEL BAY

REEL BAY

A Cinematic Essay

Jana Larson

COFFEE HOUSE PRESS
Minneapolis
2021

Coffee House Press books are available to the trade through our primary distributor,
Consortium Book Sales & Distribution, cbsd.com or (800) 283-3572. For personal
orders, catalogs, or other information, write to info@coffeehousepress.org.

Coffee House Press is a nonprofit literary publishing house. Support from private
foundations, corporate giving programs, government programs, and generous indi-
viduals helps make the publication of our books possible. We gratefully acknowledge
their support in detail in the back of this book.

LIBRARY OF CONGRESS CATALOGING-IN-PUBLICATION DATA
Names: Larson, Jana, author.
Title: Reel bay : a cinematic essay / Jana Larson.
Description: Minneapolis : Coffee House Press, 2021. | Includes bibliographical
 references.
Identifiers: LCCN 2020024148 (print) | LCCN 2020024147 (ebook) |
 ISBN 9781566895989 (paperback) | ISBN 9781566896047 (ebook)
Subjects: LCSH: Larson, Jana.
Classification: LCC CT275.L2714 A3 2021 (ebook) | LCC CT275.L2714 (print) |
 DDC 977.6/05092 [B] --dc23
LC record available at https://lccn.loc.gov/2020024148

PRINTED IN THE UNITED STATES OF AMERICA
27 26 25 24 23 22 21 20 1 2 3 4 5 6 7 8

For Tukuko

REEL BAY

TITLE CARD:

"THIS IS A TRUE STORY. THE EVENTS
DEPICTED TOOK PLACE IN MINNESOTA
IN 1987. AT THE REQUEST OF THE
SURVIVORS, THE NAMES HAVE BEEN
CHANGED. OUT OF RESPECT FOR THE
DEAD, THE REST HAS BEEN TOLD EXACTLY
AS IT OCCURRED."
 — FARGO, BY JOEL AND ETHAN COEN[1]

If this book were a film, it would open on the black-and-white image of a woman walking alone on a snow-covered road. She is seen from a distance, a dark impression against a frozen backdrop of wheat fields covered in white. A closeup reveals her hands, bare, flushed with cold. She cups them to her face, mostly obscured by a fur-lined hood, and exhales a cloud of steam, trying to get warm. She looks out at the landscape in front of her. Her face is young, moon-shaped, her pale skin framed by straight black hair that goes blond at the tips. Wind stirs the fur trim on her hood as if prodding her to move on. She pulls a folded map out of her pocket and studies it, then looks out across the fields at a wall of blowing snow that occasionally lifts and swirls into eddies. She pockets the map and starts to wade through deep banks of white into the distance. Her figure recedes until it disappears, overtaken by an alternate geography of shifting drifts.

This image first appears to you when you read a newspaper article with the title "Coroner Unable to Find Cause of Death of Japanese Woman," a small item published in the *Bismarck Tribune* on January 7, 2002. You read the story, and something about it catches and holds you. You look for more information and find nothing, but over the coming days the image of the woman *searching* at the edges of nowhere replays in your mind, feels like a message.

Coroner Unable to Find Cause of Death of Japanese Woman

DEENA WINTER, *Bismarck Tribune*, January 7, 2002

A Minnesota police chief says the Japanese woman who was apparently searching for the hidden money featured in the movie "Fargo" wanted to commit suicide, although a coroner was unable to determine the exact cause of her death.

Takako Konishi, 28, was found dead near Detroit Lakes, Minn., on Nov. 15. Her body was sent to the Ramsey County Medical Examiner's Office in St. Paul, where the final autopsy could not pinpoint a cause of death, but did find a number of drugs in her system.

A bow hunter found Konishi's body in a wooded area on the southern edge of Detroit Lakes, Minn., which is about 60 miles east of Fargo. Six days prior, the Tokyo woman had been in Bismarck, where police said she spent a night in a hotel and then went looking for money that had been hidden by a character in the movie. She was found wandering around near a landfill with a crude map of a tree next to a highway.

Eventually, she ended up at the Bismarck police station, where an officer spent hours talking to her. She showed the officer her map and referred to the movie and being in the U.S. to find the money. The officer tried to explain to her that "Fargo" was just a movie, but they had trouble overcoming the language barrier.

Since Konishi had money and her papers were in order, police dropped her off at a bus station. She took a bus to Fargo, then took a taxi to Detroit Lakes, where she apparently hitchhiked a ride out of town.

Detroit Lakes Police Chief Kelvin Keena said the autopsy found no sign of sexual assault, trauma or an "overriding medical condition" that could have caused Konishi's death. But he learned that the woman had sent a letter to her family expressing a desire to commit suicide.

"Our working theory is that she was intending to commit suicide and, although perhaps not directly successful, she was ultimately successful," Keena said Monday.

He said she tested positive for at least six different drugs in her system, including sedatives, anticonvulsant drugs, tranquilizers and antipsychotics—but they weren't concentrated enough to directly cause her death. He said the drugs were probably a contributing factor—"that, and the exposure to the cold." Authorities are still performing lab work on additional substances that were found in her possession, Keena said.

She is believed to have arrived in Detroit Lakes on Nov. 12, and the temperature dipped to 26 degrees that night. Keena said she was seen hitchhiking and standing beside a road.

"She was given a ride by two people and they were under the impression that she was in a hurry to go someplace and that she was late for work," he said. "I just know that they had a real hard time understanding her."

REEL 1

TITLE CARD:

"THREE MONTHS EARLIER"

FADE IN:

EXT. VISUAL ARTS FACILITY - DAY

Rocks, cacti, and brush. A gray, ultramodern, almost monstrous structure glinting in the noontime sun on the dusty chaparral at the edge of a university campus.

After a time, a group of students and faculty crosses a large central courtyard and climbs an exterior staircase to the second floor.

INT. ART STUDIO - DAY

The students and faculty crowd into a minimalist white studio. Three faculty members sit on a few chairs in front, facing a blank white wall; a group of art students shoves in behind them.

When everyone settles, a WOMAN in her late twenties, wearing combat boots and a vintage dress over trousers, messy brown hair piled on top of her head, calls out above the rustle and chatter.

> WOMAN
> (shouting)
> O.K. I've only got a couple of shots!

She turns on a 16mm projector that hums and clicks and projects a beam of light, white at first, then black and white with bits of dust and hair that dance across the bright square on the opposite wall.

IMAGE PROJECTED ON WALL

FADE IN:

A Sullen Woman in her late twenties, pretty, with curly hair, walks through a crumbling cement and stucco neighborhood. Pigeons scatter as she passes a chain-link fence, grabs hold of it and stares into a vacant lot overgrown with succulents and cacti.

She rushes through a colonnade and vanishes into a doorway.

Inside, the building is dark with glowing orbs of light -- an aquarium. The Sullen Woman moves along the dark wall opposite the incandescent row of tanks. Luminous fish eyes follow her.

She stops and leans in toward one of the tanks.

Salamander-like creatures with large, translucent faces stare back at her.

The Sullen Woman stands captivated, unmoving, before them.

The projected image goes black, then white, then quivers to a stop.

BACK TO SCENE

The lights go up and the Woman walks to the front of the room.

> WOMAN
> That's it so far. The rest is in the storyboards.

She waits through a long pause stretched longer by shifts and murmurs in the crowd. Finally, one of the faculty members, a small BALDING MAN in front, speaks.

> BALDING MAN
> I wanted to address that question in particular. The storyboards. I like them.

The balding man looks through a series of
pages covered in notes and drawings, stapled
together into a booklet.

> BALDING MAN
> They tell your story so
> economically. This thing you just
> showed us -- it's less clear what
> it's trying to achieve.

Another faculty member, a WHITE-HAIRED MAN
with black spectacles and a thick accent,
clears his throat.

> WHITE-HAIRED MAN
> I agree with him. There's something
> conveyed in your drawings . . .

The White-Haired Man holds up his copy of the
booklet for emphasis.

The Balding Man's CELL PHONE RINGS; he jumps
up and walks to the door.

> BALDING MAN (O.S.)
> (whispering loudly)
> Hi. I'm in a crit . . .

> WHITE-HAIRED MAN (CONT'D.)
> . . . that I don't know how you will
> show in this film, or why. Maybe
> that's the question: Why make a
> film? This film you are proposing
> is complicated: it takes place in
> Mexico, there are crowd scenes, a
> volcano erupts, a woman disappears
> into a dense fog . . . How are you
> going to show that? I agree with Jim,
> use the drawings to tell your story.
> Or, I think, why not put two mimes
> in a white room and have them act out
> your ideas? I think that would be
> interesting.

The Woman nods and closes her eyes to consider
the idea: two mimes in a glass box, disappear-
ing into the mist . . .

Before she gets far with that thought, a third
man, a FIREBRAND with feathered hair, a puffy
face, and a wide, impish grin, jumps up, ges-
turing and spitting in a heavy accent.

 FIREBRAND
 (shouting)
 Mimes?! What the fuck are you
 talking about? Why make a film?
 She's a filmmaker, that's why!

The Firebrand, red-faced, leans in toward the
White-Haired Man.

 FIREBRAND (CONT'D.)
 And filmmakers make films, which
 have locations and actors! She knows
 that because she is a filmmaker, not
 just some . . .

Before he can say more, an ADMINISTRATOR
rushes in.

 ADMINISTRATOR
 That's it! Time's up, everyone! Time
 to move on!

The art students push toward the door. The
Woman takes a breath. She and the Firebrand
exchange a look as he exits with the others.

 FADE OUT.

It's the fall of 2001, and you are the woman in this scene. You've been
in graduate school for about a year, trying to make a film. Everything
in this scene is told exactly as it occurred, except for the film. Here
the flickering lights and the sound of the projector are like wish-
ful thinking, creating space, a feeling of possibility, a way forward.
Because at the moment there is no film, only a few storyboards—
poorly drawn stick figures inside rectangles—sketching out a half-
written screenplay about a woman who goes to Mexico with her
husband to get a divorce.

The script is hopelessly complicated, but the bigger problem is that, at the end of the first act, the protagonist disappears from the side of a volcano into a dense fog, and then you don't know how to keep the story going. The idea of mimes in a white room does not help you for all of the reasons the Firebrand suggests. The only thing on the mark about this thought is white on white. You're obsessed with white, its luminosity and transparency, with things disappearing into white.

FADE IN:

INT. LOCKER ROOM - DAY

The Woman stands in front of a mirror in the locker room at the pool. She wears a white terry cloth robe, smears white cream on her face, and makes exaggerated mime expressions to herself in the mirror.[1]

SILVIA, a woman in her late fifties, wearing large, fogged-over glasses, comes in with a towel wrapped around her head and another around her body; a waft of steam follows her, nearly obscuring the Woman and misting over the mirror.

 SILVIA
 (speaking in a thick accent)
 Ah, hello.

Silvia sits down on a bench near the Woman and starts looking through her bag.

The Woman clears a circle in the fogged mirror and watches Silvia for a moment.

 WOMAN
 Did you read it?

Silvia sighs loudly.

 SILVIA
 Ah, yes, your screenplay.

 WOMAN
 Yes. What did you think?

 SILVIA
 Well, for me, it's not interesting.
 You are a woman, an intelligent
 woman, but I don't see how this is
 a woman's film. The woman in your
 script, she disappears very early
 on from the side of a volcano. And
 that's it for her? I don't get it.

The Woman listens carefully, continuing to
watch Silvia in the small circle she cleared
in the steam.

 SILVIA
 I don't know, but it seems to me
 that you're trying to deal with
 alienation. I don't think that's
 relevant anymore. Films in the
 fifties and sixties were about
 alienation. People today are totally
 connected. All they do is talk to
 each other on the internet . . .
 which creates something else, not
 alienation . . .
 (trails off, thinking about that)
 But the problems with this film
 start even before that. Like the
 way it begins: the woman is trapped
 in a car with this man -- a vague
 character, not very interesting.
 There is no drama in the car
 ride. You cannot start there.
 Then the characters are stuck in
 a hotel . . .
 (audible sigh)
 a location that takes away every
 possible element that could make
 this film cinematic. Cinema is
 about time. This film seems to
 be about weather -- a storm, some
 thick fog . . . I mean, how are you
 planning to shoot that?

The Woman, who has been poised with one hand in
the air, listening intently, slumps.

> SILVIA
> (shrugs and shakes her head)
> I don't know how I can help you. You
> should think about doing something
> else.

 FADE OUT.

Your obsession with white started long ago, when you were writing a script about Yuki-Onna (snow woman), a Japanese demon who appears during blizzards in the form of a beautiful woman with white, nearly translucent skin, jet-black hair, and shining eyes.[2] She lures travelers off their paths so they become disoriented. Eventually, lost in the snow, they sit down in despair and freeze to death, then disappear into flurries that bank up over their bodies.

In your adaptation of the story, Yuki-Onna is a young woman living alone in Tokyo during the hottest summer anyone can remember.[3] She spends her days in a tiny apartment sitting in front of a fan. At night she rides the subway, pickpocketing drunk businessmen and sleeping derelicts.

FADE IN:

INT. TOKYO SUBWAY - NIGHT

Darkness. The ECHOING ROAR OF A SUBWAY TRAIN moving through a tunnel.

White, yellow, and red lights reflect on the tunnel walls as the lights in the subway car flicker.

Sweaty bodies, smashed together, undulate with the motion of the train.

Darkness.

In a burst of light, the face of YUKI, a young, pale-faced Japanese woman with black hair, steel-blue eyes, and a bright green raincoat, appears; she stares toward the back of the train car.

Darkness.

> JOHN (V.O.)
> (dramatic oration)
> The Snow Goddess, with four arms,
> two eyes, two breasts, no feet, no
> heart, or a heart, but cold like an
> ice crystal . . .

The TRAIN SQUEALS around a corner, and a mass of bodies lurches inside the car.

Yuki's hand slips a wallet out of a purse and into the pocket of her green raincoat.

The TRAIN SCREECHES and shakes.

Yuki pushes her way through the crowd to the next car.

> JOHN (V.O.)
> . . . comes upon a young man in a
> hut, taking shelter from the storm.
> She wants to kill him, blow her icy
> breath into him.

The DOOR CLOSES behind Yuki with a WHOOSH as she enters the next car. Her eyes scan the crowd: everything is moist and hot; steam covers the windows.

> JOHN (V.O.)
> But something stops her. She
> promises him life in exchange for
> his silence.
> (whispering demon voice)
> "Never tell anyone what you have
> seen,"
> (normal voice)
> she says in a cold whisper.

Yuki holds on to the nearest handrail and leans her face into her arm. The lights of the train flicker on and off like a strobe as Yuki moves to the center of the car. She pretends to lose her footing and grabs the back of a pinstripe coat.

> YUKI
> (in Japanese; subtitled; sweetly)
> Excuse me.

Yuki's hand slips into the pinstriped pocket and removes a wallet, which she puts into the pocket of her raincoat. An announcement plays from the loudspeaker in the train.

> ANNOUNCEMENT (O.S.)
> (in Japanese; subtitled)
> Next stop, Shinjuku Station. Doors will open on the right side of the train. Thank you for riding with us.

Yuki maneuvers around a fat man in a dark suit, toward the right side of the train.

INT. SHINJUKU STATION - NIGHT (CONTINUOUS ACTION)

Yuki steps onto the noisy, congested platform as a wave of people pushes past her onto the train.

Her eyes follow the flow of the crowd to where it stops, forming an arc around JOHN, a young American man in a vintage suit, who maneuvers two marionettes in front of a makeshift stage.

Yuki walks over to the crowd.

> JOHN
> The young man, Minokichi, nearly dies that winter. But he lives, and in the spring he returns to the forest. He spends a day chopping wood; it's nearly dusk when he starts home and finds a young woman wandering, lost in the trees.

John moves the woodcutter marionette through a pop-up forest, where he sees a second marionette twirling in circles and SOBBING loudly.

Yuki opens a wallet at waist height, pulls the money out, and slips it into her pocket. She inconspicuously drops the wallet at her feet and kicks it into the crowd.

Yuki pulls out another wallet, about to do the same, when she looks up and sees John watching her. Their eyes meet for a moment, and Yuki freezes, slowly putting the wallet back into her pocket.

> JOHN
> Minokichi looks into her pale eyes.
> It's love at first sight. He asks for
> her name.
> (whispering)
> "Oyuki"
> (normal voice)
> she whispers.

Yuki shakes off a feeling of uneasiness. She pulls the wallet back out of her pocket, opens it, and takes out the cash.

John maneuvers the two puppets toward their case, styled to look like a traditional Japanese house, and sits them down next to it.

> JOHN
> He takes her home, and soon they're
> married. One night, Minokichi and
> Oyuki are sitting together by the
> fire, mending their children's
> shoes.

Yuki puts the cash into her pocket, drops the wallet, and kicks it into the crowd.

> JOHN
> A glint in his wife's eye takes
> Minokichi back to that night in the
> forest when the strange, almost
> translucent demon hovered over him.
> (MORE)

 JOHN (CONT'D)
Forgetting himself, he begins to
tell the story.
 (deep voice of character)
"Wife, one night in the forest I
met a demon with white skin and
terrifying eyes -- "

John lets out a TERRIBLE SHRIEK and swoops one
of the marionettes in a circle. It flies above
his head, then hovers over the other puppet.
The crowd GASPS.

Yuki instinctually takes the opportunity to move
into the crowd, jostling a man, grabbing the
wallet from his pocket, and stashing it in hers.

 JOHN
 (loud and dramatic)
Oyuki, who has once again become
the snow demon, Yuki-Onna, floats
over the young woodcutter, poised to
breathe her terrible breath into him.

Yuki lurks in the shadows behind the makeshift
stage. She slides her hand into the pocket of
John's satchel, which hangs over the back of
one of his cases, and pulls out his wallet. She
opens it and looks inside. She rifles through
receipts and business cards.

 YUKI
 (in Japanese; subtitled; under her
 breath)
Shit.

She looks up at John, then puts everything back
into the wallet, and back into the pocket of
his bag.

 JOHN
But she hesitates.
 (demon voice, screaming)
"That woman you met was me! You have
broken your promise, and for that,
I should kill you! But I won't,
because of the children."
 (MORE)

15

 JOHN (CONT'D)
 (normal voice)
 With that, Yuki-Onna flies off into
 the dark, stormy night, never to
 return.

The crowd CHEERS. They rush off, dropping
money into the suitcase on the ground.

Yuki walks out from behind the stage and nearly
bumps into John.

 YUKI
 (in Japanese; subtitled)
 Excuse me.

 JOHN
 I'm sorry.

 YUKI
 (Japanese accent)
 Ah, English. Excuse me.

John looks at Yuki and checks his pockets.

 JOHN
 I was looking for you. I think you
 may have dropped your wallet.

He pulls out a wallet.

 JOHN
 This yours?

 YUKI
 Oh, thank you.

Yuki acts surprised and takes the wallet.

 JOHN
 I noticed there was no money in it.
 Do you need some cash to get home?

John grabs a few bills from his case and offers
them to Yuki.

Yuki shakes her head, backing awkwardly toward
the exit of the station, giving small, repeti-
tive bows in John's direction.

 YUKI
 (bowing)
 No, thank you.

 JOHN
 You're welcome. I'm at this station
 sometimes. Maybe I'll see you again?

 Yuki bows again and continues to take small
 steps backward, away from John.

 JOHN
 What's your name?

 Yuki turns and rushes toward the exit, dis-
 appearing into the darkness.

 FADE OUT.

This is the moment you're interested in—the moment when Yuki-Onna falls in love and wants to become human. How does one woman disappear and another woman appear? Even when you set aside the Yuki-Onna script to write other films, they continue to circle this question.

REEL 2

```
TITLE CARD:

"ONE YEAR LATER"
```

Bismarck, North Dakota, is a six-hour drive from Minneapolis, but it takes about ten hours by bus. You sit toward the back, next to an old man who sleeps with his mouth hanging open and an older woman with a red checkered shirt and dyed black hair in curlers. She reads a coupon circular like it's a novel. Just in front of you, three Amish brothers talk among themselves in a thick Germanic language. You eavesdrop and try to figure out what they're saying. It sounds biblical at first, but occasionally they say things in English, like "solid oak door," and you second-guess that theory.

You settle in, take out your video camera, and start to film the landscape going by outside the window. You try to imagine you are Takako—that you've watched the movie *Fargo,* believe it's a true story, believe there's a suitcase full of money buried somewhere on this road, and believe you can find it.

Fargo is a black comedy by Joel and Ethan Coen. It tells the story of a car salesman named Jerry Lundegaard, who hires two thugs to kidnap his wife so he can buy a parking lot with the ransom money from his rich father-in-law. It's a harebrained scheme that goes wrong in every way. Most pertinently for Takako's story, one of the hired kidnappers, played by Steve Buscemi, buries a suitcase containing nearly one million dollars in a snowbank on the side of a road, and then he winds up dead.

That wouldn't mean much if the Coen brothers hadn't claimed that *Fargo* was a true story: "At the request of the survivors, the names have been changed. Out of respect for the dead, the rest has been told exactly as it occurred."[1] After the film came out, in interviews and publicity, the Coen brothers maintained that the film was

definitely true, all true. In March 1996, they appeared on the *Charlie Rose Show.*

```
FADE IN:

INT. SET OF THE CHARLIE ROSE TV SHOW - DAY

JOEL AND ETHAN COEN sit at a wooden table oppo-
site CHARLIE ROSE on an all-black set in a
television studio.

          ROSE
     Here is my first question: This
     movie was not based on an actual
     crime . . .

Ethan Coen smiles and fidgets with a coffee mug
on the table.

          ETHAN COEN
     Who says?

          ROSE
     . . . was it?

          JOEL COEN
     Yeah.

          ETHAN COEN
        (nodding emphatically)
     Yeah. Yeah.

          ROSE
     It was. And this story is completely
     based on a real event?

          JOEL COEN
     Yeah, the story is.² The characters --
     you know we weren't interested
     in making a documentary, and the
     characters are really inventions,
     based on the sort of outline of
     events.
          (MORE)
```

> JOEL COEN (CONT'D)
> So we invented the characters, and
> they're really sort of our creation
> and the creation of the actors that
> played the parts.

While Joel is talking, Ethan sips from his cup
and tries to stave off a laugh.

> ROSE
> So Steve Buscemi and Frances and all
> these terrific ensemble company that
> you've put together here in a sense
> made their characters what they
> became.

> JOEL COEN
> Yeah.

The Coen brothers managed to create a fair amount of confusion with their claims. An article published in the *Brainerd Dispatch* on February 11, 1997, reports that both the Brainerd police department and the newspaper received multiple phone calls and letters after *Fargo* came out, asking for more information about the case.[3] Even the cast of the movie was led to believe *Fargo* was a true story: William H. Macy, upon learning that the events of the film weren't actually true, said, "What?! You can't do that!"[4] So if Takako watched *Fargo* and thought it was based on fact, she wasn't the only one.[5] It would have made sense for her to take the geography represented in the movie at face value and to think the ransom money was still buried out there somewhere.

Fargo takes place primarily in Minnesota, near the towns of Brainerd and Minneapolis, with an opening scene in Fargo, North Dakota, and a final scene in Bismarck. The bus you're on, the one Takako would've taken, goes from Minneapolis, to Brainerd, to Fargo on its way to Bismarck. It's almost like a tour of the movie locations. You settle back, expecting to see the landscapes from the film: endless, flat, white, empty.

But that's not what happens as the bus pulls out of Minneapolis. Instead, traveling northwest on the highway, you pass car dealerships, shopping malls, billboards, and housing developments. You set your camera down and lean your head against the glass, watching the moisture from your breath condense and freeze into an oblong circular patch. It will be several hours before you get to Brainerd.

You saw the movie *Fargo* for the first time at the Uptown Theater in Minneapolis. You were back home for a brief stint in March 1996, and a friend from college came to visit. The plan was to drive to Lake Superior, but first your friend wanted to see "the new Coen brothers film" in a theater with "real Minnesotans." On the drive north after the film, your friend adopted a "Minnesotan accent," gleefully slipping phrases like "Okie doke!" and "O.K., you betcha!" into every encounter with the locals. To you, he said again and again, "Hey! You're from Minnesota. Why don't you talk like it?" By the end of the trip, like most Minnesotans, you hated that stupid movie.

If a person watched *Fargo* multiple times to try and figure out where Carl Showalter, the character played by Steve Buscemi, had buried the money, one of the major clues would be the scene in which Gaear Grimsrud, Showalter's partner in crime, shoots a highway patrol officer. Since Marge Gunderson, the officer assigned to the case, is from Brainerd, the shooting must have happened near there.

Grimsrud and Showalter were en route to a lake cabin when they shot the officer, so the money would probably have been buried somewhere near the cabin. The only clue to its location is a short scene late in the movie in which a "local" reports to a police officer that two suspicious guys are hiding out on Moose Lake. There are twenty-four Moose Lakes in Minnesota, but only three of them lie to the northwest of the Twin Cities, through Brainerd, and only one has cabins on it: the Moose Lake in the Chippewa National Forest near Blackduck. But that still leaves a couple of 150-mile stretches of highway between Brainerd and Blackduck to search for a snow scraper or a suitcase lying in a ditch on the side of the road.

That's the joke of the scene where Showalter buries the money. He's just received the suitcase with a million dollars in it. His jaw is bleeding because he got shot in the face when he went to pick it up.

Getting a million dollars was a surprise. Showalter and his partner were only expecting $40,000. So, on his way back to the hideout, Showalter pulls over, takes $40,000 out of the suitcase, digs a hole in a snowbank, and buries the suitcase with the remaining $960,000 in it. But after he buries it, as he looks up and down the featureless expanse of road with wire fence strung between wooden fence posts, telephone poles repeating forever in both directions, he realizes there's no sign, no building, no identifying feature, nothing that could help him find the money again. So he sticks a snow scraper in the snowbank to mark the spot, a tiny thing that's hardly better than nothing at all. That's part of the black comedy: the impossibility of ever finding the money again.

But if Takako went through a similar process to locate the money, she must have come to another conclusion. Her body was found near Detroit Lakes, Minnesota, far from any Moose Lake. Maybe she was lost, but there's another possibility, an interesting bit of misinformation: a tourism website mistakenly lists the location of a Lakeside Resort on a Moose Lake just a couple miles from Detroit Lakes. If this Moose Lake existed, and if Showalter and Grimsrud were driving there from Minneapolis, they would have followed the same route as this bus, and the money would likely be buried near the place where Takako's body was found. Maybe Takako found that listing in her research and thought, *This is it.*

You set your video camera on your lap and stare out the window, searching for stretches of highway that look like the spot where Showalter hid the money. You figure this is how Takako spent her trip, and you want to see the landscape like she did.

The bus stops for breakfast at a McDonald's outside Little Falls, Minnesota. You're a vegan and you know it's wrong to be giving McDonald's your money, but it feels like you've stepped out of your life and into another with different rules. You strike up a conversation with the girl in front of you in line—Stephanie, "from up north," she says, but without saying where. You order a coffee with nondairy creamer and sit next to her in front of the windows to keep an eye on the bus.

Stephanie says she's on her way to see her boyfriend, who's older. The way she says "older" makes you think she means a lot older.

Stephanie tells you that she and her boyfriend were living together on the streets, even in winter, drinking a lot and getting into trouble. Then the police picked them up for something and they both got locked up. The boyfriend had a criminal record and was given more time. Stephanie has been out for a while. The boyfriend is in treatment now, in Brainerd, and she's going to see him.

Stephanie is young and pretty, and you wonder why she wastes her time with him.

"I've never been to Brainerd before," she says. "I don't know where I'm going to stay. I need to make some fast friends, I guess."

That sounds like a bad idea to you, but you don't say so. You know she'll find everything out the hard way, which is really the only way.

The driver walks through McDonald's, signaling that the bus is about to depart. You and Stephanie grab your things and follow him outside.

You sit next to her in the back of the bus. Mostly the two of you sit in silence, staring out the window at the passing fields. In less than an hour you're in Brainerd. Stephanie stands up, grabs her bag, and turns to look at you. She waves tentatively and walks to the front.

You watch her through the window as the bus pulls away. She's standing in the parking lot of a hospital, looking lost. You wonder if that's what it looks like, just before someone disappears.

You go back to scanning the road. Just before Detroit Lakes, you make a note about a stretch of land just after State Highway 228 that looks flat and white like in the film, only on the wrong side of the road. And much later, near Steele, North Dakota, there are a few more bits of road that are possibilities. You write a note: *Steele, mile marker 208.*

Then the sun starts to go down, and the three Amish brothers in front of you sing a song together in their language. It must be a song for the setting sun, but it sounds like a song for the end of the world.

It's late by the time you arrive. You get a cab to the hotel, a tall building at the end of the main street in town. Though Bismarck is the

capital of North Dakota, it seems tiny and not quaint; just an unexceptional strip of businesses a few miles from the interstate.

Lisa, a slight woman in her early thirties, is working at the front desk. You ask about Takako as she checks you in. To your surprise, she remembers her.

"Oh yes, I remember her. I checked her in," she says. "Are you part of the film crew?"

"Film crew?"

"Yeah."

Lisa tells you that two days before, a couple of guys from the BBC in London were here asking about Takako. They were traveling with a Japanese actor who was playing Takako in their film.

This throws you. When you contacted the police officers in Bismarck to arrange a meeting, they mentioned that they'd be talking to a reporter about Takako, but you had the impression that there was just one journalist, not a whole film crew. You don't want to dwell on this now, so you steer the conversation back to Takako.

"Do you remember anything about Takako?"

Lisa nods. "She had a pure complexion. She looked young to me. Short hair. No glasses. Ah, more of an oval face, almost round. But not heavy at all, she was thin. And not very tall, like five foot one or five foot two. The day she checked out, I remember distinctly, she was wearing a short black miniskirt. And kind of a short jacket, black, up to about her waist."[6]

You nod, taking notes in a small black notebook.

"When she arrived, did she say she was looking for anything?"

Lisa nods her head. "Snow. She asked about snow."

You're surprised. "What about snow?"

"She wanted to know when there'd be snow."

You pause for a moment to think about this. "There was no snow when she arrived?"

"No. It was early November."

"Are you sure?"

"Yeah. I told her she'd have to wait. That there would be snow, but she'd have to wait for it."

You don't like that she's sure. There must have been snow.

"Anything else?"

"No. I mean, I don't know why everyone's so interested in a girl like that. But she was real quiet and polite. You'll have to talk to the others. I just checked her in."

You thank Lisa and grab your luggage.

When you get to your hotel room, someone is inside cleaning it. There's a law-enforcement convention at the hotel—no vacancies. You don't mind the wait. The ten hours on the bus have lulled you into a zone where there's no rush. You sit in the hall and shoot some footage of the generic doorways. You try to imagine Takako's reaction to this place, and nothing comes. It's just a hotel, the only one in town.

After the cleaning person leaves, you look around the room—probably not the same room Takako stayed in, but likely almost identical. Floral bedspreads, teal carpeting, dark wooden furniture, a Gideon's Bible in the nightstand, and a window overlooking the parking lot. You pull the curtain aside and look out toward the freeway, the empty snow-covered fields and the nothingness you crossed to get here. You crank up the heat and perch on the radiator, hugging your knees to your chest. Hearing there was no snow has shaken your confidence. You now feel that you don't know anything about Takako. You try to picture her walking out there in a scene without snow—brown fields, monochrome autumn, maybe dusk with the streetlights slowly coming up. It's different. You realize you're starting from zero, or almost zero: you only know that Takako wanted snow.

The next evening, you meet two of the Bismarck officers who spent time with Takako, Stu Carlson and Cort Baumler, at the police station. After a brief stop at a bar on the strip—too dark and crowded and loud to film the conversation—you're back at the hotel bar, a windowless area in the basement with beige walls and maroon floral cushions. There's spillover from the convention, a post-9/11 training session for law enforcement and firemen, and the bar is full of men drinking beers and high-fiving each other. Carlson and Baumler are off duty and drinking, and there's something flirtatious about their manner and the way they comment on what you're wearing—cords,

a down jacket, combat boots, and green wool socks. It's the socks that, for some reason, they find hilarious, but you stay polite and even flirt back to keep the conversation going.

Carlson does all the talking. He says a local found Takako near the city dump and brought her to the station because "she seemed lost and spoke no English."[7]

You ask him to describe Takako, and he tries to deflect. "You know, in our line of work there's certain people that you deal with that, for whatever reason, you just remember them. And she just was not one of them people. You know, I don't remember, I really don't."

You push a little, asking the question in other ways, until Carlson says, "You know, initially we thought she almost gave the appearance of being either a stripper or a prostitute. We have a couple of clubs in Mandan that bring in a lot of dancers from Minneapolis. We thought maybe they brought her over here and then just kind of, you know, kicked her to the curb, and just kind of left her out in the elements. But when she didn't speak any English, obviously it was quite easy to discount that and say no, she's obviously here for another reason." You don't really follow this line of reasoning, but you don't say so.

You ask whether Takako was brought to the station because she was suspected of prostitution, and Carlson says no. "You know, most police departments wouldn't have dealt with her, but in a community like Bismarck, we don't have the typical crime rates that a lot of big cities have, so, I mean, that's a typical call for us. People, they don't know who else to call, so they'll call the police department. You know, 'I've got a water leak in my basement,' so they'll call the police department. And we go over there and say, 'Yeah, you do, you've got a water leak in your basement.' So that part of it wasn't unusual for us. We've always had that policy, that if somebody calls and requests a cop, they get a cop."

From what Carlson says, it sounds like three officers spent the better part of a day with Takako, trying to understand what she was looking for. He explains that talking to her was difficult because of the language barrier. She had an electronic translator, and that was their primary means of communication. "It was probably a lower-end translator because you could only translate one word at a time. Even with being able to do that, it still remained difficult because

there were so many different literal translations for every word that we typed in."

You ask how they were able to determine that Takako was looking for the money buried in the movie *Fargo*.

"We were able to figure out, early on in the conversation, that she had just flown in from Japan and that she was trying to find Fargo, North Dakota. She flew into Bismarck because she couldn't get a flight into Fargo, and so she was wondering how to get to Fargo."

You pause to clarify with Carlson that Takako had flown to Bismarck. You just spent ten hours on a bus, looking out the window for a snow scraper, because the newspaper said Takako had taken the bus. But Carlson was sure. Takako had flown to Bismarck from Minneapolis.

Fargo is 223 miles northwest of Minneapolis, on the North Dakota side of the border with Minnesota. Bismarck is 196 miles west of Fargo, in the center of North Dakota. By flying 386 miles west to Bismarck, Takako only got about 27 miles closer to Fargo.

"While we were talking to her about Fargo, she started talking about the movie *Fargo,* that she knew the two actors' names, or the one actor and the one actress that starred in that movie. And she had a hand-drawn map that she had drawn on an eight-and-a-half-by-eleven piece of paper. It had one road on it, and it had a ditch that was on both the left and right sides of the road. About halfway up the page, there was a tree drawn in the road, and then on the other side of the tree, there was a fence line. With her pocket translator we were able to assume, with the limited amount of conversation we had with her, that there was a scene in that movie *Fargo* where they had buried some money in a ditch, and that is what she was looking for. That's why she was here."

You go over this story a few times with Carlson, asking him to remember the exact words Takako used and how, from those words, they were able to construct the story that Takako was in North Dakota looking for the ransom money from the movie.

"The only English that we could really understand from her was 'Fargo.' I mean, she spoke that very clearly, and also one of the actors and one of the actresses from the movie, she knew their, not their stage names, but their real names."

"So who were the actors? Steve Buscemi?"

"Yes, that was one of them."

"Steve Buscemi and . . . who plays the policewoman? I can't remember her name."

"Yes, the policewoman. That's who she knew."

"Right, but what other words did she say?"

"You know, quite honestly I don't remember exactly what words she said, but somehow or another she tied in this particular scene with money."

The other officer, Baumler, interjects. "It was more like an exchange of words. That she'd use more body language. Like a yes or a no, an agreement or disagreement, that she understood or didn't understand. It was more like we were feeding her information and she'd either agree or disagree. That's how we were able to, or these guys were able to, put together something."

You nod. Up to this point in the conversation, you've been thinking Takako definitely must have come here to find the money. But Baumler's comments bring some uncertainty. He makes it sound as if the conversation were a game of charades, with the officers suggesting something and Takako nodding her head to agree. But according to the officers, Takako spoke no English, so it's impossible to be sure of what she thought she was agreeing with.

Carlson pauses then, suddenly serious. "You know, I've never seen the movie *Fargo,* but from what I hear, the way it depicted North Dakota . . . I mean, you know, you're from Minnesota, it's a slap in the face of Minnesota, North Dakota, South Dakota, this whole tristate area."

Baumler chimes in. "How many times have you heard 'you betcha' since you've been here? How many times have you heard that? None! Who says that?"

"Actually," you say, "the very first person I contacted about this case, not in North Dakota but in Detroit Lakes, Minnesota, a local resident, really did talk just like the characters in the movie."

"I guess you will find those people, who were born and raised, or in smaller communities," Baumler concedes.

The next day you meet Jamie Harmon, the third officer who spent time with Takako, in a coffee shop in downtown Bismarck. Sun streams through the frost-edged storefront windows, and occasionally a gust of cold whisks in. It's packed and loud, and at times the coffee grinder and espresso machine nearly drown out the conversation. You talk for a long time. Officer Harmon has a gentle, sincere way of speaking; it seems like he was genuinely concerned about Takako.

Like the other officers, Harmon says that at first he thought Takako was a stripper or a prostitute. "Well, being from the North, you just don't see people dressed like that around here. Now I don't think she was, because I've been to Japan, you know, twice over the last year, and that's just how they dress over there. You know, every girl you turn around, they've got short skirts, no matter the weather."[8]

When the officers talk about Takako this way, you feel outraged and protective: How dare they assume she was a prostitute because of the length of her skirt? Later, you realize that every cop you talk to on this trip says they thought Takako was either a stripper or a prostitute. You have to wonder: Do cops have a sense for that? The tangible reason they give for their impression is the very short skirt, but was there something else? Something about the way she carried herself, the way she moved her body, made or didn't make eye contact? Something less tangible but somehow more telling?

You ask Harmon about that. "She wasn't acting like she was a prostitute or anything. She was real polite. But you don't know, different cultures, their prostitutes over there might be real polite. I don't think I seen any prostitutes or strippers while I was over there, so I don't know how they're supposed to act."

"You know, I don't know what she looks like. Could you describe her?"

"She was a pretty girl. You know, she was attractive looking. Um. Dark hair, straight, about shoulder-length. Real light on the makeup. Thin, well, you know, average size. I remember the boots that she had on. They had the real high heels on them, which, you know, she looked, when she walked, she looked like she was uncomfortable. She was probably a little bit shorter than me—and I'm five foot nine—with those boots on. Actually, for a female she seemed above

average. She kept saying 'Fargo.' You know, that was the one, one of the words, that she knew, was *Fargo*. She kept saying 'Fargo.' And she had a piece of paper with a hand drawing of a road and a tree. That's where she wanted to go. She kept showing me this piece of paper, saying she wanted to go there."

"And saying 'Fargo'?"

"Well, kinda. She was saying 'Fargo,' but to me, what I got out of it, was she was looking for this road and this tree by Fargo. North Dakota, as desolate as it is, everywhere you turn around there's a road with a tree."

You nod and pause for a moment, then ask, "What do you think she was looking for?"

"You know, that's a mystery, 'cause I don't know. At the time I wasn't sure what she was looking for. Now I think she was looking for somewhere to die. I really do. She was looking for this certain spot, and that's what she was looking for. Which really doesn't make sense, but, I mean, if you've never been in that situation, how do you know what goes through your mind when you want to die? Why a certain spot? Why here? I don't know. You know, I've always wanted to sit down and watch that movie and see if I could find something in that movie that would trigger that kind of thing. And I could be totally wrong. That's just my opinion, that she was looking for somewhere to lay down and die."

For some reason, you find this shocking and upsetting. The newspaper article mentioned that Takako's death may have been a suicide. But when Officer Harmon says it, it's like you're hearing it for the first time. You hear it, but you also brush it aside as an unlikely explanation. Like Harmon says, it just doesn't make any sense.

"I remember thinking to myself that it takes a lot of courage to just hop on a plane and go somewhere you can't communicate with. Either she was a very courageous person or she had a mission."

"Which did it seem like to you?"

"I think it was the mission. She was bent and bound and determined to do what she set out to do, regardless, it seemed to me. She would've got in anybody's vehicle. That's pretty obvious, because she got into a total stranger's vehicle on that dead-end road. You know, a guy pulled over, he couldn't speak her language, she couldn't speak

his language, yet somehow he got her in his vehicle and brought her to the police station. Plus the fact that she wasn't dressed for the weather. She could've froze to death. And I think that's what ended up happening . . . is I think she froze to death in Minnesota."

"Do you think it was her intention to freeze to death?"

"Boy, you don't hear of too many people trying to commit suicide by freezing to death. When she was at the police station, she kept pointing to her stomach, you know, and saying a word. I didn't know what the word was, but I said, 'Are you sick?' And she said, 'Yeah, die.'"

Harmon points at his stomach the way Takako did at the time.

"For some reason I said, 'Do you have cancer?' and she said, 'Yes, cancer. Cancer, here.' So then I started thinking, well maybe she wanted to see something that she'd seen on that movie, you know, she seen the open country and thought it was beautiful or something, and that's why she jumped on a plane and came over here, to see something before she died."

Back in your hotel room, you listen again to the conversation with Harmon. You recall that Carlson had emphasized the role of the electronic translator in his communications with Takako. Harmon mentions it briefly, too, and you realize you never clarified which words were spoken between them directly and which came from the translator. Early in the conversation, Harmon had said that *Fargo* was one of the only English words Takako knew, so it seems plausible that *cancer* was a translation.

You type *cancer* into a translation program and come up with the following:

癌: cancer, malignant tumor
キャンサー: cancer
腫瘍: tumor, cancer, neoplasm, malignancy, growth, melanoma
悪性: malignancy, cancer, malignity, malignance, virulence, evil nature
凶: misfortune, unluck, ill luck, mischance, miscarriage, cancer

Of course, there are literal translations of the word, but you notice that, like in English, cancer can also be used metaphorically,

to describe evil or misfortune or a bad feeling. You notice that the second word down is spelled out in katakana, the Japanese phonetic alphabet, and is pronounced "kyan-sah." You wonder if Takako knew that "cancer" was a word in English and had used it metaphorically, to describe her feelings or the situation she was in.

At different points during your conversation with Harmon, the visit from the BBC film crew just two days before comes up. It turns out the "film crew" was two American guys and a Japanese model in a micromini and high-heeled boots. They were making a docudrama using real people in North Dakota to reenact their parts in Takako's story. Harmon explained their version of Takako's story like this: "Takako met an American in Japan and was apparently dating him or something, and apparently he was a married man and broke it off. So she wanted to die, and it's possible that she found somebody to help her do it. Or you know, I don't know... maybe in some way she was twisted, and maybe took this bottle of champagne and two glasses and thought that her guy who had broken off the relation-ship, she pretended to sit there and drink with him but actually didn't drink anything. And then took some kind of pills, to make her sleep or something, and then she froze to death."

This sounds even crazier to you than flying to North Dakota to look for the ransom money from a fictional movie.

You say, "So I'm confused, the Bismarck Police Department said Takako was here because of the movie. Now it seems you have the impression she was trying to get to the city of Fargo, not saying the name of the film."

"Yeah, the movie came up too. I've never ever seen the movie, but Officer Carlson had seen the movie so he. ... She had said one of the actors' names and we were like, 'Oh, *Fargo* the movie,' and she was like, 'Yeah, *Fargo*, *Fargo*.' And I don't remember what actor she said, but, uh, somebody made the comment, and I don't remember who it was, that in the movie there was some money buried by a tree, and so then we're like, 'Is that what she's looking for is this money?' Of course she was in the lobby and she didn't hear us, and we're in the back, and I said, 'No, nobody'd be that dumb to see some buried treasure on TV and think that there's money actually buried under

that tree.' And of course, you know, we kind of laughed about it. You know, nobody's that stupid.

When he couldn't figure out what Takako was looking for in North Dakota and couldn't find anyone who spoke Japanese, Harmon brought Takako to the Greyhound station so she could catch a bus to Fargo.

You ask him why he decided to do that.

"She kept saying 'Fargo,' and she kept pointing at [the map], and I said, 'Do you want to go to Fargo?' And she goes, 'Yes, Fargo. Fargo. Fargo.' She kept saying 'Fargo.' So I thought, O.K., well. She wanted me to drop her off on the interstate, and I said, 'No, you know, it's not safe.' I . . . And I don't know if I ever got through to her or not. So I told her, I said, 'I will take you to the bus station. The bus.' And she, you know there was words that I would say that she would repeat and then nod her head like she understood. So I said, 'O.K.' So I took her to the bus station. And the really odd coincidental thing is, I get to the bus station and we walk inside and there's one other person in there and it's an Oriental, and I'm like, hey, this is, I just spent two hours on the phone trying to find an interpreter, and I got one sittin' right here in the bus depot. And it's a male. And so I walked in and I said, 'Hey,' I said, 'You speak Japanese?' And this guy looked at me. He didn't understand me either. So she says something to him, in Japanese, and he rattled something back at her, and then she turned to me and she said, 'Uh, Chinese, no, no speak. No speak.' So I thought, here we got a Chinese male, Japanese female, and an American male, and all three of us can't talk to each other. So I thought, well, this is just the way the day's went so far."

You say, "So when you left her there, you felt pretty confident that's where she wanted to be?"

And Harmon nods. "Yeah."

Before you leave town, you interview Donald Keller, the bellman who drove Takako out to the truck stop near the interstate before the stranger picked her up and brought her to the police station. He describes Takako to you as a "nice sexy lady" in a way that gives you the creeps.[9] He vividly recalls the map she had with her: a pencil drawing of a tree and a road with the contours of the landscape drawn

on either side like lines on a relief map. But he has no idea where this road or tree was supposed to be, only that Takako pointed to the drawing and said "Fargo" again and again. He says that on one of her first days at the hotel, he drove Takako around the countryside, thinking the tree and the road meant she wanted to see some nature, but once they were out, she didn't seem interested in the landscape at all. On the day she left, Donald says he figured Takako wanted to go to the city of Fargo, so he dropped her at the truck stop thinking she might hitch a ride with one of the truckers. You remember Harmon had said that too: that Takako wanted to hitchhike. You ask Donald how he knew she wanted to hitchhike. He says she kept holding her thumb up and saying, "Fargo."

You mentally compile a short list of things you know about Takako: she wanted to hitchhike to Fargo; she wanted snow.

A friend from Minneapolis drives out and picks you up at the hotel in Bismarck, and on your way out of town, you stop at the landfill where the stranger found Takako before bringing her to the police station. (There is no record of who brought Takako to the police station, and nobody remembers.) The landfill is a flat, chained-off area at the end of a narrow road that runs alongside the interstate. It's dotted with small white metal containers and a large white metal shed.

Up to this point, you'd imagined the "landfill" as a large mountain of trash. You'd pictured Takako sorting through heaps of refuse, looking for a suitcase full of money. This landfill is nothing but a flat, empty space without a single piece of garbage in sight. You can't imagine what Takako would have wanted here. There is quite literally nothing here.

Continuing out of town, you review the impressions you got in Bismarck with your friend: Lisa had referred to Takako as "a girl like that"; the bellhop kept calling her "a nice sexy lady"; the officers circled back to her miniskirt again and again, writing off her quest as an elaborate way to commit suicide. It makes you uneasy. You think of Freud's famous question: What does a woman want?[10] As if he couldn't imagine a woman wanting anything at all. Like the officers and the BBC filmmakers, Freud might have imagined that when Takako's relationship was over—if there was a relationship—her

life was over. But that doesn't make sense to you. You think that if Takako was a jilted lover who wanted to off herself, she would've done it at home in her bathtub; she wouldn't have flown to the other side of the world to be in a place where she'd "once been happy with her lover." If there was a lover, they'd been happy in Tokyo, hadn't they?

You think Takako wanted something, or she wanted to figure out how to want something. You think she wanted to find a way back into her own life.

REEL 3

Or perhaps Freud and the officers are right: You would never have taken that trip to Fargo if it weren't for the lonely heartbreak summer you spent in San Diego the year before. If so, and if this book were a film, after the image of the woman lost on a snow-covered road, there'd be a scene on the deck of a large, white, modern house that sits on a cliff overlooking the ocean, the day you leave for Fargo.

FADE IN:

EXT. DECK OVERLOOKING OCEAN - DAY

A MAN and a WOMAN in their late twenties recline on chaise lounges on a deck overlooking the ocean. They drink cappuccinos in the weak February sun, which hangs low over the water and reflects a bright wedge at the horizon. From this distance, the ocean looks like a piece of leather, dark and wrinkled and still.

The Woman cradles her head in her hands and sighs, breaking the silence. She walks to the edge of the deck and stares at the ocean, feeling the wind on her face. She is pretty, if a bit plain, with a muscular build and long brown hair streaked with gray.

The Man's gaze follows her. He is handsome, if a bit odd looking: tall and thin with greasy black hair, tanned skin, multiple piercings, and Coke-bottle glasses.

The Woman turns toward the man and shrugs.

 WOMAN
 And so . . .

 MAN
 So what?

WOMAN
What now? After everything we talked about?[1]

The Man squints and stares off, not making eye contact.

The Woman sighs and turns back toward the ocean. She closes her eyes, and the breeze from the water makes her feel like she's on the deck of a ship, forging into the unknown. She just wants to get on with it, even if it's a shipwreck. It's practically a whisper, more to herself than anything, but she manages to say:

WOMAN
I should go.

The Man watches her for a moment, thinking. He approaches and puts his hand on her arm, squeezing it and looking into her eyes.

MAN
How long until your flight leaves?

The Woman continues to look at the ocean.

WOMAN
Hours. But I've got a book.

MAN
You don't need to leave now.

The Woman turns to look at him. She stares into his eyes for a moment, then sighs loudly, wriggles away from him, picks up her coffee cup, and heads inside.

INT. KITCHEN - DAY (CONTINUOUS ACTION)

The Woman sets the cup down in the kitchen sink. The Man approaches, puts his hands on her arms, and looks over her shoulder out the window.

MAN
Are all your interviews set?

She turns around to face him, leaning against
the counter.

> WOMAN
> Only with the cops in Bismarck. I
> don't really know who else saw her
> while she was there. I'll have to
> make connections by asking around.

> MAN
> It's going to be cold.

> WOMAN
> Cold, but white, which is good.
> That's how I imagine the film:
> little dark figures moving around
> in an endlessly white landscape.
> Kind of like the footage of the
> Shackleton expedition. Have you
> ever seen that?

The Man shakes his head. He hates movies. He
lowers his gaze to look at her.

> MAN
> You know how I've told you I don't
> always feel like having sex with
> you?

She nods, looking away.

> MAN
> Well, right now, I do.

He sets down his coffee cup, continuing to look
at her.

> MAN
> Right now, I'm very attracted to
> you.

He leans in closer, grabbing her arm.

She stiffens, staring past him as he kisses her
neck.

He pauses.

```
                    MAN
       I can't tell how you're reacting to
       this.

                    WOMAN
          (shrugging)
       Yeah, it'd be more awesome if you
       were a little more unequivocally
       psyched to be with me.

                    MAN
          (sighing loudly)
       Yeah, I know.

    He stares off for a moment, leaning into her.
    He grabs her hand.

                    MAN
          (gently)
        Come on.

    He pulls her toward the stairs. She follows.

                                    FADE OUT.
```

You are the woman in this scene. The man is Henri. You've known him for about a year. Henri studied ethnomusicology at the University of Chicago and played in a punk band for a few years. Now he's in graduate school, living at his parents' house, trying to figure out what to do with his life.

You remember the day, two years earlier, when you fell for him.

```
FADE IN:

EXT. VISUAL ARTS FACILITY - DAY

The desert in spring: rocks, sand, blooming
maguey, and jacaranda. The gray metal sid-
ing of a modern structure rising at the edge
of it.
```

A cast of performers in elaborate costumes rushes across the cement courtyard of the gray modern structure, toward a Victorian garden across the road. A WOMAN in a maroon ball gown with a hoopskirt runs with them, fussing with a tall orange rococo wig that sits at a strange angle atop her head.

EXT. VICTORIAN GARDEN IN SPRING - DAY (CONTINUOUS ACTION)

The Woman rushes into the symmetrical garden in full bloom and takes her place next to a freckled man wearing a tall blue wig and blue gown.

The STAGE MANAGER waits for everyone to settle, then calls out:

> STAGE MANAGER
> (shouting, counting with her hands)
> And five, four, three, two . . .

The Stage Manager makes a dramatic gesture to signal "one."

The Woman and the freckled man begin to goose-step in a circle, holding their hands out from their sides like stick figures. Five other performers lock arms and start to jig and spin in a wide circle around them: Kim, in a long purple wig; Margaret, in a tall green hat; Patty, in pink velvet trousers; Blake, dressed like a cotton ball; and Jennifer as the dancing bear.

The dancers represent the sun and moon and five planets[2] orbiting in space, part of an opera about utopia. The planetary choreography is based on baroque court dances and ritual movements performed by the disciples of Gurdjieff, a spiritual guru from the twenties. For Gurdjieff's followers, the monotonous back-and-forth movements, arms held stick-straight while rotating in circles and repeating incantations, were meant to induce an altered state of consciousness, a sense of connectedness to the cycles of nature.

EXT. VICTORIAN GARDEN IN SPRING - DAY
(CONTINUOUS ACTION)

The Woman closes her eyes and imagines their
steps and twirls will transport them all to
Mars, bring the solar system to touch the
Earth, turn everything into empty space.

An audience arrives and stands at the edge of
the garden to watch the performance. They are
dressed in white hazmat suits, listening to a
soundtrack on headphones.

The Woman opens her eyes and, with each solar
rotation, scans the crowd. They seem distant,
as if in another sphere. Her gaze falls on a
man in his late twenties, clutching his head-
phones, hunched over, eyes closed, listening
to the soundtrack, not watching the perfor-
mance at all. He's beautiful in a strange way,
with greasy black hair and chiseled features,
a bit like a tall, thin, gothic version of Tom
Cruise with multiple piercings and a ski jump
nose. He stands and looks in the direction of
the performance. The Woman notices that thick
glasses magnify his eyes into giant discs.
She wonders if perhaps he can't see well. The
man closes his eyes and hunches over again,
clutching his headphones. His fingers are
tense and straight, like antennae or two ends
of a divining rod.

INT. BLACK-BOX THEATER - LATER

After the performance, the cast and costumes
are strewn across the chairs and floor of a
black-box theater. The Woman stands in a cor-
ner, head hung forward, working the pins out of
the orange wig. MARGARET, a pixie with over-
sized acetate glasses and a tall green hat,
rushes toward the Woman, laughing with excited
energy. Margaret stops in front of the Woman
and turns around.

 MARGARET
 (laughing)
 Unzip please.

The Woman stands up, her wig hanging at an
even stranger angle from her head, and unzips
Margaret's dress.

Margaret turns and stands next to the Woman
in front of a full-length mirror. She looks at
the Woman's reflection and starts to undress,
giggling.

> WOMAN
> O.K., what?

> MARGARET
> Blake says he saw you coming out of
> Arthur's studio last night at, like,
> one in the morning. What's going on?!

> WOMAN
> We drank some whiskey and geeked out
> on Gurdjieff for a while, but there
> was no sex involved, if that's what
> you're asking.

> MARGARET
> Interested?

The Woman shakes her head.

> MARGARET
> In anyone on campus?

The Woman stares off in thought for a moment.

> MARGARET
> Oh my god, there is someone!

The Woman starts to LAUGH.

> WOMAN
> It's nothing. I don't even know his
> name.

> MARGARET
> What does he look like?

> WOMAN
> It's seriously nothing.

Margaret opens her eyes wide, silently demand-
ing information.

Jana Larson

 MARGARET
 Tell me!

 WOMAN
 O.K. . . . He was at the performance
 today. . . . He's kind of tall, with
 facial piercings and a greasy, black
 mudflap of hair . . .

 MARGARET
 Oh, that's Henri Iverson from Force
 Majeur. Cute, but married.

 WOMAN
 See, like I said: it's nothing.

The Woman bows her head and starts to work on
the pins in her wig again, moving on. Only she
doesn't move on. She finds herself thinking
about Henri Iverson.

 WOMAN
 What's Force Majeur?

 MARGARET
 They were a punk band from Chicago.
 You never heard of them?

The Woman shakes her head, and a couple of pins
CLINK to the cement floor.

 MARGARET
 They were good. We played with them
 a few times. That Henri guy's a dick,
 though. I tried to talk to him once
 after a show, and he just rolled
 his eyes and looked away. Can you
 believe that?

The Woman lifts her head slightly to give
Margaret a look of astonishment, shaking her
head.

 WOMAN
 No way.

The woman drops her head again and continues to
work on the wig.

But you can believe it. Once, at the coffee cart, "that Henri guy" caught you staring at him and widened his eyes, like "What the fuck are you looking at?" You looked back as if challenging him to a grade-school staring contest. It was meant to be a joke, but he didn't laugh. He stared back for a second, then looked away. It made you feel bad. But afterward, whenever you went to the coffee cart, you found yourself looking for him.

INT. BLACK-BOX THEATER - CONTINUOUS ACTION

The Woman frees herself from the wig and stands up. She looks at Margaret as if coming out of a reverie.

 MARGARET
 (continuing a thought)
 I dunno . . . I see guys working
 really hard to get your attention
 and then, once you like them a
 little, they don't have to do
 anything to keep you interested.
 It's kind of messed up.

 WOMAN
 What do you suggest I do?

Margaret shrugs.

 FADE OUT.

You're in graduate school in San Diego, but you live part-time in Los Angeles in a tiny bungalow in a parking lot below the Hollywood sign. You spend a lot of time adrift in the hundred miles between them, stuck in traffic on the 5, obsessively checking your bag for things you might have forgotten, witnessing things: a car on the side of the road with a sign in the back that says "Help Me," held by invisible hands; a car speeding against traffic, headlights barreling toward you, then disappearing into nowhere; a car hanging from a cement barrier like a barge on a sandbar after the river has dropped. You light a cigarette and dial 9-1-1. You dial 9-1-1 a lot.

You spend your days in Los Angeles at the corner of Franklin and Tamarind Avenues, sitting at a table in front of a café called the Bourgeois Pig, staring at the screenplay about a woman who disappears from the side of a volcano. You look out across the sea of tables full of twenty-somethings busily typing away—everyone in Hollywood is writing a screenplay—and then back at your computer screen, not knowing how to go on.

Your screenwriting teacher always said, "Look for desire. Stories are driven by characters who want something, who *need* something. Without desire, there is no story, no character."

And you think maybe he's right, that we have to want something—to get to Kansas, see Boo Radley, free Princess Leia, save the Empire, redemption, Rosebud. That's what makes us. That's how we know if we're living a comedy or a tragedy. Desire is what drives the action, tells us who we are and what comes next. Until one day it doesn't.

One day, you lose your place in the drama you've been living. You become a stranger to your life, a stranger to desire. Sometimes the gap lasts for a moment and then you're swept back into the flow of things as if nothing happened. But sometimes it lingers, and no amount of heel-clicking will get you back to the story you were living because that's just it: you've lost your homing beacon, you're lost.

```
TITLE CARD:

        "A YEAR PASSES -- IN THE GAP -- AND
        SPRING ARRIVES AGAIN"

FADE IN:

INT. GYMNASIUM - DAY

A WOMAN stands in a crowd of hipsters bouncing
to ELECTRONIC MUSIC, staring toward one end of
a gymnasium, where a man in a bunny suit occa-
sionally appears above the sea of people in
front of her. She turns to look at her friends,
who are high and bouncing to the music. She
bums a cigarette and pushes her way through
the crowd toward the door.
```

A VOICE calls out above the din of the music.

> VOICE (O.S.)
> Hey!

The Woman slows and looks around but sees nothing. She starts walking.

> VOICE (O.S.)
> Hey!

The Woman stops and scans the crowd again.
This time, back in a corner of the gymnasium,
she sees two men staring at her. It takes a
second for her to recognize HENRI. He is standing next to a tall, lanky man with a wiry blond
ponytail. She approaches.

> WOMAN
> Hey.

> HENRI (VOICE)
> (shouting over the music)
> What are you doing up here?

> WOMAN
> (shrugging her shoulders,
> shouting)
> Checking out the bands.

She looks at the friend, whom she mentally dubs
PONYTAIL. He stares at her silently from under
a pair of bushy eyebrows in a way that makes
her feel like a bug under a microscope.

> HENRI
> (shouting over the music)
> I mean L.A.!

> WOMAN
> (shouting)
> I live here!

> HENRI
> (shouting)
> Are you serious?

> WOMAN
> (shouting)
> Yeah! I have friends here! I don't
> really know anyone in San Diego! And
> besides, it's so . . .

The MUSIC STOPS, but the Woman continues to shout.

> WOMAN
> (shouting)
> . . . "wastin' away in
> Margaritaville"!

Henri and Ponytail LAUGH, and the Woman LAUGHS, too, looking at the floor, abashed.

The silence between the song and the crowd screaming "More!" stretches uncomfortably.

> CROWD (O.S.)
> M-o-o-o-re!

Finally, Ponytail comes up with a question.

> PONYTAIL
> What's up with your hand?

The Woman extends her hand to show the cigarette she's clutching, now crushed but still smokable.

> WOMAN
> I was gonna smoke before the
> Boredoms came on.

> PONYTAIL
> No, I mean this.

He rotates his wrist to demonstrate.

> WOMAN
> Oh, it's a habit. Carpal tunnel.
> I edit on the computer a lot.

 HENRI
 (blurts out suddenly)
 I could help you with that!
 Sometimes you just need to put your
 computer on a phone book or, like,
 a dictionary under your feet or
 something . . .

 PONYTAIL
 (looking at Henri, incredulous)
 Ergonomics?!

Henri ignores Ponytail and takes out a scrap
of paper. He writes his phone number on it and
hands it to the Woman.

 HENRI
 Call if you want me to come over and
 check out your work station.

The Woman takes the piece of paper and glances
at it.

 WOMAN
 O.K., thanks.

The Woman stands looking at the two. After an
awkward silence, she waves, turns, and walks
toward the exit.

 VOICE IN THE CROWD (O.S.)
 (shouting)
 Boredoms!

The Woman stops and tries to find Henri in the
crowd again, but he's gone. She looks at the
number on the piece of paper, at the name writ-
ten out: H-e-n-r-i.

She scans the crowd again.

The Boredoms start: PERCUSSION AND SCREAMING.

The Woman shoves the piece of paper into her
pocket and rushes into the crowd.

 FADE OUT.

You don't call for the ergonomics adjustment, but you run into Henri at a concert the next week. After another brief and awkward conversation, he says, "Hey, a bunch of friends have a pickup soccer game in Balboa Park on Sundays, if you wanna play sometime. Know where that is?"

```
FADE IN:

EXT. BALBOA PARK - DAY

The Woman walks slowly through a grove of
eucalyptus trees at the edge of Balboa Park,
scanning the sea of picnicking families and
joggers with dogs, until she sees Henri walk-
ing slowly toward her, shoulders hunched,
hands held stiffly at his sides, fingers
extended.

                 WOMAN
            (waving and calling out)
        Hey! Where's the game?

Henri keeps walking and doesn't respond until
he arrives in front of her.

                 HENRI
        There was a huge antiwar protest
        here earlier. Nowhere to play
        soccer.

                 WOMAN
        But isn't the game supposed to start
        now?

She looks at her watch.

                 HENRI
        An hour ago.

Henri pauses for a moment, monitoring her
face, before he explains.

                 HENRI
        Daylight savings.
```

 WOMAN
 Oh, shit! I'm sorry.

Henri is silent for a moment, looking her up
and down, considering . . .

 HENRI
 We could still hang out, now that
 you're here. We could drive up to
 campus and leave your car, and then
 you could change and we could drive
 together. If you want.

The Woman looks down at her sweatpants and
tennis shoes, then back at Henri.

 WOMAN
 Yeah, we could . . . but all my
 clothes are in L.A. I don't have
 anything else to wear.

Henri LAUGHS.

 HENRI
 O.K., we can go from here. I just
 thought maybe you wouldn't want to
 wear sweatpants.

She pauses and nods, then follows behind Henri
as he walks quickly to his car. It's a small
detail, the sweatpants. She looks down at them
again, ill at ease.

EXT. SIDEWALK CAFÉ - DAY

The Woman sits across from Henri at a table on
the sidewalk in front of a Mexican restaurant
in La Jolla, favored by Henri for the vegan
tacos served in red plastic baskets.

 WOMAN
 . . . Before grad school, I lived at
 an ashram in New York. That's where
 I started to meditate.

 HENRI
 I don't meditate, but I do try to
 notice what my mind is doing.
 (MORE)

HENRI (CONT'D)
For example, what's the first thing
you think of when someone approaches
you?

WOMAN
(shrugs)
I think it depends on the person.

HENRI
Yeah, but I mean on the most basic
level. For example, I've noticed
that when a man approaches me, I try
to figure out whether or not I could
take him in a fight. And when a woman
approaches, I think about whether or
not I want to sleep with her.

The Woman considers that.

WOMAN
Yeah, I guess it's basically the
same for me. When a man approaches, I
try to figure out if he's planning to
attack and, if so, if I should fight
or run. When a woman approaches, I
try to figure out if she's more or
less attractive than me.

Henri nods and chews his taco and mulls that
over. He takes a pen out of his pocket.

HENRI
Let me see your arm.

WOMAN
Why?

HENRI
Let me see it.

The Woman lays her arm on the table. Henri
pushes up her sleeve and draws a lightning bolt
with the letters D-I-O under it. The Woman
looks at her arm.

WOMAN
Dio?

 HENRI
 (nods)
 Ronnie James Dio.

 WOMAN
 Rodney James Dio?

Henri LAUGHS. The Woman LAUGHS, too, not know-
ing why.

EXT. CHILDREN'S POOL BEACH, LA JOLLA - DAY

Henri and the Woman stand looking at a beach
covered with seals and pups. The male seals
hang on the periphery, sparring.

 HENRI
 How'd you end up making films?

 WOMAN
 I didn't really fall in love with
 cinema until a few years ago, when
 I started seeing more experimental
 work, films by Jack Smith, Andy
 Warhol, Joseph Cornell, Buñuel,
 Brakhage, Maya Deren, Jean
 Cocteau . . .

Henri shrugs and shakes his head, indicating
cluelessness.

 WOMAN
 . . . But immediately, when I saw
 those films, something in me was
 like, yes, this is for me. . . .
 Sometimes I think it's because of
 something that happened to me when
 I was a kid.

The Woman shakes her head and trails off, hesi-
tant to go on.

 HENRI
 What do you mean?

 WOMAN
 Well . . . I was five the first
 time I saw a camera. Not like my
 Oma's Instamatic with the square
 flashbulbs that made a loud "snap."
 But a real camera on a tripod, with a
 stop-motion motor attached to it. We
 were in the kitchen that day, baking
 bread . . .

FLASHBACK - INT. MIDCENTURY KITCHEN - DAY

A YOUNG GIRL with blond ringlets stands on a
stool in front of a kitchen island next to OMA,
an elderly woman with permed brown hair and
spectacles.

Oma PUNCHES down the mass of dough and tears
off pieces, which the Young Girl forms into
tiny loaves. She lays each in a pan, tucking
the edges carefully as if putting a small being
to bed.

Oma covers the loaves with plastic, and the
Young Girl leans into the counter, monitoring
them closely.

 OMA
 When they push up on the plastic,
 they're finished.

The Young Girl nods.

 OMA
 Go tell Opa lunch is ready.

FLASHBACK - EXT. BACKYARD OF SUBURBAN
MINNESOTA HOME - DAY

The lawn is a sea of perfect green, edged on
one side by lilac bushes and in the back by
a wooden fence and a small hill with a giant
maple growing from its center.

Opa is lying in the center of the green, his
belly protruding toward the sky like the
loaves in the kitchen.

The Young Girl kneels down and touches his arm.
He doesn't move. She shakes him gently.

> YOUNG GIRL
> (softly)
> Opa.
> (loudly)
> Opa!

FLASHBACK - INT. MIDCENTURY KITCHEN - DAY

The screen door SLAMS behind the Young Girl as
she enters the kitchen.

> YOUNG GIRL
> Opa's sleeping, and I cannot wake
> him!

Oma drops a ball of dough and pushes past the
Young Girl, out the screen door. The Young Girl
follows.

FLASHBACK - EXT. BACKYARD OF SUBURBAN MINNESOTA
HOME - SERIES OF SHOTS FROM MULTIPLE CAMERA
ANGLES

CLOSEUP: Opa is lying still

CLOSEUP: Oma is SOBBING LOUDLY.

BIRD'S-EYE VIEW: Oma shakes Opa gently,
SOBBING LOUDLY.

> WOMAN (V.O.)
> I see it all so clearly, from every
> perspective -- floating above,
> looking down; standing at the
> window, looking out; kneeling beside
> Opa, watching as Oma shakes and
> tries to wake him. It's as though
> I have broken free of my body and
> can move about in a scene that is
> outside of time. It's the first time
> I experience this -- being both
> present and absent, both present
> in and separate from time.

POV, THROUGH WINDOW: Oma is kneeling next to
Opa, holding him, mouth agape, her whole body
shaking.

 OMA
 (sobbing and shrieking)
 Get Benita! Mrs. Johnson, she's a
 nurse. Go next door and get her!

The Young Girl turns and runs.

FLASHBACK - INT. NEIGHBOR'S LIVING ROOM - DAY

Benita sends the Young Girl to the back porch
with her son CHRISTOPHER, then rushes out the
door.

FLASHBACK - EXT. NEIGHBOR'S BACK PORCH - DAY

On a small wooden porch, a 16mm film camera
sits on a tripod, attached to a stop-motion
motor, aimed at a small plant on a table, TAKING
A PICTURE once a minute or so. The Young Girl's
hand reaches toward the camera.

 CHRISTOPHER
 Don't touch it!

The Young Girl stops abruptly, pulling back
the hand already in motion.

 CHRISTOPHER
 It's filming now. If you touch it,
 you'll mess up the whole thing. That
 plant is growing a flower right now.
 We can't see it, but the camera can.
 Everything is moving if you look at
 it right.

 END FLASHBACK.

EXT. SEAL BEACH, LA JOLLA - DAY

The Woman and Henri still stand next to each
other, looking toward the ocean.

 WOMAN
 I didn't understand what he was
 saying, but I did understand one
 thing: the camera could see things
 that were otherwise invisible. I
 remember thinking about Opa then,
 lying still on the lawn, his belly
 pushing up toward the sky, and
 wondering what the camera would
 see in that.

The Woman falls silent and watches the seals,
still SPARRING. Henri looks, too, for a
moment.

 HENRI
 Whoa, that could seriously mess
 you up. You should really talk to
 someone about that.

EXT. STREET IN THE GASLAMP QUARTER OF SAN
DIEGO - NIGHT

Henri and the Woman walk together down a street
lined with bars and cafés; people overflow
onto the street and queue to get into clubs.
They walk past a crowd of muscled and tanned
guys, and girls in tiny dresses, waiting to get
into a bar.

 HENRI
 (whispering)
 O.K., pretend you have to take one of
 these guys home with you.

The Woman bursts out LAUGHING.

 WOMAN
 Come on.

 HENRI
 No, seriously. Pick one.

Henri slows down and looks at the Woman.

 HENRI
 This is purely hypothetical.

The Woman slows down and looks at one guy, then another.

> WOMAN
> If I had to take someone home from
> this bar, it would not be a guy.

Henri LAUGHS out loud.

> HENRI
> Good one!

The Woman LAUGHS too. In the glow of Henri's approval, something inside her lifts.

INT. COFFEE SHOP - NIGHT

Henri and the Woman arrive at a coffee shop that looks like it's been around since the late sixties. They order coffees and sit down at a table.

> HENRI
> Let's go back to the guys in line
> outside the bar. I mean, clearly
> they were exhibiting what we might
> call deal breakers for you. Let's
> talk about that. What are some of
> your deal breakers?

> WOMAN
> Define "deal breaker."

> HENRI
> Something that would keep you from
> being at all interested in someone,
> no matter how awesome they might be
> in other respects.

> WOMAN
> I don't know. I like to think I'm
> pretty open-minded. There are things
> that are a turnoff, for sure, but if
> I met someone I liked, I wouldn't not
> date them just because they're . . .
> like, a jock, for example.

 HENRI
 No way. Everybody's got deal
 breakers. Like, for me: Tevas, UGG
 boots, high heels . . . I just think
 high heels . . .

 WOMAN
 (laughing)
 So you've got a shoe thing!

Henri looks at her with mild annoyance.
Clearly she is not taking the deal-breaker
conversation seriously enough.

 HENRI
 I can't believe you've never thought
 about this before. Meat eater --
 that's another one for me.

 WOMAN
 (still laughing)
 So if someone were to date you,
 they'd have to become a vegan?

 HENRI
 (defensively)
 You've got nothing like that? No
 line that can't be crossed?

Noticing that the tenor of the conversation
has changed, the Woman falls silent, thinking.

 WOMAN
 I don't know, I guess I find bad
 posture kind of a turnoff . . .

 HENRI
 Great. I have terrible posture.

 WOMAN
 Oh, shit! I'm sorry. You don't!

 HENRI
 No, I do.

 WOMAN
 See, I don't have deal breakers.

> HENRI
> Forget it. I can see this isn't going
> to be a fun conversation with you.

The conversation lapses into an uncomfortable
silence.

> WOMAN
> (eager to be fun)
> I guess someone who kills
> spontaneity, who has to analyze the
> fun out of every last thing.

Henri glowers and sips his coffee.

> HENRI
> That also describes me perfectly.

Henri stares off. The conversation is over.

EXT./INT. HENRI'S BMW, GASLAMP QUARTER - NIGHT

As Henri drives up Fifth Avenue out of the
Gaslamp Quarter, he TURNS UP THE RADIO.

> HENRI
> This song is, like, so, "I want to be
> inside you."

The Woman listens to the song for a moment.

> WOMAN
> This song is, like, so "I _am_ inside
> you."

Henri bursts out LAUGHING, and the Woman
starts to LAUGH too.

> HENRI
> When we're on tour we play this
> game where if someone says something
> funny or, like, fucked in a good way,
> we write it on a Post-it and stick
> it to the roof of the van. So by the
> end of tour there are all these gems
> people have come up with, like a
> list of all of our inside jokes.
> (MORE)

> HENRI (CONT'D)
> "This song is, like, so 'I am inside
> you'" would definitely be a Post-it.

The Woman LAUGHS, relieved.

> FADE OUT.

On the day before you move to San Diego, Henri drives up to Los Angeles, and you get a coffee at the Bourgeois Pig. While you're trading jokes about the Scientology Celebrity Centre across the street, Henri reaches out and puts his hand on your leg. Your breath catches. It feels like the world stops.

Together, you walk back to your place in the parking lot below the Hollywood sign, and he helps you load boxes and furniture into a rented van.

That night, you go to the Hustler Hollywood store on the Sunset Strip. It's Henri's idea, a thing you do together—enter a public place and improvise a scenario. Like the night on the harbor in San Diego when he pulled you into a touristy gallery selling prints by the artist Wyland.

FADE IN:

EXT. WYLAND GALLERY, SAN DIEGO HARBOR –
ESTABLISHING SHOT – NIGHT

EXTREME LONG SHOT through a storefront window;
Henri and the Woman stand inside an art gal-
lery looking at a painting. Reflections in the
window glare appear between the CAMERA and the
action.

INT. WYLAND GALLERY, SAN DIEGO HARBOR – NIGHT
(CONTINUOUS ACTION)

Henri and the Woman stand inside an art gal-
lery. The walls are hung with brightly colored
prints of underwater fantasy scenes.

> HENRI
> (whispering loudly)
> Pretend you have to buy one of these
> paintings to hang in your living
> room. Which one?

The Woman bursts out LAUGHING.

> HENRI
> We're not leaving until you decide.

Henri raises his eyebrows, and the edges of his mouth twist into a quiet smile.

Stifling laughter, the Woman walks up to a painting to consider it.

Henri watches her from the corner of his eye as he walks over to engage the SALESPERSON in conversation, feigning interest in the process of creating and printing each "work."

The Woman moves around the gallery, looking at paintings of dolphins, brightly colored fish, and rainbow-filled skies. In front of a painting of a nearly life-size figure, half woman, half leopard, in classical reclining pose, she calls out to Henri.

> WOMAN
> Honey, what about this one?

Henri walks over to her and crosses his eyes.

> HENRI
> This one?

The Woman nods, suddenly unsure of herself.

> HENRI
> Why?

> WOMAN
> Well, it kind of reminds me of the
> cover of a Duran Duran record. If it
> has to hang in the living room, maybe
> we could say it was the original
> artwork for a rare twelve-inch
> released in Japan in eighty-four.

Henri nearly laughs. He calls the salesperson
over.

> HENRI
> How much is this piece?

The Salesperson pulls a laminated sheet from a
folder and consults it.

> SALESPERSON
> Two thousand three hundred and forty
> dollars.

The Woman turns her face to conceal laughter.

Henri keeps a straight face.

> HENRI
> What do you think?

The Woman turns to look at him long enough to
speak.

> WOMAN
> It would be perfect in our living
> room.

Her body starts to shake with silent laughter
and she turns to hide her face again. Henri
puts his arm around her and leads her to the
exit.

> HENRI
> Let's think about it.

Henri nods to the Salesperson as they exit the
gallery.

> FADE OUT.

At the Hustler Hollywood store, Henri stands contemplating a row
of mannequins in various s/m ensembles, pretending to weigh the
options. You close your eyes and stand next to him, feeling into his
presence.

The next morning, you and Henri load the last of your things
into a rental truck. He follows you to San Diego and helps you carry

everything up several flights of stairs to your new apartment. You return the rental truck, then meet him at a coffee shop that looks like a Goodwill, with rows of old couches. You order a coffee and sit next to him. A jangly band starts up. Henri rolls his eyes and suggests moving outside.

FADE IN:

EXT./INT. PICKUP TRUCK ON A NEIGHBORHOOD
STREET IN SAN DIEGO - NIGHT

The Woman leans across the front seat of her
truck to unlock the passenger door. She rolls
down the window as Henri gets in.

> WOMAN
> Sorry. Smells like cigarettes in
> here.

> HENRI
> That's O.K.

She turns to look at him, and nervous elec-
tricity shoots through her body. She feels
nauseated.

> WOMAN
> Is this the part where you kiss me?

Henri LAUGHS.

> HENRI
> No. But that's what I want to talk to
> you about.

Henri SIGHS into the charged silence.

> HENRI
> I have been trying to find a way to
> tell you this . . .
> (sigh)
> I have a girlfriend. I've been
> trying to break up with her for
> a while now, but I can't.
> (MORE)

HENRI (CONT'D)
She's been very depressed since
nine-eleven, and I guess I'm afraid
what she might do.

Henri turns to look at the Woman. She is quiet;
lights a cigarette; goes to roll down the win-
dow, but it's already open.

WOMAN
Like you think she might kill
herself or something?

Henri half shrugs, half nods.

HENRI
Something like that. Anyhow, it
seems pointless to break up now.
She's going to Macedonia at the
end of the summer for like three
years. . . . I know it's totally
fucked to impose a timeline on this,
but could you wait a few more months
before we, like, get together? We
can just keep hanging out like this?

The Woman turns to look at Henri as he stares
through the windshield at the dark and empty
street. She stares out the windshield too, and
another silence opens up.

WOMAN
I can't. I'm not well-cast in the
role of the other woman.

Henri lets out a weird, CHOKED LAUGH.

HENRI
Have you ever noticed that you talk
about everything like it's a movie?

The Woman turns slowly to look at him. His face
looks back in CLOSEUP. The CAMERA STARTS TO
PULL AWAY and the back of the Woman's head comes
into the shot. The CAMERA KEEPS TRACKING BACK,
A CRANE SHOT THAT PULLS UP, AWAY FROM THE SCENE.

```
CUT TO A CLOSEUP OF THE WOMAN'S FACE -- she
turns slowly away from Henri to stare out
the windshield. A POV SHOT TRACKS HER GAZE,
PANNING SLOWLY across the dark, empty street,
the pools of illuminated pavement under the
streetlights, the glowing foliage in nearby
lawns. The CAMERA settles on a figure in the
distance -- a woman walking alone down the
street. CUT TO THE CRANE SHOT again, now high
above the tiny truck, the surrounding street-
lights, the lone woman walking away. Cut to the
same shot in negative -- everything more light
in color than dark; the tiny figure of a lone
woman walks away from the truck, glowing white.
```

In 1958 the French New Wave filmmaker Alain Resnais was hired to make a short documentary about the atomic bomb.[3] He had already made a successful documentary about the Holocaust, *Night and Fog*, shot in the ruins of Auschwitz, and the idea was likely to do something similar with Hiroshima.[4]

Resnais spent two months working on the film. He shot (or imagined shooting) elaborately staged reenactments of the aftermath of the bombing, scenes in which scorched schoolgirls clung to each other as they waded into the sea to try to escape the heat, scenes in which disheveled survivors crawled out of collapsed buildings, in which scores of the wounded and shell-shocked sat together waiting to die. In addition to the reenactments, he documented (or imagined documenting) the bomb's lingering effects: He recorded people in hospital beds years after, quietly tolerating their maladies and awaiting death. He photographed children who were in utero during the blast and stared past masklike deformities into the camera. He filmed survivors who pulled back clothes, hair, and flesh to reveal missing eyes, twisted limbs, shrapnel impressions on skin. He shot footage in the museum where remnants of the blast were on display—twisted bicycles, burned cinder blocks, bits of human skin floating in jars, mannequins in the charred and disintegrating clothing of victims—and miniature reconstructions showed Hiroshima before and what remained after. He collected newspaper photographs and newsreels

from just after the blast: temporary survivors wandering through the wreckage; the terrible, empty valley where Hiroshima had once stood.

But in all of this, Resnais found nothing that captured the horror of the bombing. He told his producer the film could not be made. "Of course, if someone like Marguerite Duras were interested . . ." he joked.[5]

The film Duras wrote in collaboration with Resnais, *Hiroshima mon amour*, is a fiction. On the surface, it's a love story. In the rebuilt city of Hiroshima, an affair between a French actor and a Japanese architect (we do not know their names) triggers memories of the war.

In the opening shots of the film, fragments of their bodies clutch at one another, shimmering with atomic ash or sweat. A man's voice says, "You saw nothing in Hiroshima. Nothing." A woman says, "I saw everything. Everything." She lists the things she had seen—the hospital, the museum, "iron made vulnerable as flesh, the bouquet of bottle caps: Who would have suspected that? Human skin floating, surviving, still in the bloom of its agony"—as the film cuts to Resnais's documentary footage. But no matter what the woman says, the man repeats, "You saw nothing in Hiroshima. Nothing."[6]

In the film, the man and the woman wander through 1950s Hiroshima like ghosts surveying the wreckage. They try to touch into the void left by the bomb, but it eludes them. The shiny new city of Hiroshima, with its blinking neon signs and resplendent facades, feels static and surreal; its tinny newness makes the trauma distant and intangible.

So, too, the entanglement of the lovers. They can neither go further into love nor walk away from it. If there is any drama at all, it is in that tension, that evenness, designed to point to the formless past, still everywhere present, if invisible.[7]

So it begins—the lonely heartbreak summer. You live in a studio apartment on a hill overlooking the San Diego Bay and the Coronado Bridge. Most everyone from your academic department is away on holiday, and though the city is full of tourists, it feels empty and a bit unreal, as if you've fallen into a space between things, cut off from the flow of normal life.

You spend hours sitting on the roof, listening to the hum of traffic on the 5, imagining that what you hear is the sound of waves and that you've washed up on shore, a stranger with no past who's looking for a way to remember herself and move on.

You find yourself wandering the streets, lost in a haze of half-formed thoughts. You take long walks over the hill into the Balboa Park canyon, through a garden of overgrown succulents where lovers carve their names in cacti, indelible scars that grow larger and distort. You walk through the colonnades of the Spanish Colonial–style buildings in the park—remnants of the 1915 exposition to commemorate the opening of the Panama Canal—and into the arboretum to look at the plants. In the zoo, you contemplate the animals; you wonder if they remember who they're supposed to be, if they dream at night of a landscape that suits them, that feels real.

You start to attend a self-help meeting called Focusing on Herself. The odd shift in the name of the group echoes the displacement in your mind: you've begun to think about "her" a lot, Takako, a stranger in an empty field, searching for something, lost. You begin to see, in her, a mirror of yourself.

With *Hiroshima mon amour,* Resnais and Duras invented a new cinematic language. The film wasn't about the thing itself—the detonation of the atomic bomb—but about the turning away it provoked and, quite possibly, required. Duras called it "an exemplary delusion of the mind."[8] The dull reality of the film—the story of two unexceptional lovers in a featureless city—imitates the everyday, in which the horrors of Hiroshima are known but cannot be grasped. There is an unbridgeable gap between the horror—"Hiroshima"—and life that is, by contrast, impossibly banal—"mon amour."

In her notes about the film, Duras wrote, "Impossible to talk about Hiroshima. All one can do is talk about the impossibility of talking about Hiroshima."[9]

REEL 4

Fargo is three hours east of Bismarck on the interstate. Your first stop is the Greyhound station, a fluorescent-lit square of brick and linoleum lined with vending machines and molded plastic chairs in mid-century orange.

You ask the ticket agent about Takako, but she shakes her head; she doesn't remember her. You ask for a hotel recommendation, and she tells you that Quality Inn is the cheapest place in town, only a few miles from the station. As she talks, she scrawls the address and phone number on a piece of paper and hands it to you.

It's a generic motel surrounded by a giant parking lot. When you ask, to your surprise, the front desk clerk remembers Takako and says she stayed there for two nights. You ask if she left anything behind. The desk clerk nods and says there were some papers in the trash in her room with "Oriental writing" on them.

"Any idea where they are now?"

The clerk shakes her head, and you don't ask any more questions.

Fargo feels like a dead end. You leave your stuff in your room and go downtown to get a sandwich near an old movie theater with a marquee that spells *Fargo* in tiny bulbs. You leave the next morning and drive east to Detroit Lakes, Minnesota, where Takako's body was found.

Chief Kelvin Keena, one of the officers who led the investigation into Takako's death, is expecting you at the Detroit Lakes Police Station. There's something about him that makes you think of an undertaker. He's tall, with a white, waxen complexion; a balding head covered with thin wisps of hair; a droning voice; and large, milky-blue eyes that stare out from behind wire-rimmed glasses. While you and your friend set up cameras and microphones for the interview, he asks questions about your interest in Takako. He seems to want to dissuade you from thinking Takako was searching for ransom money or had any interest in the movie *Fargo*. He says that when he first

arrived at the scene where Takako's body was found, he thought she was probably a stripper who had been killed by some pimp or john and then dumped in the woods. Though no identification was found on her body, he says he could tell right away she wasn't from around there. Lots of strippers pass through Detroit Lakes on their way to perform at "gentlemen's clubs" in the area, he explains. You note that, even when she was dead, Keena read Takako as a stripper or a prostitute.

Once the cameras are set up, and after further conversation about the case, you ask Chief Keena to tell you the story of Takako's last day. He suggests you move across the hall to a small conference room so he can reference a large aerial photograph of the lake (which is shaped like a backward C; it's actually two lakes: Detroit Lake and, at the bottom tip of the C, Deadshot Lake) and the tiny downtown.

In the conference room, your friend sets up the camera to frame both Keena and the photograph. As he runs through the events of the day, Keena uses a black mechanical pencil to point out the location where each had occurred.

"She arrived in Detroit Lakes by taxi. The driver wanted to drop her off in town, here on the north side of the lake, and that's where she felt there were just too many people. So the taxi driver brought her around the lake"—Keena uses his pencil to trace from the north end of the lake down the west side to the southern edge—"and at about this area here"—Keena draws an imaginary circle on the lower part of the C, near a narrow strait and bridge that connect Detroit Lake to Deadshot—"is where she felt comfortable and wanted out. It's hard to tell on the map, but this is a hill right here"—Keena points to an area just south of the long bridge—"and this is probably the high point of the hill. There were several sightings of her in this group of trees by people driving past. And something must have scared her, because she came running down the hill, got scratched up on some branches, and flagged down a pickup that was passing. And so, uh, this"—pointing to a spot on the map—"is where she received the ride from two boys that were removing docks. This is a very beautiful area in that there is a gorgeous, unobstructed view up across the lake. All of these trees out here"—Keena points to the east side of the

lake—"you know the colors, and so on and so forth. And you know, she had some conversations with a hotel clerk in Fargo, saying that she wanted to view the Leonid meteor shower that was happening at that time. This place, as it's away from the lights of the city, would've been good for that...."

As he runs his hand over the landscape on the south side of the lake, it occurs to you that the chief is likely performing this scene in the same way the BBC film crew directed him to just two days before. The director, Paul Berczeller, probably told the chief to stand to the side of the map so the camera could see the locations in Takako's story. Your friend, who is behind your camera, is standing where Paul's cameraperson would have been standing—it's the only framing that makes sense. And the Japanese model was probably in the room, too—Takako's double—and maybe she was standing where you're standing now, close to the lens, so that when Chief Keena looks at you to tell his story, he looks toward the film's future viewer.

"She was dropped off here, and this is 270th Avenue." He traces a straight line to indicate a road that runs due south, away from the lake.

"Right, she was dropped there by the boys," you say.

"Yeah. And they last saw her walking southeast, out in this direction." Keena uses his pencil to indicate a trajectory across a field. "Now, there was some evidence that she had held up for some time in this group of trees"—pointing to some trees along the east side of 270th—"because one of these trees was on fire that night, and so we are assuming that, or theorizing that, she might have started a fire here that got away from her a little bit. She must have been a country gal, because she knew how to get a big fire going. And that probably caused her to leave out across these fields. And so the stand of trees that she was found in actually would have been"—Keena scans the map carefully, then singles out a topographical blot—"this group right here"—tapping it with his pencil—"which is pretty much smack dab in the middle of this fellow's property. She started another fire here, a small fire that left a burned area about the size of a dinner plate. She was found a ways off from it, so we're theorizing that she got up to pee, tripped, and never got up."

Keena stops and stares into the camera in silence for a moment. You're sure Berczeller directed him to do that too. "Done deal?" he asks.

You nod. "I think that's it."

Back in his office, Chief Keena takes a seat at his desk and begins to show you some of the evidence collected during the investigation. As he methodically describes the conclusions drawn from each item, you only half listen. You become absorbed in the evidence itself, and a feeling of disconnection overwhelms you. You find yourself thinking, *No, this isn't her. This girl, I don't know what she wanted. . . .*

She's not the protagonist in the story you imagined, about a woman who set out on a difficult journey, who was searching for something.

Suddenly, there is no story; there's just a dead girl.

When you get back to San Diego, you spend several weeks at the arts building on campus, sleeping on the fold-out couch in your studio, pacing in front of the editing room, listening to the drone of the videotape as it digitizes. You live on boxes of soup, frozen dinners, and crackers. At night, you drift through the empty hallways and the cement courtyard enclosed by metal gates. Your monotone focus, combined with the smell of wet concrete and ocean breeze, gives the vague, isolating impression that you are on a ship. Plants sprout from the gutters, moisture collects and runs down interior walls, fine black mold rains from the ductwork. You're absorbed into the dark aura of the place.

When the tape has been digitized, you sit in the editing room and scroll through the footage, trying to find a film in it. You had imagined a narrative film when you first conceived of the piece, a scenario of intense longing and bitter disappointment, a tragic end. But now you wonder if even the simplest documentary about your journey to North Dakota is possible. It seems you captured nothing in Fargo that might evoke the feeling you got when you first read about Takako and the image appeared in your mind: the dark figure traveling alone in a field of white, searching for something. It's the feeling

of longing that interests you. And if the film can't make someone feel that, what's the point?

You pace the halls near your studio, thinking this thought, chain-smoking.

The pacing is interrupted when a thick envelope arrives in the mail—the police report you ordered from the Detroit Lakes Police Department.

Report 01007826 commences its fractured narrative at 5:23 p.m. on November 15, 2001, when Detroit Lakes Police Captain John Anderson responds to a call about a "Jane Doe" at Morrie Levenson's tree farm. The report is more than four hundred pages long, and after you've been through it a few times, it begins to read like a script for a film that opens on a crisp, clear November day, at about 5:00 p.m.

```
FADE IN:

EXT. CHRISTMAS TREE FARM - DUSK

The sun is setting and the sky glows a bright
orange as LOUIS, a tall man in his midforties,
with sandy hair and a muscular build, finishes
work at a Christmas tree farm. He walks to his
truck, takes off his tool belt, and DROPS IT
in the back. He pulls on a pair of camouflage
trousers and a windbreaker, grabs a hunting
bow out of the truck, and slings a container
of arrows across his back.

Louis walks quietly through the tall pines on
the farm. The temperature is dropping. Each
step CRUNCHES PINE NEEDLES underfoot. Each
breath leaves a puff of steam hanging in the
air. A squirrel SCAMPERS across the forest
floor and runs up the side of a tree. Louis
glances quickly in its direction. A small tree
branch shakes; a BIRD CHIRPS and hops to a
higher one.

Louis relaxes and continues walking.
```

Just ahead, not far off the leaf-covered path
that cuts through the trees, Louis sees some-
thing on the forest floor: a duffel bag with
miscellaneous personal items next to it. As he
gets closer, a few empty wine bottles come into
view, and then, at the base of a tree, a body
lying down, mostly covered by a blanket or a
coat. Louis doesn't move.

> LOUIS
> (shouting)
> Hey!

The body lies there, still and unmoving. Louis
turns and runs.

In the distance, Louis sees two figures on
horseback. He SHOUTS, waving his arms over-
head, and runs toward them.

> LOUIS
> (as he gets closer)
> Morrie!

MORRIE and his wife SARAH follow behind Louis
on horseback as he leads them through the woods
and back to the scene. It's dusk, nearly dark.
Louis stops a ways off from the body and turns
to Morrie.

> LOUIS
> (loud whisper)
> It's here.

Louis points to the body.

Morrie and Sarah dismount from their horses.
Morrie advances cautiously toward it.

> MORRIE
> (yelling)
> Hello!

The three of them inch closer. Slowly they
discern a bare leg sticking out through the
vent of a long purple coat, and tufts of dyed
reddish-blond hair sticking out from under
the collar.

Morrie approaches the body and gently nudges
it. He waits for a response. Nothing. He
kneels down and touches a hand. It's still
and slightly blue. Morrie looks at Louis and
shakes his head.

Morrie's wife Sarah draws in to take a closer
look, the two horses trailing behind her.

> SARAH
> (loud whisper)
> Do you think we should roll her over
> to see if we know her?

Morrie is quiet for a moment. He turns and
takes in the rest of the scene, then stands
and walks a few yards to pick up an empty wine
bottle; he reads the label and tosses it back
to the ground.

> MORRIE
> I think we should call the cops.

EXT. DRIVEWAY IN FRONT OF LOG HOME - NIGHT

At 5:23 p.m., DETROIT LAKES POLICE CAPTAIN
JOHN ANDERSON pulls into the Levensons' drive-
way, lights flashing. Morrie opens the car
door and leans in.

> MORRIE
> She's out on the farm. I'll have to
> show you where.

> ANDERSON
> (nods)
> Get in.

The squad car pulls out of the driveway onto
a dirt path leading through the trees. Louis,
Sarah, and one of the Levenson children follow
in an old pickup.

EXT. CHRISTMAS TREE FARM - NIGHT

The two cars pull up near the scene, and every-
one gets out. It's night now, and the headlights
shine into the dark space below the trees, illu-
minating the still form lying there.

Captain Anderson approaches slowly, pauses
to survey the scene, then takes hold of the
outstretched arm. For a moment, everything
is silent except for the SOUNDS OF A FEW BIRDS
and a CAR PASSING in the distance.

Anderson stands up and backs away.

> ANDERSON
> O.K., everyone. Let's back away from
> the scene, please.

He gets into his car and picks up the radio.

> ANDERSON
> This is Captain Anderson. We've got
> a Jane Doe here on the Levenson farm,
> out on South Shore Drive.

Everyone stands in hushed stillness next to
the cars as a RESPONSE CRACKLES FORTH OVER THE
RADIO. The beams of the headlights shine into
the forest.

During your first trip to Detroit Lakes, you went out to the Levenson farm after you spoke with Chief Keena. Morrie, a smiley, flannel-shirt-and-jeans guy, with curly hair and glasses, met you and your friend at the front door of his log home, complete with taxidermy trophies hanging on the walls. He invited you inside and talked for a while. He seemed to find your interest in "the dead girl" amusing and was happy to help with your inquiry. At his suggestion, you all went outside, piled into the front seat of an old green pickup, and drove through the trees on the farm to the spot where they found Takako.

You step out of the truck, and a cold wind whips around the trees and shakes the boughs overhead. In a matter of seconds, all you can think about is how cold your hands and face are. Morrie

seems unaffected, though, and takes his time walking through the scene, describing in detail where and how Takako's body was lying when they found her, and how the duffel bag, firepit, and champagne bottles were arranged.

It's the cathedral of branches arching overhead that most impresses you. You shoot some 16mm film looking straight up at them with an old Bolex. Morrie points to a small pile of oranges lying at the base of one the trees. He says the Japanese actor left them as a ceremonial offering for Takako. He describes how the actor had lain in the snow, playing Takako's corpse, wearing a miniskirt with bare legs. You contemplate the forest floor, trying to imagine yourself lying under the trees the way Takako did in the moments before she died. You picture yourself rising up, looking down at your body beneath the pines, their branches swaying in the wind, the falling white snow.

Another pickup drives toward you through the trees, and Louis gets out, dressed in camouflage hunting gear. Morrie says, "I told Louis you guys were out here, and he said he'd come over." You shake his hand and ask, "Is it hunting season?" Louis blushes a little and explains that the BBC crew had asked him to dress in the hunting gear he'd been wearing on the day he found Takako, so he figured you might want the same. You are struck by the kindness of that, by the kindness of everyone you've met so far, all of them so earnestly trying to help you, even though you have no idea what you're looking for.

In an attempt to make everyone feel more comfortable, you ask Louis to reenact the scene for you too. He walks into the distance, then turns and walks toward you through the trees with his bow and arrow raised, pretending to look for deer. You shoot some video, then talk through the scene with him, directing him to pause in a spot with sunlight coming through the trees, to look off-screen as if he sees a body there.

Louis walks into the distance and turns around, ready to begin again. You start the camera and call out to Louis, and he walks toward you. Once again, it occurs to you that you are shooting Paul Berczeller's film. And that by asking Louis to reenact this scene, to reshape it a little for the camera, you, too, are helping to rewrite his memory of the events.

Louis pauses and focuses off-screen, pretending to see the body for the first time. You look out from behind the camera and ask, "What did you feel in that moment? When you first saw her there?" Louis stops acting and his face drops. He says it was freaky, that he was scared because the first thing he saw was an empty bottle and he thought Takako was a homeless guy who'd passed out in the woods. He hollered a couple of times and then ran. Later, when he found out it was a dead girl, he felt sad. He still feels sad.

FADE IN:

EXT./INT. SQUAD CAR - NIGHT

SPECIAL AGENT GRUNEWALD from the Minnesota Bureau of Criminal Apprehension drives down a dark, empty highway in rural Minnesota. A call comes over the radio.

> POLICE RADIO (V.O.)
> Grunewald?

Grunewald picks up the radio and speaks into it.

> GRUNEWALD
> This is Special Agent Grunewald.

> POLICE RADIO (V.O.)
> We've got a Jane Doe out in Detroit Lakes. You still in the area?

> GRUNEWALD
> Affirmative.

> POLICE RADIO (V.O.)
> We need you to take a look. She's on a tree farm at the south end of the lake. What's your ETA?

Grunewald slows down and pulls over to the side of the highway. He looks at his watch and SIGHS.

```
                    GRUNEWALD
              Nineteen hundred hours.

               POLICE RADIO (V.O.)
             Stand by for the address.
       Grunewald sets down the radio and leans back
       into his seat, awaiting further instructions.
```

You can't help but think of the movie *Fargo* here, of Chief Marge Gunderson, played by Frances McDormand, getting an early morning call about a triple homicide on a highway outside Brainerd, Minnesota. Her husband, Norm, makes her eggs and gets the prowler warmed up. Gunderson, who is seven months pregnant, arrives at the scene, waddles up to the corpse of the highway patrolman, kneels down, rolls him over, and vomits. She looks up at her partner and says, "Morning sickness."

That's when you imagine SA Grunewald driving past on his way to the Levenson farm, slowing down to wave to Chief Gunderson, one police officer to another.

Maybe that's what Takako wanted—to write herself into a few moments of the movie *Fargo*.

You have watched the scene in *Fargo* where the highway patrolman gets shot many times. After the shooting, a car driving past slows down and a young couple looks out the window and sees the patrol car and Carl Showalter (played by Steve Buscemi) behind it, trying to pull the patrolman's body into the ditch. The young couple speeds away. Gaear Grimsrud hops into the driver's seat and takes off in pursuit, driving fast, gaining on the two red taillights in front of him. Then suddenly the lights disappear. Grimsrud slows down and sees the young couple's car overturned on the side of the road. He backs up and gets out of his car. One of the doors on the overturned car pushes open and the young man gets out and starts to run away into the dark. Grimsrud shoots him in the back. Then Grimsrud walks to the overturned car and peers inside. The young woman is alive, breathing heavily, looking up at him with terror. He shoots her.

This character, the young woman who's in just a few frames of the film, almost invisible and insignificant to the story, is the kind of character that might be open to revision, that might provide an opening into the film.

The idea of "an opening" occurs to you because, in trying to understand what it was about the movie *Fargo* that Takako became obsessed with, you've wondered if perhaps it wasn't the money itself but the landscape—the snow, the trees, the oddball characters. Maybe she wanted to die, but maybe it was more about becoming other, merging into the strange netherworld of the film.

There's a short story by Julio Cortázar, titled "The Distances," about a girl named Alina Reyes who can't sleep and passes the time with word games. She rearranges the letters of her name and finds "la reina y . . ." ("the queen and . . ."). "That one's so nice," Alina writes in her notebook. "Because it opens a path, because the queen and . . ."[1] You read this piece in a collection of Cortázar's work, *Blow-Up and Other Stories,* during the time you're reading the police report, piecing together its narrative, and trying to make a film about Takako. Over time you will reference this book so much that it becomes dogeared and torn; the cover will start to peel and the binding will give in. In certain stories, nearly every word will become underlined or highlighted, marked as essential and significant. Because in these stories, Cortázar easily points to that border, that slippage of reality, that yearning to move from one state to another you find so mysterious and difficult to describe. Cortázar would have known what Takako wanted, you think; he would have understood her longing to disappear, to become other. But more than that, he would have known how to write about it.

You know little about Cortázar apart from a few biographical details. He was born in Belgium to an Argentinian diplomat in 1914, at the start of World War I. Because of the war, the Cortázar family moved to Switzerland, living for a very short time in Zurich during the days of the Cabaret Voltaire.[2]

The collages of Hannah Höch, the work of Duchamp, and the performances at Cabaret Voltaire reflected the nonsensical arbitrariness of the world after World War I but also seemed to ask, "How do

you put Humpty back together again?" You like to imagine Cabaret Voltaire as a séance, an incantation to a god that might intervene and make sense of the cities blown apart, the shell-shocked men wandering the streets with unconvincing prosthetic limbs and metal parts instead of faces. The Dadaists were interested in the rituals of tribes in Africa and the Americas who wore masks and danced and chanted to connect with the dead. There was an urgency in those rituals—to make something impossible happen, or to make sense of the impossible that had already happened; to rearrange chaos into order or to talk about how order had been transformed into chaos; to trace the insanely thin border between these states, how they touch each other; to try to will control into existence in a world that was out of control—all of which requires a negation of the world as it is.

You know the connection you're creating between Cortázar and the Dadaists is tenuous, but it serves your imagination to think that the zeitgeist of the time might have entered his infant consciousness and shown up years later in his work.

Alina, in "The Distances," gets caught between two consciousnesses, begins to live her life aware of another self, in the distance, "this her who is not queen."[3] Alina's mind gets pulled to this other realm, where she is a beggar in Budapest, gets beaten, has a hole in her shoe where the snow comes in, is often crossing a bridge.

Alina can't get rid of her thoughts of the other woman. Images of her appear in Alina's mind at inopportune times, demand her attention, seem to want something from her.

Alina goes to Budapest to find the woman, hoping to put an end to the thoughts, but instead she is taken over: the other woman enters her body, and Alina is left in the snow on the bridge, a beggar with a hole in her shoe.

This is how obsession works. A thought becomes an obsession when you don't want to think it, when you want to get rid of it. Perhaps this is how Fargo, or *Fargo*, became an obsession for Takako. *Fargo* demanded something from her, despite anything she wanted or did not want.

FADE IN:

EXT. ROAD AT THE EDGE OF A CHRISTMAS TREE
FARM - NIGHT

Special Agent Grunewald's cruiser arrives at
the edge of the Levenson farm on South Shore
Drive, slowly passing fire trucks and ambu-
lances and their crews, who are staged and
awaiting further instructions.

Grunewald sees Anderson waving and slows down.
Anderson gets into his vehicle, and together
they drive down the narrow path into the
forest.

EXT. CHRISTMAS TREE FARM - NIGHT (CONTINUOUS
ACTION)

Bright lights powered by a LOUD GENERATOR
illuminate the area around the body. Grunewald
parks his cruiser outside the yellow police
tape that cordons off the scene. Chief Keena
from the Detroit Lakes Police Department and
two other investigators approach Grunewald
and Anderson as they get out of the car, and
together they climb over the tape and enter
the scene.

Grunewald stops to look at the duffel bag
and the campfire. He crouches down to examine
the body. Then all the investigators exit the
scene.

Grunewald walks over to his car and makes a
call on the radio as the other investigators
stand just outside the yellow police tape,
waiting for instructions. Grunewald shouts
over to the officers.

 GRUNEWALD
 Check the bag for ID.

Two of the officers go back into the crime
scene and carefully look through the bags,
pulling out each item and then replacing it.

OFFICER
(shouting to Grunewald)
No ID.

Grunewald continues talking on the radio, then
walks over to the scene.

GRUNEWALD
We're to proceed as if this is a
homicide. That means photograph the
scene and find some officers to lock
it down until the crime lab can get
here tomorrow morning.

Two of the officers follow Grunewald under
the tape into the scene and begin to take
photographs.

FADE OUT.

Later you will re-create this crime scene in a stand of trees in San Diego, working with a model and using the evidence list and details from the investigation report to take forensic-style photographs of Takako lying on the forest floor. In the first pictures, the model lies almost in fetal position with one arm outstretched, facedown, her head resting in the cradle of her arm. She's a few feet from the small burn mark left by the fire. The most prominent detail in the image is a pair of bright pink underwear, exposed, along with bare legs in black knee-high stockings, through the backflap of a long, purple houndstooth coat. In the next group of photos, the woman lies faceup, as if her body has just been turned over by investigators. Her face is puffy and slightly blue. There's a patch of dried blood under her nose. Her whole body looks flattened, and there are impressions of twigs and pine needles in her skin in the places where her body settled into the ground. One of your students, who had taken a class in special effects makeup, used a mixture that included coffee grounds to re-create some of these details. Her efforts were not wholly successful. But even if they had been, these photographs wouldn't have conveyed much about Takako. In them, she's just a corpse and, as such, a refutation of any story you could invent about her. Still, you find yourself

feeling something for the woman in these photographs. Her story wants to be told. It feels like the desperate story of a woman who had nowhere to go and nothing left to do, who wagered what little she had to make this trip out to the middle of nowhere. There was hope in this trip, a promise that didn't deliver. You try to imagine the first scene in a film about this woman—the real Takako.

FADE IN:

EXT. ROAD NEXT TO LAKE (MINNESOTA) - DAY[4]

A gray, windy day in November. Litter blows across an empty road. A CAR PASSES, a DOG BARKS, but mostly one hears WIND BLOWING across the water, WHISTLING through the wide-open spaces, SHAKING THE FEW LEAVES left on the trees. A swirling plastic bag catches on tall reeds next to the lake and holds there, QUIVERING. The grass shivers and bends until the bag breaks free and blows out across an open field.

From a distance, at the edge of the field, there is a figure lying on the forest floor, surrounded by yellow police tape. A closer shot reveals the body of a woman, facedown in a long purple coat.

Two officers sit in a patrol car a short distance from the scene, eating sandwiches and listening to MUSIC ON THE RADIO. They watch as a large black truck pulls up and two investigators in black uniforms get out.

As the investigators duck under the police tape and start to process the scene, the CAMERA TRACKS UPWARD: the bodies of the agents get smaller and smaller as the CAMERA PULLS UP ABOVE THE TREES, the officers' voices become distant, the lake and surrounding farm fields come into view.

EXT. FOREST - DAY

LEAVES AND PINE NEEDLES CRUNCH as TAKAKO walks through the forest.

EXT. ROAD NEXT TO LAKE - DAY

Takako arrives at the road near the lake and starts to walk quickly, then breaks into a run. She carries nothing; her hair is a tousled mess. In the distance a car approaches; a black SUV comes around a bend in the lake and pulls over next to Takako. The door opens.

A WOMAN IN DARK GLASSES and a long dark coat leans out of the car.

> WOMAN IN DARK GLASSES
> Get in.

A YOUNG MAN in the driver's seat leans over and translates into Japanese.

> YOUNG MAN
> (in Japanese; subtitled)
> If you would please come with us.

The Young Man gestures toward the rear door. Takako gets in, and they take off down the road.

EXT. SMALL AIRPORT - DAY (MOMENTS LATER)

The black SUV pulls up to a chain-link fence at an airport; a gate opens. The car enters and drives up to an airplane hangar. The three get out of the car. The Young Man unchains the large metal door on the hangar and slides it open. Inside is a table and some chairs. He motions Takako forward.

> YOUNG MAN
> (in Japanese; subtitled)
> Please.

INT. AIRPLANE HANGAR - DAY (CONTINUOUS ACTION)

Takako takes a seat at the table. The Woman In Dark Glasses and the Young Man sit opposite her.

WOMAN IN DARK GLASSES
Do you speak any English?

TAKAKO
(in Japanese; subtitled)
A little.

WOMAN IN DARK GLASSES
You probably already know this,
but . . . you died, a few days ago.

YOUNG MAN
(in Japanese; subtitled)
Please excuse me for saying this,
but, you are dead, for a few days now.

Takako listens and nods her head.

TAKAKO
(in Japanese; subtitled)
Yes.

WOMAN IN DARK GLASSES
We're sorry for the delay in
processing your case. I needed to
secure a translator to ask you some
questions. It will help to determine
your next placement.

YOUNG MAN
(in Japanese; subtitled)
I am so sorry you had to wait for us
to arrive. There was some trouble
finding a translator for you. We
must ask you to please describe your
life for us. We want to find a good
incarnation for you.

Takako pauses and thinks about this for a
minute.

TAKAKO
(in Japanese; subtitled)
I love movies . . . Um . . .
especially science fiction and
superhero films. Movies with endless
possibilities.

YOUNG MAN
(translating, looking at the woman
in glasses)
I loved science fiction movies, and
movies with superheroes. In films
like that, the possibilities are
endless.

TAKAKO
(in Japanese; subtitled)
Also love stories, like: <u>Badlands</u>,
<u>Paris, Texas</u>, <u>True Romance</u> . . .

The Woman in Dark Glasses shifts impatiently,
then interrupts.

WOMAN IN DARK GLASSES
O.K., you loved movies, but I'm
asking about you: what did you want?

Takako turns to look directly at the CAMERA.

TAKAKO
(in Japanese; subtitled)
I wanted to be an actor in a film
about women searching for happiness.

The CAMERA HOLDS ON TAKAKO'S FACE as the Young
Man translates.

YOUNG MAN (O.S.)
I want to star in a film about a
woman who finds happiness.

FADE OUT.

You write this scene hoping it will function like a Ouija board, that it will help you to channel Takako from beyond the grave, to ask her what she wanted. But she only says what you already know: she loved movies, she wanted to be happy, and for her these two things were connected, are still connected, even in death.

The objects found at the scene are inventoried in photographs. There's a black canvas gym bag, empty foil blister packs, Mintia

Wild & Cool breath mints, a silver electronic translator that looks like a calculator, plastic Ziploc bags with Japanese writing on them ("feeling uneasy, take two times a day," "before sleeping, take two tablets," "feeling uneasy, hemorrhoid medicine once a day"), empty green J. Rogét champagne bottles, the burned remains of their colored foil and wire cages mixed with ash. There's a pager, a Panasonic flip phone, a Walkman, headphones, and cassette tapes. A closeup of a cassette tape shows the songs listed on the side, written in neat English. Side one: "Scatterheart," "I've Seen It All," "In the Musicals," "107 Steps," "New World," "Ghost House Club Long and Alive Version," "Gandhara," "Monkey Magic," "Beautiful Name," "The Galaxy Express 999," "Humans Being," "Melancholy Mechanics." Side two: "I Sing for You," "Mia Culpa I," "Sadness," "Mia Culpa II," "What a Feeling," "Love Theme," "Manic," "The Child in Us," "Broken Homes," "Being Boring," "Angel." They're songs from movie soundtracks: Paul Schrader's 1982 film *Cat People*, Lars von Trier's *Dancer in the Dark*, *Twister*, *Flashdance*, the 1979 Japanese cult TV show *Monkey (Saiyuki)*, and the 1979 manga show *Galaxy Express 999*. Though there are no songs from the *Fargo* soundtrack, these tapes seem to be further evidence that Takako was into movies and that her journey had something to do with the film.

There is no snow in the photographs. Takako's body is not covered by a snowdrift or surrounded by white. She's lying on fallen pine needles on a Christmas tree farm. Takako wanted snow; it was the first thing she asked for when she checked into her hotel in Bismarck. So which image is a better index of Takako's mind—the scene she imagined, or the scene as it actually occurred?

There is no passport either. The hand-drawn map she showed the police officers and the bellman in Bismarck is not there. There's a *National Geographic Road Atlas* among her things, but it has the entire state of Minnesota crammed onto one page, which doesn't seem useful. There's also no compass, no shovel, no binoculars, no food, no water or water-purifying equipment, no additional clothes for inclement weather, no decent shoes—nothing that would have prepared her to go out looking for treasure in a remote area. Either she had never been on a hike before, or it's unlikely her plan included walking into the countryside for a prolonged search.

Two bottles of champagne, a pager, a flip phone, towels, makeup, a Walkman, some cassette tapes, and medications; these are the things she brought with her for whatever she planned to do. They're things any tourist might have. She could have been planning anything.

In 1986, a Japanese psychiatrist working in Paris identified a bizarre malady he called Paris syndrome, a type of psychiatric breakdown that afflicts around twenty Japanese tourists a year.[5] The typical sufferer is a Japanese woman in her thirties who arrives in Paris full of romantic ideas about an idyllic city of twinkly lights, cobblestone streets, and glamorous people. The shock of the real Paris, and especially real Parisians, is too much for them; they experience delusions, panic attacks, extreme paranoia, hallucinations, depersonalization, derealization, dizziness, fatigue, shortness of breath, chest pains, and even seizures.[6] Though less common, there are also documented cases of Jerusalem syndrome and Stendhal syndrome, the latter so called because it was first described by the writer Stendhal, who, describing his state after seeing Giotto's frescoes for the first time, wrote, "I was in a sort of ecstasy, from the idea of being in Florence, close to the great men whose tombs I had seen. Absorbed in the contemplation of sublime beauty... I reached the point where one encounters celestial sensations. ... Everything spoke so vividly to my soul. Ah, if I could only forget. I had palpitations of the heart, what in Berlin they call 'nerves.' Life was drained from me. I walked with the fear of falling."[7]

Might Takako have been an isolated case of Fargo syndrome?

Depersonalization is the strange, uncanny sensation of watching yourself from a distance. A person's own body and mind take on the sheen of the unreal, the dreamlike. Anything could happen. It's a dissociative condition that might be described as a mild version of dissociative identity disorder, usually a response to stress. Derealization is a coping mechanism that creates a feeling of disconnection from a difficult situation by making the world seem unreal. If someone experiences derealization as a child, she's much more likely to have further episodes in response to stress throughout her life.

Extreme stress, which causes a spike in cortisol levels, can also cause a person to form what are called flashbulb memories: extraordinarily detailed memories of one particularly shocking moment. The Kennedy assassination and 9/11 are commonly cited as events that, for many, triggered the creation of flashbulb memories. The memories are so clear and vivid that it's like a person reenters the moment, moves about in the landscape of it. But nothing else moves, and they don't have any effect on it; it's frozen, like a photograph.

It's difficult to imagine a visit to Paris being stressful enough to cause all of that, but Paris syndrome is real. The Japanese consulate in Paris has created a designated hotline and a special treatment center for Japanese nationals suffering from it. They are given rest, sent home, and told never to visit Paris again.

Cortázar's "Blow-Up"—the story made famous by Michelangelo Antonioni's film of the same title[8]—tells a story about a dead man and a camera and the objectivity or floating perspective of both the camera and the dead, unfixed in space or time. Cortázar starts by attempting to tell the story from this lack of perspective, from the point of view of a narrator that is neither he nor she nor you nor we. Best if it were the perspective of a machine, the Remington typewriter or the Contax I.I.2 camera, he writes. But he can't figure out how to do it, so the dead man tells the story, harkening back to a Sunday in November when he was alive, yearning to wander the streets of Paris and take photos. The narrator describes this desire as an "impulse to go running out and to finish up in some manner with, this, whatever it is."[9] You read that line and you know Cortázar is writing about the same thing you are—the feeling Takako had the day she set out searching for something, whatever it was.

Cortázar's narrator, Michel, is an amateur photographer driven by something indefinite. But Antonioni's main character, Thomas, is different: a Hollywood-style protagonist, cocky and out for greatness. Because how do you make a film about someone searching for "this, whatever it is"?

Time and perspective shift in Cortázar's "Blow-Up" in a way that makes it difficult to follow. The narrator refers to himself sometimes in the first person (as I) and sometimes in the third (as Michel). At

times he finds it difficult to concentrate on the story himself because he is seeing things from above, where his view is often confused or obscured by clouds and pigeons floating by. At other times he sees things from the ground, from inside the story. In *Blow-Up*, Antonioni maintains this practice of dislocation and interruption, but it comes in the form of a band of mimes who occasionally drive through the action of the film. This is your favorite thing about the movie, but it doesn't dislocate the viewer in the same way as the birds and clouds passing through Cortázar's story, which actually require the reader to slow down and reread to find and follow the thread.

In Cortázar's story and the film, the protagonist takes a photograph that captures a murder. In the film, he only discovers that fact after enlarging the photo and finding a body in the grainy details. In the story, the narrator blows up the photo, hangs it on his wall, and for some unknown reason finds himself studying it. He goes over the scene in his mind again and again, and at some point the details of the photo start to move, to come alive, and he gets sucked into the scene. He becomes part of the story and lives it all again. This time, a clown-faced man he didn't see before but who was always lurking at the edge of the frame enters the scene and moves toward the camera. The clown-faced man blots out everything else as his hands come toward the lens. The reader can surmise that the narrator was killed in that moment by the clown-faced man. Cortázar writes,

> Now there's a big white cloud . . . two clouds, or long hours of a sky perfectly clear, a very clean clear rectangle tacked up with pins on the wall of my room. That was what I saw when I opened my eyes and dried them with my fingers: the clear sky, and then a cloud that drifted in from the left, passed gracefully and slowly across and disappeared on the right. And then another, and for a change sometimes, everything gets grey, all one enormous cloud, and suddenly the splotches of rain cracking down, for a long spell you can see it raining over the picture, like a spell of weeping reversed, and little by little, the frame becomes clear, perhaps the sun comes out, and again the clouds begin to come, two at a time, three at a time. And the pigeons once in a while, and a sparrow or two.[10]

Cortázar's narrators are often disappearing irreparably into scenes that appear in their minds. There is always, when this happens, the insistence that the narrator has not chosen the object of her obsession. It's something she takes casual notice of at first, but it grows until it literally consumes her. It's a difficult thing to show on film.

Maybe Takako became obsessed with *Fargo* in exactly this way. At first, something small about the film might have piqued her curiosity. Maybe she did a little research on the Coen brothers, or Steve Buscemi, or Frances McDormand, or the money. But maybe then she made a discovery or a question materialized, and along with it came a feeling she couldn't quite put her finger on—a feeling that there was something that needed to be understood. Perhaps that feeling pulled her in, kept her going over details again and again, made her think that if she could solve the mystery, she'd be free of it. That's the lie of obsession, and maybe the lie that consumed her.

The morning after Takako's body was found, officers convened at the Detroit Lakes Police Department at 0800 hours for a briefing. Chief Keena sent out a press release stating that the body of an unidentified woman had been found in the woods on the south edge of Detroit Lake. Officers canvassed the area for witnesses. Slowly the picture of Takako's last days came into focus.

During your visit to Detroit Lakes, Chief Keena told you the basics about those days: Takako spent two nights at a hotel in Fargo, caught a cab to Detroit Lakes, and died in a stand of trees. But as you read the witness testimonies, you search between these factual details for clues about Takako: who she was and what she was looking for.

Agnès Varda's 1985 film *Vagabond,* starring Sandrine Bonnaire, tells the story of a rebellious young woman who wanders the French countryside alone.[11] The opening shot of the film shows an agricultural field in the Languedoc region in late fall or winter. A tractor is spraying the crops; two trees next to a ditch whip and sway in the wind. The camera slowly zooms to a man in the deep background who is collecting twigs and burning them. The camera tracks with the man as he continues to pick up sticks, then suddenly comes upon

a woman, covered in dirt, wrapped in a filthy knitted blanket, lying faceup in a ditch. The man drops the bundle of sticks and runs. He goes to his boss and tells him he's just found a dead woman. The police arrive and photograph the scene. There's an empty bottle, a package of Gauloise tobacco, and a few other small items next to the corpse. They check her pockets and find no ID. Then the policemen begin asking witnesses about her. As the witnesses tell their stories, a picture emerges: we learn about the woman, whose name was Mona, and her last few weeks of life, but mostly we learn about the towns-people, the landscape, and the culture of the French countryside vis-à-vis this young drifter. "All the characters Mona meets bear witness to her and form a portrait of this stranger. They're all a piece of a jigsaw puzzle which is inevitably incomplete," said Varda, in a later documentary about the film. "They often tell us more about them-selves than about Mona, depending on whether they pity, judge, or admire her."[12]

There is no clear line between fiction and "nonfiction" in Varda's film. The character of Mona is an invention, based very closely on the story of a young homeless woman Varda met while doing research for the film. Some of the other characters in the film are played by actors, but many are people Varda met during her travels in the countryside: they play themselves, often repeating bits of conversation they'd had with Varda, either directly addressing the camera documentary-style or opposite Mona in lightly fictionalized and scripted scenarios.

In the police report, you read an interview with a night clerk at the Quality Inn and Suites in Fargo. He told the police that Takako arrived to the hotel after midnight and adds, "Once she got checked in, she came back down and asked for a map of the city at first, and, ah, I gave her one. And she started talking about the lakes, how far are the nearest lakes and where could she go that night. Anyway, so I took out an atlas that we keep under the desk and pointed out, showed her the map of Minnesota and how far away we are from where the lakes really start, and told her how long it would take to get to some of these places. The second night I saw her, she started talk-ing about stargazing. Well, stargazing is my word, but that's what she was asking me, was to go out and see the stars at night. It was kinda

odd. I don't think I've ever had anyone ask me about stargazing or seeing the lakes and stuff. I just took her to be a college girl on vacation; she was so interested in all the things that don't normally get talked about. I told her that probably the best place would be Detroit Lakes, 'cause that lake has a beach and a presentable lake where one can actually go and enjoy, even though it's a bit cold. And I told her she could get a cab there to do that."

You notice that, in the scene as he describes it, Takako checks in, drops her stuff in her room, and comes right back to the lobby to ask him for a map. Though she's finally arrived in Fargo, going somewhere is still urgent, top of mind.

```
FADE IN:

INT. HOTEL LOBBY - NIGHT

The NIGHT CLERK has a map of Fargo lying on the
counter in front of him. TAKAKO leans in to
study it.

                NIGHT CLERK
          We're here. Here's the new art
          museum. The old movie theater
          downtown is right here . . .

A confused look comes over Takako's face.

                TAKAKO
          Where is the lake?

The Night Clerk shakes his head.

                NIGHT CLERK
          There's no lake.

Takako frowns, then. It seems she expected to
find a lake in Fargo.

The Night Clerk reaches behind the desk and
hauls out a large atlas. He opens it to the map
of Minnesota and lays it on the counter. He
points to the city of Fargo on the map.
```

 NIGHT CLERK
 We are here. The lakes really start
 here . . .

He points to another spot on the map.

 NIGHT CLERK
 You need to drive about an hour into
 Minnesota before you get to lake
 country.

 TAKAKO
 I want to go to the lake now.

The Night Clerk shakes his head.

 NIGHT CLERK
 Tonight? No. Lakes are far away. One
 hour, driving.

He holds up two hands as if clutching a steer-
ing wheel. Then he points to his wristwatch and
makes a circle with his finger.

 NIGHT CLERK
 One hour.

Takako looks disappointed. She stands quietly
for a moment, assimilating this information.
Then she points to the atlas.

 TAKAKO
 I can take it?

 NIGHT CLERK
 (nodding)
 Sure, go ahead. You can have that.

 TAKAKO
 Thank you.

The night clerk seemed to have had a fairly complex conversation
with Takako, who he described as "interested in all the things that
don't normally get talked about." Either he was better at talking to
people with thick accents and a limited vocabulary, or he was better

at filling in the gaps. When investigators asked him about that, he said, "Her English was O.K., I mean, it wasn't great. I could understand, working at it a bit. I noticed she tried to talk to some of the other front desk people 'cause I had a note that [second] night when I came in saying she'd been down asking questions and they couldn't help her 'cause they couldn't get past her accent. So a few minutes after I came in, she came down. She knew when I was coming in. She came down, and that's when she started talking about seeing the stars."

INT. HOTEL LOBBY - NIGHT

Takako leans on the front counter, looking at the road atlas with the Night Clerk. She takes a sip of a drink in a plastic cup. She steps back from the desk and points to herself.

 TAKAKO
 O.K. I sitting. Dark. Here, lake.

Takako gestures to indicate that the lake is in front of her. Then she sweeps her hands in an arc above her head.

 TAKAKO
 Liked show.

 NIGHT CLERK
 (straining to understand)
 Lake . . . shore . . .

Takako shakes her head. She flicks her fingers in a strobing motion.

 NIGHT CLERK
 Ah, light.

 TAKAKO
 Yes, liked.

She sweeps her hands above her head in an arc, looking up, smiling to indicate delight.

NIGHT CLERK
Ah, stargazing. You want to get away
from the city to do some stargazing.

TAKAKO
Yes. Stargazing. Where?

Takako points to the map.

NIGHT CLERK
(studying map)
Hmmm . . . Detroit Lakes might be the
closest. There's a nice beach there.

Takako leans in to look at the spot the Night
Clerk is pointing to on the map.

INT. LARGE GARAGE FULL OF TAXICABS - DAY

A CABBIE in his midforties leans against a
taxicab and addresses the CAMERA.

CABBIE
On the twelfth of the month, at
twelve forty-five during the noon
hour, I was dispatched to the
Quality Inn. A Japanese, possibly,
younger gal got in my cab and
requested that I transport her
to Detroit Lakes, Minnesota, for
the purpose of "stargazing," she
said. She didn't say much else.
And, you know, having done this for
a while, I don't press anyone on
their personal issues. People get
standoffish, you know, here's this
cabbie: "What do you want to know all
of this for?" She wasn't wearing a
coat, that was kind of strange 'cause
it was a cooler day. I wear a vest all
week in the wintertime. But it was as
if she was going to a dance club the
way she was dressed. Anyway, near
Audubon she looked out the window,
as if to wonder if we were getting
closer to Detroit Lakes.
(MORE)

REEL 4

CABBIE (CONT'D)
So when we got to town, near the
Walmart, there is a green sign that
I pointed to and I said, "This is
Detroit Lakes." And she looked out
toward what would be the lake, but
of course you can't see the lake from
there. I turned onto Washington,
drove down through the center
business district, and we stopped
next to the pavilion and I said, "Is
this okay?" And she said, "Where
are we?" I took out a map and showed
her and then she said, "Go around,
go around this way." And so we drove
around the lake and when we came to
the intersection of Curfman Lake and
southwest Big Detroit Lake, there's
a little boat landing right there, we
had already chewed up approximately
twenty minutes of her quote-unquote
free hour that you get when you go
somewhere. And knowing that she's
already told me she only has, I
thought she said a hundred sixty-
seven or something like that, if I was
to charge her more and more and more
for just driving around, well, how
much money would she have left to stay
at the Holiday Inn or whatever? So I
was very grateful she got out there.
I said, "Is this O.K.?" Pulled off at
the landing and uh . . . she got out.
She took her big black tote and she
actively put on her backpack as if to
start walking somewhere. She said,
"Thank you very much." And she looked
out toward the bay. And I left.[13]

EXT. FORESTED HILL - DAY

Takako walks quickly through a forest up a
steep incline. The terrain is difficult, and
the going is made more so by the large backpack
on her back and the tote bag she is carrying.

She falls and slides partway down the hill,
scraping her leg on rocks and branches.
Nearby, TWO LARGE DOGS BARK.

Takako continues walking quickly up the hill.

A house comes into view along with two large
dogs BARKING in the yard. An ELDERLY WOMAN looks
out the window of the house. On seeing Takako,
she opens a sliding door and yells at her.

> ELDERLY WOMAN
> (yelling)
> In the name of Jesus, and through
> his blood and power, I rebuke you,
> witch! I evict you and all devils
> from this place!

Takako turns and runs, sliding partway down
the hill.

EXT. ROAD NEXT TO DETROIT LAKE - DAY
(CONTINUOUS ACTION)

Takako slides and runs down the hill to the
road. She looks terrified and disheveled. She
stands up and reassembles herself and starts
to run up the road, looking behind her.

In the distance, a pickup truck pulling an
empty flatbed trailer comes around the bend.

Takako sees the truck and turns, sticking out
her thumb while walking backward quickly. She
turns and runs a little ways and then turns
back again, sticking out her thumb to hitch
a ride.

EXT./INT. PICKUP TRUCK - DAY (CONTINUOUS
ACTION)

SKIP, a man in his forties who is driving, and
JOHN, a man in his early twenties who sits in
the passenger seat, lean forward, straining to
see the figure.

> SKIP
> Weird, is that some guy in his
> underwear?

99

The truck slows down.

>JOHN
>What? No, that's a girl in a skirt.

The truck nears Takako.

>SKIP
>(turns to John)
>Roll down your window, let's see
>what she wants.

>JOHN
>Oh my god! What? No! Go! Just go!

John motions for Skip to speed up the truck.
Instead, Skip slows down next to Takako. John
reluctantly rolls down the window.

>JOHN
>(to Takako)
>Everything O.K.?

Takako stands a ways off from the truck, look-
ing terrified. She nods and holds up a hand to
signal: O.K.

>TAKAKO
>O.K. O.K.

>JOHN
>Are you looking for something?

Takako stands back from the truck and sweeps
her hand above her head in an arch. She is
shaking and out of breath.

>TAKAKO
>Like show.

John shakes his head and turns to Skip.

>JOHN
>What is she saying?

Takako is still making the arch above her head,
trying to be understood.

>TAKAKO
>Like show.

 SKIP
 I dunno. Lake . . . something. Lake-
 shore?

 JOHN
 We're on the lakeshore.

 SKIP
 Well, I don't know!

 JOHN
 (to Takako)
 Are you late? Do you gotta go to
 work?

 SKIP
 Ask her if she wants a ride.

 JOHN
 Seriously?
 (reluctantly turning to Takako)
 Do you want a ride?

 TAKAKO
 Yes, yes. Ride. Thank you.

 John opens the door and slides over on the
 bench seat. Takako throws her bags into the
 back of the truck and gets in.

 TAKAKO
 Thank you very much.

 Takako pulls the door shut and Skip pulls the
 truck onto the road. John looks Takako up and
 down.

 JOHN
 You a waitress?

 TAKAKO
 Yes, waitress. How'd you know?

 JOHN
 I didn't know. I just guessed.
 (to Skip)
 Think she's late for work?

EXT. BOATYARD - DAY

Skip and John lean against their pickup truck,
parked in a large area full of boats on blocks,
some covered in brightly colored tarps, and
directly address the CAMERA.

> JOHN
> It was just kinda freaky, you know.
> This lady is coming out of the
> woods at a fast pace. And I mean,
> she wasn't really dressed. It was
> probably in the fifties that day.
> And I thought, well, maybe she
> needed some help. So we backed up.
> And I was trying to talk to her,
> but she really couldn't understand
> me. She was just real persistent
> on where she wanted to go. She kept
> making an arch above her head and
> saying lake something: lakeside
> or . . . I don't really know. We
> thought it was really weird.

> SKIP
> Yeah, we gave her a ride and then,
> right by that Lake Forest, on the
> corner of Four that runs out toward
> Abbey Lake. . . .

> JOHN
> Yeah, it was like we went about a
> mile and she just said, "Stop." And
> we dropped her off and she took off
> walking kinda south along, there's
> a row of big green trees, out toward
> Abbey. And that was the last we seen
> of her.

> SKIP
> Yeah, and I just thought it was
> strange because, you know, we went
> and picked up what we were supposed
> to pick up and then when we drove by
> we didn't see her.

JOHN
(nodding)
It was a little freaky.

 FADE OUT.

You agree: something about this moment seems to vibrate with strangeness. For a long time, you suspected Skip and John of something untoward. You pored over their testimonies and the facts in the police report, trying to find something to substantiate this feeling. For a while, you even imagined that Chief Keena might have been covering for them somehow. Two empty champagne bottles were found at the scene. The foil and wire cages were there, too, meaning that someone drank the champagne out there, though no alcohol was found in Takako's blood during the autopsy. That's always seemed odd. There's never been an explanation for it. Did Takako pour the champagne out on the ground as a last rite? One bottle for her, one for someone else? Did someone else bring the champagne and meet her out there, for a toast or a tryst or to say good-bye? Or did someone go to the scene after she died, to sit with her corpse? Drink the champagne, or pour it out on the ground? Why did Takako run toward Skip and John's truck, out of breath, scared or panicked, trying to describe something? She made an arc with her hands and said a word they couldn't understand—lake something—over and over. She got into the truck and they gave her a ride, but after a half mile she said, "Here, let me out here." Did she change her mind? About what? Could she feel the boundary between one state and another, between her life and something that terrified her, disintegrating? What made her set out toward that boundary? Was she trying to find a way to cross over to the other side?

Stripper, prostitute, college girl, tourist, witch, waitress; young, searching for something, anxious, lost, trying to see the stars, to get somewhere that sounded like "lake," hands above the head forming an arch. Everyone had an idea, but nobody knew anything for sure.

A week after her body was discovered, with the help of the Japanese consulate in Chicago, a medical examiner's photo is faxed to officials

in Tokyo, who get it to Takako's family. Her family says the woman in the picture looks like Takako and that they received a letter from her, written on Holiday Inn stationery and postmarked November 12, 2001, from Bismarck, North Dakota. They say they'll come to the United States to identify the body and take her home.

On November 27, Takako's mother, father, and brother arrive at the Ramsey County Medical Examiner's office in Saint Paul, Minnesota, along with two members of the Japanese consulate. The family confirms Takako's identity and arrange to have her cremated.

The next day, the Konishi family meets with BCA investigators, who tell them—through one of the consular officers who translates—the story of Takako's journey: She arrived in Minneapolis from Tokyo on November 7. On her entrance visa, she wrote that her destination in the United States was "Reel Bay, Fargo, North Dakota," a location that doesn't exist. The investigators inform (misinform) Takako's parents that Takako took a Greyhound bus from Minneapolis to Bismarck, North Dakota, where she stayed at the Holiday Inn.

Her parents produce the letter they received. One of the consular officers translates it for investigators:

By the time you receive this letter, I will be dead.
Please forgive me for being disloyal.
 Signed, Takako Konishi
 Dated, November 11, 2001

The brevity of this letter is its most salient feature. You had always imagined Takako spending her last days in the hotel room in Bismarck writing letters of farewell, that the bed and floor and dressers were covered with drafts, large sections scratched out and rewritten, until she finally arrived at these two sentences. What they don't say resounds from the blank space on the page.

You note that one of the two sentences is almost identical to a line in the note Travis Bickle left for Iris before he went on the shooting rampage at the end of *Taxi Driver*: "By the time you read this I will be dead." Perhaps this would be a line in any last letter, but the similarity

is striking. Perhaps, in the end, when language failed her, she borrowed this line from a letter in a film.

Her parents claim to know little about Takako. They say they've been estranged from her for more than seven years and did not know she had traveled to the u.s. They don't think Takako had a history of mental illness or any reason to commit suicide, but they can't be sure.

BCA investigators tell the family about Takako's desire to go stargazing, her cab ride to Detroit Lakes, and her walk across a field into a stand of trees. They show the family pictures of the scene where Takako was found and the items found with her. Despite their estrangement, her parents identify the items as belonging to Takako: disposable contact lenses, a pink zipper pouch of cosmetics, a pair of black-and-gray gloves, a knitted maroon-colored hair band, a blue cosmetics bag, and an "electronic message box" with the Konishi family telephone number programmed into it.

You wonder about this electronic message box. What is it? Is it misidentified as a pager in other parts of the police report? Is "electronic message box" just a more convoluted way of saying pager? If this message box has the Konishi family's home phone number in it, is it something a person carries with them as a way to easily contact family in case of an emergency? If so, how estranged could they have been? Maybe they know more about their daughter than they care to admit.

You are curious about the word *estranged*, which the Konishis repeat several times to describe their relationship with Takako. They say they haven't had much contact with Takako for more than seven years. This is not the norm in Japan. Children often live with their parents until they get married. You enter *estrangement* into translation software to see what comes up.

疎遠: estrangement, neglect, silence
疎外: estrangement, neglect
離反: estrangement, alienation, disaffection
乖離: separation, estrangement, detachment, breakup
隔たり: gap, distance, difference, interval, estrangement
行き違い: misunderstanding, disagreement, estrangement

Most of these six words connote disaffection and the absence of a relationship. But one of them signifies only physical and not necessarily emotional distance. You wonder why Takako and her parents were estranged. What kind of distance was between them? And was the desire for distance mutual? You wonder if the Konishis know what really prompted Takako's trip, and whether they would tell this to investigators.

Takako's parents say that Takako had been living alone in an apartment in Shinjuku, a neighborhood in central Tokyo, and that they had contact with her two or three times a year. Her father says he spoke to Takako in August and asked her to move back home to live with them in Marugame, in the Kagawa prefecture of Japan. He spoke with Takako again on October 27, and Takako said she planned to be home on November 1. He also contacted Takako's landlord twice in October. The first time, she said Takako was doing fine. The second, on October 30, she said Takako had packed up her things and said good-bye. She added that Takako said she was moving back to the countryside, which the landlord took to mean she was headed back to Marugame to live with her parents. Of course, Takako never arrived there. She went missing and turned up dead in Detroit Lakes two weeks later.

The investigators show the Konishis several small photographs found among Takako's things, but they are unable to identify anyone in the pictures. The investigators tell the Konishis Takako had been to the U.S. three previous times: in 1997, 1999, and 2001. The Konishis say Takako had been in a relationship with an American businessman who worked for Morgan Stanley in Tokyo and that she was probably traveling with him. At first the parents don't want to give the man's name because he's married, but later they say they remember it being "Doug or Douglas." They don't say whether this is a first or last name. The investigators say Takako traveled to the U.S. three *previous* times, but it's not completely clear whether the trip in 2001 was a different trip taken earlier that year, or her final trip, in November. If Takako had traveled to the U.S. with "Douglas" earlier in 2001, it would likely have meant that she was either still in a relationship with him or that it had ended recently. The agents tell Takako's parents that she made a phone call to Singapore from her hotel room in Bismarck and talked

to someone there for more than an hour. The parents say they think Takako probably called Douglas. He had wanted to start a business in Singapore one day.

The Singapore phone number is listed on a copy of Takako's receipt from the Bismarck Holiday Inn that's included in the police report. You call this number many times over the course of many years, but no ever picks up. You call because the number is there. If Douglas had answered, what would you have asked? Perhaps: Was Takako waiting for you in Bismarck? Were you supposed to meet her there? Why didn't you show? Did Takako tell you she planned to die? Did she love the movie *Fargo*? Did she think the ransom money was still out there somewhere? Did she plan to find it? To use the money to start her life again?

The autopsy, conducted on November 18 at the Ramsey County Medical Examiner's Office, finds no anatomical cause of death and no evidence of sexual assault or other trauma.[14] There were granules of unknown powder in Takako's stomach, and she had a heart defect that was not life-threatening. The report notes that Takako had a lot of dental work and that her clothes were manufactured in Japan. Blood and urine tests were negative for alcohol but positive for six compounds: caffeine, phenobarbital, benzodiazepine, Mebaral, acetaminophen, and chlorpromazine.

The death certificate, issued by Becker County on November 28, just after the Konishis leave the meeting with the investigators, lists the date of Takako's death as November 15, 2001 (though this is the day she was found, not the day she died), the manner of death as suicide, and the cause of death as multiple drug overdose.

The pronouncement of suicide doesn't sit right with you. You wonder if the medical examiner would have called Takako's death a suicide without the story about Douglas and the letter the Konishi family brought with them.

You have the idea there weren't enough drugs in Takako's system to kill her, that technically she died of exposure. *And who purposefully dies of exposure? Dying of exposure is almost always an accident,* you think to yourself. It's unclear why you feel so certain about the level of drugs found in her system. Perhaps one of the police officers said

something to you about it. There is no mention of it in your notes, in any of the interview transcripts, or in the police report. You've never been able to see the toxicology report. Still, you hold onto this idea like it's fact.

While you were in Detroit Lakes, your friend asked Chief Keena, "What is the difference between a ruling of suicide and an accidental death?" He replied, "The presence of a lot of different compounds in her system and the letter sent to her parents that declared her intentions, that is probably the difference."

"It's so mysterious," you said. "It might be true that she just wandered into a grove of trees and waited to die, but if that were her only reason to come to Minnesota, it's hard to wrap my brain around what she was thinking. It seems like there must be more, there must be something else. . . . If you were to guess, what do you think happened to her?"

"I think the evidence supports that this was probably a suicide," he answered. "She disposed of several personal belongings in Bismarck, North Dakota, which is a characteristic common in suicide. She apparently disposed of her identification at some point; that's another characteristic of suicide. There was evidence that she had consumed several over-the-counter medications and that is not an unusual method of suicide for a female. Typically a female suicide, they are very conscious of what their appearance is going to be, versus killing themselves with a gun. The fact that she wanted to be alone. The fact that, had she wanted help, she wasn't any more than a hundred and fifty to two hundred yards from several homes. And the fact that she had sent a letter to her parents apologizing for some problems in their relationship and stating that she was ashamed and wouldn't be seen again. Through a process of elimination and piecing together what evidence we could gather, it's pretty apparent."

Chief Keena was trying to tell you, without revealing any of the confidential information in the toxicology report, that Takako committed suicide. But it's as if you couldn't hear him. For Chief Keena, the manner of death was all that mattered. For you, it was hardly relevant.

"I can see the disappointment on your face," he said. "There isn't as much drama here as you'd been led to believe."

But that wasn't really true. You weren't looking for drama, you were looking for desire; you held onto the possibility that Takako didn't plan to die out there, under those trees. That maybe she'd needed somebody to think she was dead because she had other plans. Maybe she'd felt called by something, wanted to disappear, go somewhere else, get rid of something once and for all.

You thought that, even if Takako had been heartbroken and wanted to off herself, she had flown across the world to Fargo, specifically Fargo, for some reason. Everyone described Takako as, to use Harmon's words, "bent and bound and determined" to get somewhere or find something.

"Reel Bay, Fargo"—the place Takako listed as her destination on her U.S. visa—the name of a place that doesn't exist—is the only clue that points directly to what she wanted.

After you finish studying the police report, you return to the footage you shot in Fargo. You have four months to complete a film about Takako, finish graduate school, and move on with your life. You try. You spend hours poring over images you shot, transcribing interviews you conducted, trying to find something of the mystery that drew you to the story. Months slide by.

You want to construct a film about a woman who left everything behind and flew to the other side of the world in search of something. But all you know is that the woman was wearing a short skirt, might have been heartbroken, seemed to be looking for something, and wanted to arrive at a place that didn't exist.

You stand outside the editing room smoking cigarettes, drinking coffee, eating vegan chocolate chip cookies, chatting with people who pass by, waiting for the film to appear.

In July, while you're still struggling, the director from the BBC, Paul Berczeller, releases his film *This Is a True Story*. It's a clever title, both a reference to the title card at the beginning of the Coen brothers' film and a summary of his film's intention: to refute the urban legend that Takako had flown to Minnesota to search for the ransom money buried in *Fargo*. The film gets some good press coverage and launches Berczeller's career.

For a long time you refuse to watch it, not wanting Berczeller's version of the "true story" to contaminate yours. But if you had watched it, you would have seen how completely futile it was to try to isolate your thinking from his, how totally Berczeller's conclusions about Takako, and his interactions with North Dakotans two days before you arrived, had influenced the story you found while you were there.

In his film, Berczeller says, "I went to Fargo and found the true story, that was altogether more ordinary than I had expected. Easier to understand, but harder to forget."[15]

You wonder if that's really true. The officers in Bismarck said Berczeller *told* them "the true story." In Officer Harmon's words, "Takako met an American in Japan and was dating him and he was a married man and broke it off so she wanted to die."[16] It seems to you that Berczeller read the police report and went to Fargo not to *find* the true story, but to shoot a film he had already written. Berczeller enlisted the people in North Dakota to reenact their encounters with Takako through the lens of his perceived version of the truth, a truth he had decided on before he got to Fargo and that, for you, ignores several dark, complex, and contradictory facts.

In some ways, the approach Berczeller takes in his film is similar to Varda's in *Vagabond*. But with one key difference: Varda's piece shows the vagaries of perception, the shifting sands of "truth." The women in the film tend to see in Mona a desire for "freedom," a concept that, for them, is as romantic as it is unattainable; the men in the film (with one or two notable exceptions) tend to see Mona as a sex object, a role she is willing to play if it gets her a sandwich, or a ride, or cigarettes. Whatever people project onto Mona, she becomes for a short time. There is no true story.

In Berczeller's film, however, there is one "true story": Takako hadn't been searching for the money from the movie *Fargo*; she was heartbroken and had committed suicide.

When you go back over your interviews with this in mind, it seems that most of the people you talked to in North Dakota referenced a confused blend of the real Takako and the Takako posited during the filming of *This Is a True Story*. This would explain, for example, why there are such wildly conflicting physical descriptions

of her. Some people describe Takako as short and heavyset, with dyed blond hair and platform shoes. But others say she was tall and thin with straight brown hair and knee-high stiletto boots. The latter is a description of the model who played Takako in Berczeller's film. Maybe the real Takako peeks through the interviews at points where there are inconsistencies, and possibly during interviews with people who were inconsequential enough to Takako's story to be skipped by Berczeller. But these moments are few, and they're difficult to be sure about or cobble together into anything.

It's like the story you were looking for, whatever it was, had been replaced by the BBC and their actor. And why wouldn't it be? The people in Bismarck hardly remembered Takako. She was a quiet, unassuming woman, traveling alone, who didn't speak English and was just passing through. The reenactment with a TV crew and an attractive Japanese model was more compelling than the original.

Perhaps this explains why Officer Harmon, when you interviewed him, said, "At the time I wasn't sure what she was looking for. Now I think she was looking for somewhere to die." He had done his part in the reenactment of Takako's story just two days before, and the process had overwritten his memory of the actual events.

One day you're standing outside the editing room, talking to one of your professors about the film, and he suddenly slaps you and yells, "You know why you can't write anything? You're trying too hard. Just pick a story and tell it. Pretend like you're actually a filmmaker. Rip something off if you have to. Sometimes Godard would go into a bookstore and arbitrarily tear pages out of books, then use them for dialogue. It could be like that. You could just do something. You don't owe this what's-her-name anything. She's dead! What is your problem?"

What is your problem?

Agnes Varda saw a photograph of a man who had died alone in a ditch, and she couldn't stop thinking about him. "To remain outraged by such events, that's what spurred me on," she said. *Vagabond* is about the context, the milieu, in which such an event could take place. Mona—the character at the center of the story—remains a mystery; it serves Varda's film that she remain so.

But you want to know Takako. You sift through the evidence of the case and the testimonies of the witnesses to try to catch glimpses of her. You are drawn to the holes in the story, the parts that feel like openings, a way into what Takako might have been looking for: the movie soundtracks, the phone call, the champagne bottles, snow, *Fargo*, Reel Bay. Especially that: "Reel Bay, Fargo." It feels significant, like a message, as if somehow, encoded in the name, is the key to whatever Takako wanted. The reel in *Reel Bay* could mean "fishing reel"; perhaps it's the name of a fishing destination. But there are no lakes in Fargo. Or the "reel" could be pointing to "film reel," to the unreal version, *Fargo*. Or perhaps Reel Bay is the place where those two realities meet. A reel is a thing that spins, winds her around, moves her between worlds. A bay is the resting place in the middle, the interstitial space that exists between Fargo and *Fargo*. This thought becomes a wheel in your mind with a mechanism of its own. It turns but goes nowhere.

You return again to the facts in the police report, trying to find another way into the story. You find a well-researched article about the process of freezing to death in *Outside* magazine.[17] According to the author, Peter Stark, there isn't an exact temperature at which the body dies from exposure. He writes about horrifying experiments conducted at Dachau, in which Nazi doctors killed people using cold-water immersion baths and calculated that death occurs when the core temperature of the body reaches 77 degrees Fahrenheit. But it turns out this isn't a definite temperature. Stark writes that the lowest recorded core temperature for an adult surviving the cold is 60.8 degrees, and a child in Saskatchewan survived when her core temperature dipped to 57 degrees after a night outside in minus-40-degree temperatures. But people also die from exposure in much milder conditions. Stark cites three competitive walkers in a race in England in 1964 who died of hypothermia even though temperatures never fell below freezing. He also writes about instances of human adaptation to the cold: Tibetan monks who can raise their temperature through meditation and Australian Aborigines who can slip into light hypothermia overnight without damage.

The process of freezing to death usually goes as follows: First the extremities get chilled and the capillaries in the hands and feet constrict to redirect blood to the core, to protect vital organs. If chilling continues and the core temperature falls to 95 degrees, the body begins to shiver violently as the muscles contract in an attempt to generate heat. Thinking becomes cloudy and panicked and the body becomes clumsy, so the freezing person starts to make errors both physically and mentally.

In Minnesota terms, it wasn't very cold on November 12, 2001, the day Takako died. The temperature rose to almost 60 degrees during the day and fell to 38 that night. Takako wasn't dressed for 38 degrees, but she had a full-length wool coat on. It seems more likely that she was out to see the stars than to kill herself by exposure. Chief Keena said something about a meteor shower that night, and there was all the talk about "stargazing" in Fargo, but your research indicates that November 12 was a fairly quiet night astronomically.[18] A geomagnetic storm caused northern lights across much of the country on November 6; on November 8, comet 2001-TC45 came close to Earth and might have made an impressive streak across the sky; and on November 18, a Leonid meteor shower occurred; but nothing exceptional seemed to have happened on the night Takako died. There were probably stars, but nothing more.

November 8, though—the comet. Takako arrived to the U.S. on November 7. She tried to get to *Fargo* but seems to have gotten lost on the way.

One night in 1997, the Heaven's Gate cult in San Diego put on purple satin capes and black Nikes, took sedatives with vodka, and wrapped their heads in plastic because they thought a spaceship trailing the Hale-Bopp comet was coming for them. They each had a five-dollar bill in their pocket with the words *Heaven's Gate Away Team* written on it like an admission ticket to something greater waiting for them outside the world they knew. Takako was wearing a purple coat and black shoes, and she took sedatives with champagne. She might have wanted something like that. Even if she got lost and didn't make it to the right spot on the eighth, she might have been hoping to connect on the twelfth. Maybe she started to feel cold but

didn't want to miss her chance to be taken up by a spaceship or whatever might have been trailing comet 2001-TC45, so she drank more champagne and built a fire. She didn't think to look for her gloves or wrap a towel around her head. Maybe she thought to herself, *I should get going* but felt tired and wanted to lie down.

Stark writes that as the core temperature falls below 95 degrees, "You're becoming too weary to feel any urgency. A stray thought says you should start feeling scared, but fear is a concept that floats somewhere beyond your immediate reach." He writes that this is because with each degree the body's temperature drops below 95, the brain's metabolism is reduced by 3 to 5 percent. When the body reaches 93 degrees, amnesia sets in and a person can't keep anything in her mind. By the time Takako was feeling really cold, it was probably too late; she could no longer figure out how to leave.

But the first thing Takako asked for was snow. Maybe she wanted it to be cold. As far as killing oneself goes, freezing to death seems like a good way to do it.

"Apathy at 91 degrees," Stark writes. "Stupor at 90." At 88 degrees, a person enters the zone Stark calls profound hypothermia: the body is no longer trying to warm itself by shivering, the blood is starting to thicken, oxygen consumption drops dramatically, and the kidneys are desperately trying to get rid of all the extra fluid produced when the blood squeezes toward the core. A person really needs to pee.

Chief Keena said that's what he thought Takako had been on her way to do just before she died. He speculated that she got up, walked a few feet from the fire to pee, tripped on a log, and didn't have the strength or will to get up. Maybe she was in that state of deep apathy, needing to pee. It makes sense. That's why her skirt was pulled up and her panties were showing. She didn't have the strength or will or clarity to do anything.

"By 87 degrees," Stark writes, "you've lost the ability to recognize a familiar face, should one suddenly appear in the woods." At 86 degrees, the nerves are too cold to send good electrical signals; the heart starts to pump a lot slower. Hallucinations begin. At 85 degrees, constricted blood vessels near the body's surface open up, and the skin starts to feel like it's on fire. People often tear off their clothes.

Then the body enters a state of suspension. Blood is barely moving, lungs are hardly taking in oxygen, not much is happening in the brain. Under the right circumstances, the body can survive this. In fact, doctors sometimes induce this state in preparation for surgery. You wonder: if someone had found Takako that night, or maybe even the next, and they'd known what to do with her, might she have lived?

Stark writes that "many hypothermia victims die in the process of being rescued." The capillaries reopen too quickly, and the sudden drop in blood pressure causes the heart to go into spasms. "In 1980, 16 shipwrecked Danish fishermen were hauled to safety after an hour and a half in the frigid North Sea," he writes. "They walked across the deck of the rescue ship, stepped below for a hot drink, and dropped dead, all 16 of them."

But Takako wasn't rescued, wasn't given warming intravenous saline or put into a bath so her body temperature could rise slowly. She got up to pee, fell over, and never got up again. It's not clear how long she existed in a state of suspension before, either accidentally or on purpose or some combination of the two, she died.

The drugs the Ramsey County medical examiner found in Takako's system—phenobarbital, benzodiazepine, Mebaral, acetaminophen, caffeine, and chlorpromazine—could suggest that Takako was mentally ill, had a seizure disorder or very serious migraine headaches, or some combination of the above. Phenobarbital is a barbiturate used to treat anxiety, sleep disorders, and sometimes seizures. Benzodiazepine is like Valium, also used in the treatment of anxiety, insomnia, and some seizure disorders. Mebaral is another barbiturate, often used in combination with acetaminophen and caffeine in the treatment of migraine and tension headaches. And chlorpromazine is an antipsychotic, used to treat schizophrenia and the manic phase of bipolar disorder but also used, infrequently, for migraine headaches.

But these medications are also of interest because of their impact on the body's ability to regulate temperature.[19] All of these drugs, especially phenothiazines (such as chlorpromazine), barbiturates, and benzodiazepines, because of their effect on the central nervous system, significantly increase the risk of hypothermia and frostbite.

So does alcohol, of course, by dilating surface capillaries, which keeps blood at the skin's surface, where it tends to cool. This suggests that if a person really wanted to catch her death by cold, she should take barbiturates, benzodiazepines, phenothiazines, and drink alcohol.

Maybe Takako wanted to freeze to death in Fargo.

REEL 5

At the end of the lonely heartbreak summer, you start seeing Henri again, but everything is difficult and strained, and then he moves to New York. You talk on the phone every day, spend a sleepless week at his apartment in the East Village, and start to plan a trip to Suriname together.

During one of the endless trip-planning phone calls, as you sit on the floor of a bookstore in San Diego and page through a Suriname travel guide, Henri tells you he's started dating someone named Johanna in New York. She's a filmmaker in the same graduate program as you, with the same mentors and some of the same friends. Henri says, "Don't worry, she looks kind of like Jodie Foster, totally not my type." This also describes you perfectly.

It's like being knocked down with a bat. You stay in bed for days without sleeping. The world around you seems to vibrate and hum; everything is bright, luminous, too high-contrast, grainy like newsprint. You are awake, but you cannot do a single thing. Gravity is too heavy. Your mouth tastes metallic. You try to work, but nothing happens. You see yourself as if from a distance, a tiny figure lost in the cliffs and dunes along the ocean, walking slowly, alone. After some struggle, you call off the trip to Suriname.

The deadline to finish your film comes and goes.

Eventually you stop rearranging the furniture of the documentary about Takako. You start thinking again about a dramatic film, something short; you just want to finish school and get out of San Diego. But not much changes. You continue to lie in bed, going over the list of what is known about her story—*Reel Bay*, the phone call to Douglas, the days she waited in the hotel, writing letters or suicide notes, the medications she took, the map, snow—and arriving at what is not known, the point at which there are no more facts but just a feeling: that she wanted something, something difficult to explain, something that would have helped her cross the chasm between what she'd imagined for her life and how it ended up, something that

would help her fill the emptiness she felt, help her figure out who she was, what she wanted. Your mind clutches at the idea that if you can figure out Takako's story and finish the film, you'll be saved from all of this, whatever it is.

The screenplay goes nowhere. Each day you begin and end with the same scene, which is not even a scene but an image, of a woman walking alone in a white landscape in the middle of nowhere, searching for something. For you, it's the distillation of everything you want to convey: *Reel Bay,* an image that is also a portal from one form of emptiness to another. But you know this is only your perception, that even if you make this image, no one will see in it what you do. And anyway, one image doesn't make a film.

Perhaps it's an artifact of repetition, of circling over the same material again and again, but you begin to drift toward a single thought: that you will become her, that you are becoming her, that at the end of the film *you* will walk out across an empty field and disappear over the horizon. This thought rises to the top, feels true. You write:

It's like someone else is taking over my voice, speaking for me, telling me what to do. This someone is dreaming of me, of a snowy landscape. She describes her impressions of this place; what she is seeing are glimpses of her own death, of becoming me. What are we? That *she*—yes, something about her inhabits my body for a while, and I have her thoughts. I have to first, yes, establish her voice, before she disappears. I am behind the camera, and what continues is the dream, seen through her eyes. Our collective imaginations of her fate expand until it's clear they are the same. Reel Bay, North Dakota, this place that doesn't exist. She doesn't understand where she is. That is why time works backward, to a point on an airplane where our souls get mixed up and she goes on a journey in my body, to a place that is familiar to her, and we hear her voice. . . . Yes, and there is some sense that it is me but not me. She is looking back to a body she identifies with, even though it's not her own. My imagination invades her memory—the only record of her experience. So what is it? We merge, yes—she comes through the tunnel, toward me, and then she inhabits me, or I, her. This is a documentary of impressions.

You decide to build a set for the film—a Japanese 1K, a one-room apartment with a kitchen—inside your apartment. A friend in your graduate program, a Japanese woman named Emi, says she'll help you. She comes to your place and brings a stack of Japanese magazines. You flip through them while Emi explains that Japanese women can be classified into types and that the magazines are like manuals—"lookbooks"—outlining the stylistic parameters of these types: Office Lady, Gothic Lolita, Gyaru, or whatever. Emi says that in order to know what Takako's apartment looked like, we need to figure out what type of woman she was.

As you study the photographs, Emi watches your face, waits for you to say, "Ah, yes, she looked like this," but to you, Takako does not resemble any of these women. She was not neat and coiffed like an office lady, nor was she hip or punk or gothic or fake-tan or "super cute" or anything else. You describe Takako to Emi. She was heavy-set, wore a black micromini and cheap platform ankle boots, had dyed reddish blond hair with dark roots, and didn't wear a lot of makeup. Emi knits her brow, perplexed. You ask if it's possible to proceed with the idea that Takako was just normal and average, kind of quiet and unassuming, and maybe worked at a hostess club. Emi shakes her head and says the women in the magazines *are* what normal Japanese women look like (implying that Takako was not normal) and that it would be impossible for an overweight person to work at a hostess club. She leaves the stack of magazines for you to study, tacitly suggesting that, until you pick something, it will be impossible to proceed.

Over the coming days, you look at the magazines again and again, but even at a stretch, none of the women in the magazines look like the person who died below the pine trees in Minnesota. You flip through the "home fashion" magazines, also targeted at various sub-cultures of Japanese women, and see that, as Emi tried to explain, your Spanish-style apartment, with its arched doorways and hardwood floors, has nothing in common with Japanese apartments—their minimal lines, linoleum and tatami floors, and sliding doors. You think Emi sees the hopelessness of the project, so you stop talking to her about it and keep on by yourself.

Focusing on the architectural features common to Japanese apartments, you attempt an arrangement that suggests a certain Japaneseness

in a small area of your apartment while trying to conceal the rest behind strategically placed curtains and shelving: a curtain across a small alcove to suggest a kitchen, a curtain in front of the windows to suggest a sliding door, and a wall of shelving to make the walls seem closer. You cover the floor with woven straw mats, put your mattress on the floor, and bring in a low black lacquer table and some floor pillows. You move most of your things to a friend's house and live inside Takako's apartment for a while, waiting for the screenplay to come to you.

One day, you run into Johanna in the courtyard of the Visual Art Facility. You've never met before but neither of you pretends not to know the other. You say hello and end up sitting on the steps in the center of the courtyard, talking about film. Johanna is about your height with short brown hair, wide green eyes, and a sculptural nose. You think she might be more attractive than you, but you're not sure. You're similar.

Johanna says she is finally finishing her MFA after a long hiatus. She asks what you're working on. You laugh and tell her about the Takako project. "Docudrama, don't underestimate the possibilities," you joke. "I'm gonna blow this genre out of the water."

Johanna laughs and then gets very serious. "There's something you should know."

You feel a wave of nervousness pass through your body and hope she isn't going to bring up Henri.

She continues. "When I was finishing work on my thesis, Silvia came to my apartment in New York to meet with me. We were talking, and I asked if there was anyone in the department she thought was going to make great work. She named you."

You're silent for a moment. Silvia is a giant in your mind. It isn't easy to gain her approval, and it's never evident when you have.

"Thanks," you say.

You offer to give Johanna a ride to where she's staying, with some mutual friends, and later that night you go to the screening of her films. They're stunning. The first is impressionistic and feels like a couple of different films projected on top of each other. There's a dark forest shot in black and white; it's silent, and Johanna plays along

with the image on a wooden flute. The second has sound and a narrative. Johanna stars in the film as a woman who moves to New York and gets a job as a sex worker. In the last scene, a crowd watches while a woman in leather spanks her. Like all of Johanna's films, it's shot on 16mm film and optically printed to create a specific visual effect. In this case, there is a slight liquid-like stutter to the action that makes everything seem not quite real, similar to an effect used by Wong Kar-wai in the film *Happy Together.*

You start to see Johanna as a kind of double, a more successful version of yourself. Over the coming weeks, she and Henri go on tour together; he performs live music at screenings of her films. It's like watching your possible life from a distance.

You decide that in order to make your life work, you need to become more like Johanna. You spend days in a closet-like room that contains an optical printer, trying to teach yourself how to use it. You decide to shoot the film about Takako on 16mm and optically print it to give it a strange distant feeling, as if everything is being seen through glass—a wall that also gives the illusion it can be passed through. The stuttering double-printed images will point to the space between them, a space to enter into, just as they did in Johanna's film. In your notebook, you write:

> This story is a grid. Materialism: the rejection of the spiritual, intellectual, cultural, opting instead to explain everything in terms of the laws of matter, like physics, I guess. But how to explain consciousness, the existence of music, the elaborate dance of the western grebe, the Sagrada Família, even sushi, solely in terms of physical laws? How to hang all that on the austere grid of timeless space? The divine must exist in the material. God is not out there, but here.
>
> Etiology v. History: For an etiology of neurosis, we may take a history of the individual to explore what went into the formation of the neurotic structure. But once the neurosis is formed, we are specifically enjoined from thinking in terms of development, and instead speak of repetition.
>
> The way the story is organized, then: how to conceive of a cinema of physical laws and repetition? Things, forces, people,

gestures, gravity, all happening to each other inside of a grid that goes nowhere. The grid obliterates perspective too. In a grid everything is equal to everything else. And perhaps even replaceable, replicable. Endless repetitions of the same conflict, until the sequential becomes spatial, opening into new territory. Any piece is like a fragment, arbitrarily clipped from an infinitely larger fabric, continuous with it.[1]

In the space between the repetitions, the lines of the grid, one begins to glimpse another—

You sit on the floor at the black lacquer table of your Tokyo 1K apartment, watching films by the Japanese director Yasujirō Ozu, noting the symmetry of his images, the low angle of the shots. You watch Wong Kar-wai's films, too, studying the scenes he optically printed in order to slow them down and stutter the action, to stretch time.

Eventually, an image comes to you: Takako packs her things and moves them out one box at a time. When the apartment is almost empty, she falls asleep. She wakes in the middle of the night to snow falling from the ceiling, covering everything, piling up on the stove and refrigerator, the washing machine, swirling in drifts on the floor. You build an idea for a film around this image.

TITLE CARD:

 "REEL BAY, PART 1"

FADE IN:

STILL PHOTOGRAPH

A small dark figure in an arctic landscape, surrounded by the total whiteness of glaciers and frozen ocean. The air is filled with BUZZING, WHINING AND BANGING AS FROM GLACIERS RUBBING AND COLLIDING WITH EACH OTHER.

 FADE TO BLACK.

 TAKAKO (V.O.)
 Concentrate on the blackness behind
 your eyelids. Imagine a yellow
 speck in the top left-hand corner.
 Enter into the blackness and begin
 traveling toward the speck. Enter
 into the speck.

FADE IN:

INT. JAPANESE 1K APARTMENT - NIGHT

A CAR HORN sounds. The room is dark, full of
barely perceptible shapes. Takako lies in
bed, her arms lying across her chest so one
hand rests on either shoulder. A FAUCET DRIPS
RHYTHMICALLY in the background. Takako opens
her eyes, sits up abruptly, picks up a book of
photographs of the arctic lying open on top of
her, sets it aside, gets out of bed and goes to
the sink on the other side of the room.

She turns on the water and stares at it. She
sticks her head under the faucet and drinks
from it. She turns off the water and watches
the dripping; she adjusts the knob, but the
dripping continues.

Takako sits at a low table and opens a note-
book. She draws a picture: a road, a fence, a
tree. She writes a list of words next to the
picture:

INSERT - NOTEBOOK

Which reads:

 "SNOW, SNOWMAN, SNOW CONE, SNOWBLOWER,
 SNOWSTORM, SNOWMOBILE, SNOWSUIT, SNOW
 FORT, SNOWDRIFT"

BACK TO SCENE

Takako scribbles out the last word and slams
the notebook shut.

INT. SUBWAY CAR - DAY

Takako rides the streetcar, looking out the
window. The light reflects on her face, the
landscape outside the window is a blur.

> TAKAKO (V.O.)
> When I first arrived, it was odd,
> the lack of people, the emptiness. I
> half expected that one day the train
> would be full, as though everyone
> had been away on holiday. Then I
> got used to the quiet. I thought to
> myself, "Things are different here."

The train stops and the doors open. They remain
open for a moment. Takako stares at them. No
one gets on. The doors close automatically,
and the train starts moving again. The image
reverses to negative: everything turns to
shades of vibrant black outlined in silver.

> TAKAKO (V.O.)
> (loud whisper)
> I know it's cold there. That her nose
> and the inside of her throat aches
> when she breathes. Sometimes snow
> gets into her boots, melting and
> then freezing against her ankles.
> Her toes and the tips of her fingers
> burn, then lose sensation.[2]

INT. OFFICE - DAY

Lights flash on a telephone. Takako sits in
front of a computer, typing and wearing a
headset.

She prints something and gets up from her desk,
grabbing the pages from the printer.

INT. STALL IN OFFICE BATHROOM - DAY

Takako leans against the side of the stall
looking at the pages. She studies one of
the pictures very carefully: a diagram of
a snowflake. Outside her stall, TWO WOMEN
enter the bathroom, LAUGHING AND CONVERSING.

Takako crouches onto the toilet so as to remain undetected.

EXT. CITY STREET - NIGHT

LOUD SOUNDS OF HORNS AND TRAFFIC. The entrance of a tall, modern building in a cityscape. Takako exits through the front door of the building and walks quickly down the street, carrying a large black bag. She walks up another street and around the corner as the CAMERA TRACKS WITH HER.

> TAKAKO (V.O.)
> There are two kinds of snow. Most people think about snow when it is falling: snowflakes, each separate, no two alike. But once it has fallen, snow undergoes a metamorphosis. It loses shape, freezes into ice, becomes part of a drift.

Takako stops suddenly as though something has just occurred to her. She is next to a shop window, staring straight ahead as though an invisible force has stopped her and she can't go on. A man coming up the street runs into her.

> MAN
> (angrily)
> Watch where you're going . . .

> TAKAKO
> Oh, I'm sorry, I . . .

Turning her head, she notices a display of snow globes in the shop window next to her.

INT. GIFT SHOP - NIGHT (CONTINUOUS ACTION)

Takako goes into the store and looks out the window, through the snow globes. She takes one and puts it in her bag.

EXT. CITY STREET - NIGHT (CONTINUOUS ACTION)

Back outside, Takako takes the globe out
of her bag and shakes it, then looks at the
street through the falling snowflakes.

The BUZZING AND SMASHING SOUNDS OF GLACIERS
comes over the scene.

INT. JAPANESE 1K APARTMENT - NIGHT

Takako lies in bed with her eyes completely
open, her arms across her chest so one hand
rests on either shoulder.

 TAKAKO (V.O.)
 (loud whisper)
 The yellow speck always gives way
 to a road. On one side, there is the
 forest, on the other, a lake. Maybe
 it's Lake Forest, or Forest Lake.
 Sometimes snow falls lightly there.
 It is peaceful. Other times, snow
 falls heavily and covers everything
 in white. People disappear into that
 kind of snow.

Takako sits up and turns on the light.

She sits at a low table and takes out her note-
book and begins to draw the picture of a road
and a tree and wavy lines next to the road,
like contours or a snowdrift.

INT. OFFICE - DAY

Takako stands in front of the AIR CONDITIONER,
its HUM nearly drowning out the sound of a MAN
MURMURING IN THE BACKGROUND. Takako looks out
the window, lost in thought.

 TAKAKO (V.O.)
 A farmer disappeared like that . . .

INT. OFFICE - DAY (MOMENTS LATER)

Takako stands in front of her desk, staring
at her computer. The light is blinking on her
phone, but she stares past it.

> TAKAKO (V.O.)
> . . . on the way from the house to
> the barn. He got lost in between.
> In the storm, everything was white.
> He couldn't find his way.

The phone stops flashing and then starts again.
Takako pushes the button and picks up the
receiver, lost in thought. She says nothing.

> TAKAKO (V.O.)
> They always say not to sit down, but
> he did. He was covered in snow, and
> they had to dig him out. When you
> freeze to death, your whole body
> tingles. You feel hot. They have
> found people with all their clothes
> off, even though they were freezing
> to death.

Takako places the receiver into its cradle.

EXT. CITY STREET - NIGHT

LOUD SOUNDS OF HORNS AND TRAFFIC. The entrance
of a tall modern building in a cityscape.
Takako exits through the front door of the
building and walks quickly down the street,
carrying a large black bag. She walks up
another street and around the corner as the
CAMERA TRACKS WITH HER.

> TAKAKO (V.O.)
> Frostbite can be recognized by
> stinging, burning, clumsiness,
> throbbing, pain, and sensations
> resembling those of an electric
> shock.

Takako walks forward, then stops suddenly,
as though something has occurred to her. She
is in front of the shop window where the snow
globes are on display, but that isn't why she
stops. She stares straight ahead as though
some invisible force has stopped her and she
can't go on.

TAKAKO (V.O.)
Mustn't think about that.

Takako looks across the street and sees flash-
ing lights on a sign that blinks: DANCE DANCE
DANCE. ALBEE'S BEEF INN.

INT. STALL IN OFFICE BATHROOM - DAY

Takako leans against the side of the bathroom
stall, looking at a topographical map. She
copies the lines into her notebook. Two women
walk into the bathroom.

WOMAN (O.S.)
(low and distant sounding)
I don't believe in the future. You
can only think about now, don't you
think?
(voice fades into the background)

TAKAKO (V.O.)
The thing about Forest Lake: that's
not for sure. Maybe I imagined it.
There's also a place called Moose
Lake, Reel Bay. I could go there. . . .

INT. JAPANESE 1K APARTMENT - DAY

Takako lies in bed with her eyes completely
open, her arms across her chest so one hand
rests on either shoulder.

She sits up; she is fully dressed. The things
in her apartment are packed into boxes. She
stands up, grabs one of the boxes and carries
it out of the apartment.

She comes back inside, pulls aside the curtain
and looks out the window. The SOUNDS OF THE
CITY flood in. The image turns negative. The
SOUNDS OF GLACIERS BANGING AND HUMMING take
over the scene. Takako's face becomes dark,
her clothing white.

> TAKAKO (V.O.)
> Snow reflects light. It doesn't
> absorb it. You must be careful about
> snow blindness. When you can't see
> and your eyes are like sandpaper.
> Even on days without much sunlight,
> everything emanates whiteness. It's
> like staring into the sun.

Takako opens a drawer in her bedside table and
takes out a stack of currency. She counts it
and puts it back into the drawer. Then she lies
down again, crosses her arms, and looks at the
ceiling.

Takako closes her eyes.

> FADE TO BLACK.

FADE IN:

INT. JAPANESE 1K APARTMENT - NIGHT

When Takako opens her eyes again, it is night.

Snow falls from the ceiling, twirls across the
floor into streams, piles on top of the boxes,
her suitcase. Takako sits up. Watches the
snow.

> TAKAKO (V.O.)
> Besides the whiteness, what is
> there? The road, the tree and . . .

Takako gets out of bed and gets dressed. She
puts on a backpack and goes out the door.

> FADE OUT.

You're not sure if this actually constitutes a film. Maybe it's just
a sketch. You have a vague idea for a second part, shot in Tokyo,
about another woman's life and obsessions. It would be a mirror
image to the first, another section in the grid. But for now you must
focus on this one and hope it's enough of a film to get out of gradu-
ate school.

You make fliers for an audition and post them around campus. A friend says he'll shoot the audition for you. You plan to hold it in one of the dance studios on campus.

You decide to show your script to Silvia. You put it in her mailbox and then, a few days later, knock on the door of her studio. After a moment she answers. "Ah, come in," she says. She appears to have just come from the pool; the lenses of her glasses are still dark, and she has a towel wrapped around her head. She leaves the door ajar, and you enter her studio—a warehouse-like room with tall ceilings, full of bookshelves and computers and editing equipment. She sits on a couch under a large window at the opposite end of the studio, surrounded by stacks of books and eating figs.

"I am planning for the class on Chinese cinema."

"I wish I had time to take that." You sit down next to her. After a small pause, you ask, "Did you read it?"

"I did. And I don't think you're going to like what I have to say." She looks up from a book she's reading, picks up your script, and hands it to you. "But this is not interesting."

You struggle to maintain a neutral yet interested expression. "O.K. . . ."

"I'm sorry, but the scene with the snow falling from the ceiling, it's sophomoric. Is it a dream? A hallucination? Memory? And how do you let the viewer know which? You move between these different modes—dream, memory, or I don't know—but nothing seems to be happening in the present. We don't even know who this woman is, and then I think maybe she dies. What for? I'm sorry, but it's terrible. I mean, I know something is going to be bad when it starts with a dream." She pauses for a moment to think. "I just . . . I don't know what to tell you. You should do something else."

Twelve Japanese women show up to your audition. One of them is tall and thin with long red hair and knee-high stiletto boots. Another is short and cute and dressed like a skater girl. Another is mousy, with wire-rimmed glasses and a large overbite. Few resemble the women in the magazines Emi brought over. And none of them look like Takako.

After the meeting with Silvia, you hadn't expected anyone to show up, so you've got nothing planned. You improvise. You lead all twelve women through a series of theater exercises. Then you have them come in one at a time for an interview in front of the camera. You tell them what you know about Takako—what she looked like, where she lived—and ask them to tell you what kind of person they think she might have been. Then you have each perform as the character they've described. You tell them to pretend they're lost in a field in North Dakota, trying to hitchhike to Fargo. A car pulls up, and they try to explain to the person in the car—you stand in for this person—that they want to get to Fargo.

In your opinion, the audition is only marginally successful, but your friend is thrilled. He sees a film taking shape starring all twelve of the women. You consider this idea—an ensemble piece in which each of them works with you to enact Takako's search and disappearance. It's a good idea. You consider asking five of the women to play Takako and proceed in this direction for a while, working on a scene in Takako's apartment starring all five versions of Takako.

After a few weeks, you abandon this idea and return to your initial script. You decide to attempt to shoot the image of snow falling from the ceiling of the 1K, where you are still living. Despite Silvia's critique, this feels central. You borrow a giant 16mm film camera with a set of prime lenses from a friend. You get lights from the equipment room at school. You rent a dolly from a local shop. You choreograph a somewhat complicated shot in which the camera dollies across the room, following the snow, into a closeup of Takako lying in bed. You gather a crew—a handful of your students who have developed some technical abilities. You order film from Kodak.

You have some vague thoughts about the snow, how to accomplish that—something might be rigged from the ceiling, or maybe a Shop-Vac could propel fake snow across the floor at the right moment. You put one of your students in charge of figuring this out.

You plan a rehearsal bringing together all of these elements. You will shoot a test on film and send it to the lab for processing. This will help you figure out if you're going to be able to achieve the look you want—grainy, slow, stuttered, surreal. You've asked a Japanese

woman from the music department to "star" in the film. You've seen her hanging around the coffee cart on campus, and something about her reminds you of Takako. You approached her one day to ask her to be in your movie, and to your surprise, she said yes.

You start early in the morning. The actor and your crew come to your/Takako's apartment. It takes hours to set up the lights, the dolly track, and the camera. You begin to rehearse the dolly shot, pushing the dolly along the track around a corner. One student operates the camera and rides on the dolly while another student pushes it. The first student has to pan the camera as she approaches the bed while a third student racks the focus, trying not to jostle anything. Another student has to turn on the snow at the right moment, before the camera rounds the corner. You would need six people to do this well, but you've only got four, so you end up directing and racking focus. One student pushes the dolly by himself, and another operates the fake snow machine.

During all of these hours, the woman from the music department lies on the mattress, doodling in a notebook. She doesn't need to be on set for all of this. She's just waiting. She seems to be seething, hating you silently. You can feel it emanating across the room.

Once the dolly shot is rehearsed, you turn your attention to the snow, which is key to the shot. The student you put in charge of it hasn't figured anything out. He has decided there's no way to rig something from the ceiling. You look up and agree; that would be difficult. He has purchased a Shop-Vac and some fake snow, but he hasn't tested it.

"o.k.," you say, nodding.

You grab the Vac, fill it with snow, point it at the set, and turn it on. It does not make a nice stream of snow that snakes across the floor as you had hoped. It sprays snow scattershot all over the set for a fraction of a second. The set is a mess. You try vacuuming up the snow, but it doesn't really work. What snow you do retrieve now looks like dirt. You contemplate sending the student to buy more fake snow but realize there's not much point.

You make a small pile of snow and try manually fanning it across the floor with paper, then with a blow-dryer. You try setting up a student on each side of a pile of snow to fan and counter-fan, hoping this

will direct the snow into the desired stream. This doesn't work either. Every approach sends fake snow all over the place.

The actor sits in the corner, watching with contempt.

The crew stays for about eight hours, trying to make something work. You end up shooting about three minutes of film, enough for the test, before the movie lights blow the power for your whole apartment building. Then everyone rushes out, in the dark, before your landlord shows up. And anyway, it's late.

As the actor is walking out the door, she stops and looks into your eyes and tells you quietly but venomously that she is a concert musician and she has turned down *actual concerts* in order to make time for your film. But, she says, leveling her gaze at you, she won't be able to make any more time for it.

You nod silently. You understand.

During the course of your research, you find a book titled *Delusional Beliefs* in the library. It's a compendium of research on delusion by multiple scientists. Since Takako may have been prescribed anti-psychotic medication—at least it was found in her bloodstream—you think it's possible she had a delusional belief that had something to do with *Fargo,* either the movie or the town. You want to understand the mind and mental processes of someone who would fly across the world in an attempt to enter the landscape of a film and find the ransom money buried in a snowbank by one of its characters, assuming this is at least possibly what Takako did.

You spend the better part of the day in the library, reading, taking notes, and copying passages into your notebook. You write:

> "Delusions are best thought of as theories—much like scientific theories—that serve the purpose of providing order and meaning for empirical data obtained through observation. The necessity for a theory arises whenever we are presented with a puzzle. Puzzles are surprise events that are seen as significant and demand explanation."[3]
> Delusional beliefs are secondary to the primary delusional experience—which has a perceptual quality to it—during which psychotics come to believe that particular objects or events have

special significance; they are somehow uncanny, mystifying, ineffable. This primary delusion has no content per se; delusional beliefs are an attempt to structure or explain the primary, incomprehensible experience of psychosis.[4]

Isolation is key to the creation of delusional theories. When someone isn't able to test her ideas with others, she tends to fixate on them. Over time, the process of compulsive thinking overemphasizes emotional experiences and increases the intensity of emotional impressions at the expense of physical reality or facts.[5]

False perceptions and hallucinations are most likely the result of a change in judgment or interpretation in response to real visual or aural stimuli. Researchers conducted an experiment: Subjects looked into a cylinder that limited their field of vision, and then images were projected into it. Some subjects just saw what was projected—wavy lines, dots, or swirls—but many described elaborate visions and detailed scenarios. When these patients were asked to draw their hallucinations, however, they often just drew the wavy lines, dots, or swirls.[6]

Takako might have had a breakdown due to the stress of losing her boyfriend or her job, or because she was mentally ill and had a "strange and shocking experience" that caused her to see something significant in the movie *Fargo*. She thought about it again and again until its significance increased; she began to notice coincidences, things that made her think there was a message in the movie that she needed to address, that required her to walk out of her life and fly to Fargo, or *Fargo*.

The hand-drawn map Takako carried with her showed a road and a tree and wavy lines that seemed to indicate a roadside ditch. Perhaps she perceived something in this drawing that the police officers and hotel workers she showed it to did not.

Nowhere do you note that your own process—going over what's known about Takako's story again and again; arriving at a point where there are no words, just a feeling that seems significant and requires an explanation—fits the pattern of delusional belief-making. Nor do you consider the possibility that your identity as a filmmaker, your pursuit of an impossible story, years spent filling notebooks on

the topic, could be an attempt to transform your own incomprehensible experience into something meaningful, to deny some unbearable truth.

As delusion protects the mind, so the mind preserves the delusion, steps delicately around it, maintaining its crystalline integrity.

You write: "Wherever Takako was going that night, she had two bottles of champagne, she planned to celebrate."

After the challenges of the technical rehearsal and the loss of your actor, you take a step back. It's clear that, though you need to make a film, Takako's story is more than that. It's not just that you've come to see, in Takako, a parallel version of yourself, or that the questions you're trying to answer about her life aren't so different from the ones you're trying to answer about yours (Who was she? Why did she become so obsessed with this movie? Why did she make this last fateful trip? Was she trying to enter into the film itself? To merge her own destiny with that of the characters in the film? With something else? How did she get so lost?). It's that the story about Takako seems to be like a gateway, a way through to the other side of "this, whatever it is"; a way to be done with it once and for all.

Takako, whatever her motivations, seems to have been treading the line between reality and fiction, hoping to move from one side to the other. But why? You think again that the answer to this question is somehow encoded in the name of the place she was trying to get to—Reel Bay. Did she mean *real*, as in a place that felt more real? Was there something about her life that felt unreal? Or did she mean a *reel*, as in a film or fishing reel? A mechanism to reel her into another dimension? Something that appeared in the stars? That could project her into another world, maybe the fictional world of the film?

This desire, this longing, was the subject of the film you wanted to make about Takako. You imagine it as a pressure, a push, to get away, to be outside this moment, to be other than this. To be taken up or consumed by something else, to disappear, to become unrecognizable. The film itself would be a doorway; it would carry you to— what? How do you make a film like that?

In your first screenwriting class, you tried to write a film about a woman who was full of longing and at the same time didn't know

what she wanted. Your screenwriting teacher would hand back your scripts with the question "WHAT DOES SHE WANT?!" scrawled in large red letters across the front. "Until she wants something," he would say, drawing out the vowels, "you haven't got a character, or a story. Stories are about characters who want something. Maybe in the end she doesn't get it, but it's desire that sets a story in motion."

You went back and forth with him on this until finally, when you wouldn't give in, he suggested you create other characters who want something, to juxtapose the main character's nonspecific longing against the backdrop of their desires.

But that isn't what you wanted to do. You didn't want to bury your character's amorphous yearning inside a narrative about normal people whose desires drive the story toward its inevitable conclusion. You wanted the stasis of objectless wanting to be the central conflict, to emanate from the grain in the image, an ache that would bring the whole film to a grinding halt, to an end that was all-consuming in its emptiness.

Wanda is an independent film by Barbara Loden, winner of the award for best foreign film at the Venice International Film Festival in 1970, and chosen as a runner-up to the *New York Times* list of ten best films of 1971.[7] The first time you saw it—and especially an early establishing shot of a woman, played by Loden herself, walking on a road alone, a tiny figure going nowhere in a sea of white sand—the hairs stood up on the back of your neck and you knew it was, in so many ways, the film you were trying to make.

Wanda tells the story of a woman who walks out of her life in search of something; she doesn't know what. She seems to have no skills or moneymaking prospects, so she drifts around, being passed from one man to the next until finally she ends up an accomplice in a failed bank robbery. Wanda is almost an observer in her own life. She drifts through the lives of others, a second party, accomplice, or victim to their desires. In each case, she seems to participate only long enough to say, "Not this either."

After the film opened in New York, Loden appeared on the *Mike Douglas Show* alongside John Lennon and Yoko Ono. They discussed

the difficulties of being a woman filmmaker married to a famous man. Yoko Ono played an important role in the avant-garde film scene in New York in the sixties and seventies, and Loden was married to Elia Kazan, one of the great Hollywood directors, known for *A Streetcar Named Desire*, *On the Waterfront*, and *East of Eden*. Yoko and John asked Loden questions about the film, and she described the principal character:

> She's really running away from everything. . . . She doesn't know what she wants, but she knows what she doesn't want. And she's trying to get out of this very ugly type of existence, but she doesn't have the equipment that a person that has been exposed to more different kinds of people would have. She doesn't know how to get out of her problems. She can't cope with life. . . . She can't do anything. She can't hold a job; she doesn't know how to take care of children. Life is a mystery to her. She's trying the best thing she can, which is just really to drop out. . . . This is one type of person we have in our society, the person that completely resigns and lets everything walk over them.[8]

"I used to be a lot like that," she told a reporter from the *Los Angeles Times* in 1971. "I had no identity of my own. I just became whatever I thought people wanted me to become."[9]

Loden was inspired to make *Wanda* when she read a newspaper article about a woman who had been an accomplice in a bank robbery and was sentenced to twenty years in prison. When she received the sentence, the woman thanked the judge. "That's what struck me: Why would this girl feel glad to be put away?" she said in an interview in 1974.[10] Loden, who has said that the film is partly autobiographical, knew the answer to that question. She knew immediately and intimately who this woman was because she was this woman, at least in part.

Loden was raised in North Carolina by her maternal grandparents, whom she described as religious and cold. She remembered her childhood as solitary and bleak, that she spent hours hiding behind the kitchen stove, not knowing who she was or what she was doing there.[11]

She moved to New York when she was sixteen and became a model. Later she became the Vanna White of her day, appearing on the *Ernie Kovacs Show* as the woman who got pies thrown in her face and was sawed in half during magic tricks.[12] In movies she was often cast as the attractive but unintelligent woman.

Loden said, "I got into the whole thing of being a dumb blonde.... I didn't think anything of myself, so I succumbed to the whole role. I never knew who I was, or what I was supposed to do."[13]

But in *Wanda*, Loden's performance feels true. The submissive, deluded, lost version of herself is amplified into full being. This is the stunning and singular accomplishment of the film. Marguerite Duras, in a conversation with Kazan after Loden's death, said of the film, "The miracle for me isn't in the acting. It's that she seems even more herself in the movie, so it seems to me—I didn't know her—than she must have been in life. She's even more real in the movie than in life; it's completely miraculous."

Kazan replies, "It's true. In some way there was an invisible wall between her and the world, but her work permitted her to make some openings in this wall. She would do this every time."

And Duras says, "It's as if she found a way to make sacred what she wants to portray as a demoralization, which I find to be an achievement, a very, very powerful achievement, very violent and profound."[14]

On the *Mike Douglas Show,* after a clip from *Wanda* is shown, the Plastic Ono Band gets up and plays a song. Loden stands awkwardly in the background, shaking a tambourine and dancing. As you watch Yoko up front, screaming like Patti Smith, you think about how she's the kind of woman you always thought you wanted to write about—fierce, unafraid. But now it seems you're more interested in writing about the woman Loden describes—a woman who doesn't have the equipment to make her life work. You love the energy and defiance of figures like Smith and Ono, but there is something equally radical about giving space to the impossible and the broken without trying to fix it. Radical since, as the critic Marion Meade wrote after the release of *Wanda,* "Where do you go after you reject the only life society permits? And once a woman gains her freedom, what can she do with it? The answer: nowhere and nothing."[15]

You don't know when you realized Takako's journey had nothing to do with the movie *Fargo*, nor with seeking treasure, nor with being heartbroken and wanting to die. Maybe these were symptoms of her predicament, maybe even its conclusion, but they weren't the whole story, not the true story. You decide that Takako's plight was that of a woman who lived almost entirely in a world of romantic possibility—in ideas she created in her mind—because she had little confidence in herself and very few skills or abilities that would have allowed her to live successfully in the world.

Why didn't you make this film? Partly because you didn't know if that story would be of interest to anyone: about a girl who was lost, who didn't know herself or what she wanted, who was quiet and unassuming and unskilled and mixed-up, who was passed from one person to the next until she arrived at the edge of what is known and died.

It's not a very uplifting scenario. But it does draw the dependence and passivity often required of women to its logical conclusion. And it takes a close look at what can happen when a woman's only access to power and autonomy is in her mind.

But there was something else too. While you wanted to tell Takako's story, you also wanted to turn it into something beautiful, to take Takako's unhappiness and your own unhappiness and lift them into another realm where they could become something else. To simply reproduce the bleakness didn't seem to serve a purpose.

So you put the film on a shelf and, for a time, tried to forget about Takako.

REEL 6

TITLE CARD:

"NEW YEAR'S EVE, 2004, 3:20 PM"

You arrive to the Narita Airport near Tokyo, wide-eyed, in wide-legged corduroy jeans and a plaid Pendleton coat. After a thirteen-hour flight, you're disheveled and exhausted.

At the luggage carousel, you wait, mesmerized by the flow of bags until your suitcase—a large plastic trunk on wheels—comes around. You hoist it off the conveyor belt and drag it to the end of a long queue. When it's your turn, you answer a few questions and get your passport stamped.

Stopping at a pay phone, you make a call; tucking the receiver under your chin, you pull out a notebook and take notes.

At a kiosk, you enter coins, press buttons, and collect a train ticket. You flow down an escalator to the train; things seem unreal, loosely held together, as though at any moment they might begin to float apart.

Lights blink off and on as you make your way, with difficulty, through a crowded train. You find a seat and try to pull the plastic trunk out of the way, but it protrudes awkwardly into the aisle. You feel conspicuous, somehow a different sort of creature from the well-groomed, conservatively dressed Japanese people around you. Not wanting to stare, you examine their reflections in the window.

An hour passes on the train before you push your way toward the doors, pulling the heavy trunk behind you. You just make it out before the doors slide shut and the train pulls away. You're sweating, thirsty, and a bit delirious. You stop for a moment to rest, drifting in the stream of new and unfamiliar sights and sounds.

You emerge into an underground station with bright lights and scores of people rushing into tunnels that radiate in every direction.

You drag your luggage up a brightly lit staircase into a shopping center, to a landing with a small bench. You take off your coat and lean back to take in the view. Scores of women with ironed-straight hair, short skirts, and knee-high stiletto boots flow past you up and down the stairs like a dream.

After a time, Yuuko, a Japanese woman with blue hair, wearing jeans and a down jacket, rounds the corner, out of breath. "Dude. Sorry it took me so long to get here!"

You stare at her in a daze. "It's cool. I'm totally into the people watching."

Yuuko takes a look at the plastic trunk sitting next to you. "Oh my god! Look at your suitcase!"

"Sorry, it's camera and audio equipment. It's heavy."

Yuuko takes hold of one side of the bin and starts pulling it. You rush to catch up with her, grabbing hold of the other end and moving quickly into the crowd.

At Yuuko's apartment, you sit next to her at a low table. Yuuko's mother, Misho, brings in a small dish of calamari and sets it in the middle of the table. Yuuko picks up the dish and uses her chopsticks to scoop a few onto your plate and then her own. She says something to her mom in Japanese, and her mom responds.

"She says you don't have to worry. We aren't too proper around here."

You laugh self-consciously and say, "Oh, thank you." Still, you watch Yuuko and start eating only when she does. Misho sits down and takes what is left on the plate and eats it. She says something to Yuuko, who then turns to you: "She says you should go to sleep soon. You must be tired."

You laugh. "I think I'm too tired to even know I'm tired."

Yuuko translates for her mom. Her mother nods, then gets up and goes into the kitchen.

You find yourself watching the television playing at low volume on the floor in front of you. It's a game show. The host wears a sequined outfit. Members of the audience come onstage to perform humiliating tasks.

Misho comes in with another dish and sets it on the table. Yuuko picks up the dish and serves some eggplant onto your plate and then onto her own, saying something to her mother in Japanese. Her mother looks at the television, then at you, and laughs.

"Don't watch this show. It's a New Year's Eve thing. Totally stupid. We're embarrassed to be watching it," says Yuuko.

You all turn to watch it anyway, eating your meal in silence.

After dinner, you fall asleep on one of two futons in an empty room near the kitchen. In the middle of the night, you wake with a start to the house shaking violently. You open your eyes and see the dimly lit room and Yuuko asleep on a futon next to you. You are awake but unable to move. There is something else in the room—a dark presence where two walls meet the ceiling—looking down at you. The presence starts to float down from the ceiling. You feel its malevolence. You want to move, to open your mouth and scream, but you are paralyzed. The presence comes closer, hovers above you, then lands on your chest, pressing down and trying to strangle you. You want to struggle, to get Yuuko's attention, but you cannot move, cannot scream, cannot breathe. You feel the presence enter your chest—a darkness, a tight grasp around your chest and neck. The shaking of the room subsides. You remain awake, unable to move, feeling the presence, the terror, the dull pain and nausea, for hours.

```
FADE IN:

INT. MISHO'S APARTMENT - EARLY MORNING (SERIES
OF SHOTS)

As the sun comes up, B. awakens, no longer in
the grip of terror but aching all over.

B. groggily investigates the shower, an incom-
prehensible collection of knobs and hoses.

She stumbles into the kitchen, sees there is no
coffee, and exits.

B. returns to her futon and goes back to sleep.
```

INT. MISHO'S APARTMENT - LATE MORNING

Yuuko shakes B. awake.

EXT. MODERN RESIDENTIAL AREA OF TOKYO - DAY

B. follows behind Yuuko, Misho, and Misho's
boyfriend as they walk down a plant-lined
walkway through a modern neighborhood of
trendy shops and tall apartment buildings.
Overnight there has been snow, and everything
is covered with a fluffy layer of white that
sparkles in the bright sun.

> YUUKO
> (turning to B.)
> We've decided to go to Sensō-ji
> temple, in the old part of Tokyo.
> That cool?

> B.
> (nodding)
> Sure. Sounds great.

They arrive to a Starbucks and go inside.

EXT. AROUND TOKYO - SERIES OF SHOTS

B. lets herself be carried along on a series of
trains.

And through the streets of Tokyo.

To a wide boulevard crammed with people and
lined with stalls selling food and trinkets.
It seems like all of Tokyo is there, queuing to
get into Sensō-ji.

EXT. BOULEVARD LEADING TO SENSŌ-JI - DAY

As they approach the temple, the crowd
squeezes together to pass through the gates,
and the pushing becomes intense. B. feels she
might be carried along by the momentum, her
feet lifted off the ground. She keeps her eye
on Yuuko, who is overcome with fits of LAUGHTER
and the thrill of losing control.

Once they have passed through the gates, the pushing subsides. But the sun beating down on the roof of the temple loosens large sheets of snow that slide down the pitched roof, gathering momentum before they cascade onto the multitudes like small avalanches. People become agitated and attempt to scatter to avoid getting covered in snow. Waves of jostling and pandemonium ripple through the masses. Police officers stand on a balcony above it all, issuing ANNOUNCEMENTS VIA MEGAPHONE, trying to maintain order. Yuuko and B. are missed by the snow more than once, but the people directly in front of and behind them aren't so lucky.

They near the temple and walk up a large staircase toward panes of safety glass. Behind the glass, inside the temple, there's a large statue of the Buddha. In front of the glass is a large wooden box with slots for coins. People begin THROWING COINS AT THE BOX, and once again the pushing and YELLING become frantic. B. gets jostled and thrown about in the surge. Misho gets hit by flying coins, which leave bruises on her arms and a cut on her face. At long last they are pushed to a secondary staircase and descend. For better or worse, they've been to Sensō-ji on New Year's Day.

EXT. ASAKUSA NEIGHBORHOOD - SERIES OF SHOTS

Afterward, they walk along the streets of the Asakusa neighborhood, stopping at a tempura restaurant for lunch.

B. experiences everything -- the crowds on the street and lunch inside the restaurant -- as a series of impressions: bright, loud, frenetic, pressing, crisp, white, salty, sweet, uncomfortable, joyful. The impressions don't add up to anything. It's the familiar feeling of floating not quite inside her own body.

INT. STUDY IN MISHO'S APARTMENT - DAY

The next day, B. sits with Yuuko and Misho at a table in the study of Misho's apartment. Yuuko works on her laptop, Misho reads the newspaper, and B. writes in her notebook. B. looks up at Yuuko and Misho. Noting their absorption, it is with some trepidation that she breaks the silence.

 B.
 Excuse me, um, was there an
 earthquake the night I arrived?

Yuuko shakes her head and translates for her mom. A brief conversation between them in Japanese ensues.

B. watches and listens closely.

 YUUKO
 No, there was no earthquake. Why?

 B.
 Well, I had this kind of strange
 experience. I woke up to the house
 shaking. I was paralyzed, but I
 could see everything clearly,
 could see you asleep next to me. And
 then, there was some other strange
 terrifying thing in the room, too,
 like a ghost or something.

Yuuko translates for Misho, and an unhappy look comes over Misho's face. She says a few words to Yuuko, who turns to B.

 YUUKO
 This is kanashibari.

 B.
 Kanashibari. What is kanashibari?

There's another brief conversation between Yuuko and her mother.

YUUKO
Most people think it's a ghost or
evil spirit visiting you in your
sleep. It happens when you're
vulnerable, like when you're sick
or haven't slept for a long time.
They target the weak.

Of course that's what it felt like, but B. had
been hoping for another explanation.

B.
So what do you do about it?

There is more discussion between Yuuko and her
mom, and then Yuuko turns to B. and shrugs.

YUUKO
Sorry. We don't know. It's never
happened to either of us.

Yuuko turns back to her computer, and Misho to
reading the paper. It's clear that the conver-
sation is over.

B. stares at the pages of her notebook and
tries to locate a clear thought in her swim-
ming mind.

Kanashibari translates literally from the Japanese as "bound in metal";
the English term is *sleep paralysis.* Both refer to the fact that a person
wakes up unable to move. The scientific theory is that kanashibari
occurs when REM sleep is disrupted—a person wakes up but contin-
ues to experience the paralysis that is normal during REM, a protec-
tive mechanism that prevents people from acting out their dreams.

In most cultures, the language and theories surrounding the
phenomenon of kanashibari focus on the intruder—the ghost or
evil presence in the room. Scandinavians believe a mare, or damned
woman, sits on the rib cage of the sleeper, causing them to experi-
ence nightmares. Inhabitants of Newfoundland, South Carolina, and
Georgia believe the same thing but call the presence a hag. Fijians
believe the sleeper is eaten by a demon, often the spirit of a recently

dead relative. People near the sleeper often attempt to prolong the visitation so they can ask why the relative has returned. (But how do they know the demon is present? Can they see it, even when they're not under its spell?)

In Turkey, people think a demonic being comes to the victim's room and holds the sleeper down, attempting to strangle her. In Thailand, the ghost is called phi um; in China, bèi guǐ yā, which means "held by a ghost." In Korea, kawi nulita (which translates roughly to "scissors pressed"), and in Sri Lanka, amuku be (meaning "the ghost that presses one down"), are associated with the belief that a ghost lies down on top of the sufferer. In Mongolia, kara darahu means "to be pressed by the black." In Vietnam, there are two terms for it: ma de ("held down by a ghost") and bong de ("held down by a shadow"). In Pakistan, people think kanashibari is an encounter with Satan, the result of black magic performed by enemies.[1]

Pressed by the black. A demonic being attempts to strangle her. Her soul is eaten by a demon. None of these explanations do anything but reinforce the feeling that something actually happened to B. that night. Perhaps traveling across the world to find the story of a dead woman had somehow summoned the demon or hag or devil or ghost.

If B. is carrying a demon, it's not totally obvious. She spends hours trying to locate it. She can feel something on the left side of her body, near the left clavicle and up into the left side of her throat and jaw. It's a tightness that seems to have some mass or weight to it. If she sits still for a long time, the feeling becomes more pronounced, more definite, and she almost feels like she's being strangled again. It becomes difficult to speak or breathe. If she closes her eyes and tries to visualize the demon, she sees something small and dark with shining eyes. She has to be very still to coax it out of hiding, and even then it is skittish, perhaps not really there, a figment. It's impossible to tell.

Yuuko invited B. to Tokyo to help shoot a documentary about her family. Yuuko didn't explain much about the film except to say that it was about an aunt and a closely held family secret. B.'s main qualification for the job, aside from being a filmmaker, is that she speaks no

Japanese. Yuuko thinks her family will only talk about "the secret" if no one else is in the room—the implication being that, since B. doesn't understand Japanese, she will be as good as no one.

But now that B. is in Tokyo, Yuuko hardly mentions the documentary or the family secret. At first, B. thinks Yuuko is giving her time to recover from jet lag, but when she asks about the plan, Yuuko says vaguely, "Well, we would have to travel to Nagoya to interview my aunt, and I don't know if we're going to be able to do that. We'll see . . ." She says it in hushed tones, avoiding her mother's glare.

Later, during a small party at the apartment, Yuuko hands B. a video camera and asks her to shoot. After ten minutes, Yuuko takes the camera back and reviews the footage. She doesn't comment on it and never brings up the documentary again. B. considers asking Yuuko for more of an explanation but decides against it. It seems like a closed topic, and she doesn't want to push into private family matters.

So B. starts to think again about her own film, and the whole mechanism of unresolved questions about Takako starts to whir in her mind. As she wanders through Tokyo, its sites become the backdrop for a litany of arguments about what is and is not interesting about Takako's story.

After B. got back from Fargo, she was overcome by the feeling that Takako was absent from her own story even while she was living it, though she couldn't articulate that at the time. It was as if Takako had been carried along by the stories of others: whatever someone else saw in her, she became. Sure, she was quiet and unassuming, but it was more than that, as if the fundamental quality of Takako's being was absence, emptiness, as if somewhere along the way she learned to remove herself from the equation. Things were easier if she didn't want anything, didn't impose her ideas or wishes on anyone.

B. remembers what one of the Bismarck cops said about Takako: "There are people who you meet and you remember them. She just wasn't one of those people."

Something about her was already not quite there. Maybe that's why, eventually, she ceased to exist.

B. can't decide if this makes her task as a filmmaker easier or more difficult. It raises a different set of questions. What kind of person

makes almost no impression on those around her, is invisible long before she disappears? What kind of story can be indelibly fictionalized by those who pretend an interest in its subject? How do you get to know someone who is missing from her own life already? How do you turn toward this emptiness? Understand what she wanted? What turns someone into no one?

B. decides to stay in Japan until she arrives at answers to some of these questions.

FADE IN:

INT. COMMUTER TRAIN - DAY

B. rides on a commuter train, taking in the apartment buildings that line the tracks and the other passengers on the train.

B. pulls a notebook and pen out of her bag and writes --

INSERT - NOTEBOOK

Which reads:

> "How do you represent a culture that is all about surfaces? Is there a way to get to the center?"

INT. NATIONAL MUSEUM OF MODERN ART - DAY

B. stands in front of a wall of nude photographs. The subjects stand facing the camera in anatomical position. Like paper dolls, they express complete neutrality.

She moves on and pauses in front of One Hour Run by Dennis Oppenheim: a detailed topographical map and black-and-white photographs of a snowy landscape.

B. takes the notebook out of her bag and writes down the title of the work.

She pauses in front of:

Automobile Tire Print by John Cage and Robert
Rauschenberg, a single tire print on many
pieces of paper, taped together into an end-
less scroll.

General Male Catalog '63 by Natsuyuki
Nakanishi, a series of blue-printed photo-
graphs of male bodies, taken from behind.

B. takes out her notebook and writes --

INSERT - NOTEBOOK

Which reads:

> "Collecting remnants of a set of facts
> and sewing them together points to
> something felt, below the surface.
> Perhaps that's all that is required."

BACK TO SCENE

As B. arrives in front of another Rauschenberg,
she grabs her notebook, but she can't find
her pen.

She retraces her steps through the museum and
still cannot find it.

She approaches a GUARD and makes a pantomime
gesture like she is writing on her notebook.

 B.
 Pen?

The Guard shakes his head, and then his eyes
light up and he pulls a pencil out of his
pocket. He holds it up to B. She takes it with
a smile and a bow.

 B.
 Arigato gozaimasu.

The Guard bows in return.

GUARD
 Tondemonai desu.

Under her first set of notes, B. makes a pencil
drawing of a pen and writes --

INSERT - NOTEBOOK

Which reads:

 "Lost pen."

BACK TO SCENE

She then writes, in pencil, a description of
the work by Rauschenberg --

INSERT - NOTEBOOK

Which reads:

 "Several X-rays of a skeleton; a
 chart of the movement of the moon and
 planets."

Over the coming days, B. wanders through the streets of Tokyo, lost
in a barrage of visions and sensations. Electronic beeping. Tall build-
ings. Flashing signs. People pressing tight, then flowing like rivers
down streets and across intersections.

She didn't know it would be so cold in Tokyo. She wears every
sweater, scarf, hat, and jacket she has with her at all times, yet she is
always freezing.

She feels happy, overwhelmed, confused, unhappy. She likes the
city, but she's also afraid of it. She can't read Japanese, and there are
so many trains to catch. When a train pulls into the station with only
Japanese writing on the front, B. panics, shuffling through her note-
book to find the kanji for the station she's trying to get to or, failing
that, pointing at the train and shouting the name of the station she
wants to get to loudly.

Jana Larson

INT. TOKYO TRAIN STATION - DAY

B. stands on a train platform in a busy station
as a train pulls in.

> B.
> (loud, with urgency)
> Shakujii-kōen? Shakujii-kōen?

> KIND STRANGER #1
> (nodding)
> Hai. Hai. Shakujii-kōen. Hai.

INT. TOKYO TRAIN STATION - DAY

B. stands on a train platform in a busy station
as a train pulls in.

> B.
> (loud, with urgency)
> Shakujii-kōen? Shakujii-kōen?

> KIND STRANGER #2
> (holding up arms in an X)
> Ee-yay. Shakuji-kōen, ee-yay.

Most of the time nobody responds, and B. stands next to the door of
the train trying to decide whether to board or not. It's usually a last-
minute, toss-of-the-coin decision. Sometimes she gets lucky and gets
on the right train; sometimes she's unlucky and gets on the wrong
train or misses the right one.

B. writes the Japanese words she's learning in her notebook:

Kanashibari—ghost visitation
Oishii—tasty
Mazui—not tasty
Konnichiwa—hi
Hajime mashite—nice to meet you

She writes:

Takako must have felt she was a strange creature in the midst of all the other strange beings in Japan. She felt separate. There was one thing that excited her, made her feel connected, and on that she pinned everything, all her longings and hopes. She moved toward it as though it were a lost part of her, and then, just when she thought she was getting close, it became something frightening and strange.

Ohayo—good morning
Konbanwa—good evening

FADE IN:

INT. LOCAL BAR - NIGHT

Yuuko, Misho, and B. sit on cushions at a low table on a platform in the corner of a dimly lit, traditional-looking bar. The three of them LAUGH together about something. Suddenly, Misho becomes serious and says something in Japanese that Yuuko then translates.

> YUUKO
> She wants to know: How are you surviving now?

B.'s face falls and she shifts uneasily.

> B.
> Credit cards.

Misho asks another question, which at first Yuuko refuses to translate. Then Yuuko turns to B.

> YUUKO
> Did you finish school before you came here?

B. shakes her head. A hush falls over them. B.
feels ashamed, like she has been exposed as a
loser or imposter.

No one says anything else. They turn to their
plates and finish their food and drinks
quickly.

They leave in silence.

EXT. RESIDENTIAL NEIGHBORHOOD, TOKYO - DAY

A few days later, B. pulls her suitcase through
a quiet residential neighborhood in the north-
ern part of central Tokyo.

She arrives at the gate in front of an old,
traditional-looking Japanese house with an
overgrown Japanese garden and koi pond in
front. A WOMAN FROM THE RENTAL AGENCY is wait-
ing for her.

> WOMAN FROM RENTAL AGENCY
> Hello. Welcome.

> B.
> Hello. Thank you.

The Woman From Rental Agency holds up a key on
a long keychain.

> WOMAN FROM RENTAL AGENCY
> Here is your key. It's a little
> tricky, but you do like this. O.K.?

She shows B. how to open the front gate. They
go to the front door and she demonstrates how
to operate the lock on the door.

> WOMAN FROM RENTAL AGENCY
> And here it's like this. O.K.?

B. nods and the woman hands her the keys.

INT. OLD HOUSE - DAY

The woman shows B. to a small room on the lower
level. There are tatami floors, two small win-
dows, and sliding doors that open into a closet.

B. leaves her suitcase in the room, then follows the woman into the rest of the house.

The woman shows B. an unkempt bathroom full of toiletries, quickly flicking the lights on, then off.

> WOMAN FROM RENTAL AGENCY
> Here's the bathroom.

She shows B. the kitchen, also filthy, with overflowing trash and recycling bins and shelves packed with condiments.

> WOMAN FROM RENTAL AGENCY
> This is the kitchen. You share with four other women: three Japanese who are students and one Canadian who works at a bank.

> B.
> O.K.

The woman lets herself out and B. goes back to her room. She starts to unpack her suitcase.

The Canadian Woman, SIMONE, pokes her head into B.'s room.

> SIMONE
> Hey, you're the new roommate. I'm Simone.

B. stands up and shakes Simone's hand.

> B.
> Hi. Nice to meet you.

> SIMONE
> You don't want to live in this room. There are rats down here. The rental agency knows that. I'm going to call them, and I'll help you move upstairs. It's nicer.

INT. UPSTAIRS BEDROOM - DAY

B. gets settled in the upstairs room: also
small with tatami floors, but with sunshine
coming in through the windows.

INT. KITCHEN - DAY

A little later, B. finds Simone in the kitchen.
Simone opens the refrigerator and hands B. a
can of beer.

> SIMONE
> How long are you planning to stay in
> Tokyo?

> B.
> I don't know. Depends on whether or
> not I can find a job.

> SIMONE
> (nodding)
> That's a tough one.

> B.
> Yeah, I'm kind of figuring that out.

> SIMONE
> I wish I could help, but I'm leaving
> for Canada in a couple of days.

> B.
> For good?

Simone shakes her head.

> SIMONE
> No, I wish. Just a vacation.

EXT. SHINJUKU - DAY

B. walks down a street at the edge of Shinjuku.
She stops a MAN ON THE STREET and shows him a
piece of paper with Takako's address written
on it.

> B.
> Sumimasen. Doko? Where?

The man nods, takes the piece of paper and a
pen from B., and sketches a few streets on it.
He puts two X's on the map and points to one of
the X's.

> MAN ON THE STREET
> You, here. O.K.?

B. nods.

He points to the second X and up the street,
and moves two fingers in a walking motion.

> MAN ON THE STREET
> You walk. O.K.?

She nods.

> B.
> Arigato gozaimasu.

The man LAUGHS.

> MAN ON THE STREET
> Japanese. Very good!

B. LAUGHS and bows to the man, then turns
to walk up the street in the direction he
indicated.

When did she fully notice the maps? Notice that, whenever she stopped someone to ask for directions, they pantomimed a request for pen and paper, she handed them her notebook, and they drew a map? On the map they drew landmarks as squares or *X*'s. Then they looked her in the eye and pointed at the ground and to the map and said something like "you" to indicate her current location on the map. They pointed to the destination on the map and said the name of whatever it was—Tokyu Hanzu, for example. Then they pointed in the direction she should walk. Pointing to the map again, they said the name of a landmark she should look for—Vodafone shop, maybe—and pointed in a direction and said the word "left" or "right" in English. All of this because, in Tokyo, there are few street names and no grid. Instead, there are geographic regions, indicated

by various suffixes (*-chō, -machi*). Each region is further organized into city blocks or plots of land (*-chome*). Numerical addresses within these sectors seem to be random, referencing time (when something was registered) instead of location. It's not only foreigners who ask for directions. Even taxi drivers and delivery men seem to be lost half of the time.

For a while, B. collects the little maps people draw for her. Still, several weeks pass before she makes the connection between this phenomenon and the hand-drawn map Takako had with her in Fargo. Maybe for the cops in Bismarck, a map with an X on it is a treasure map. In Tokyo, it's just a way to give and get directions.

EXT. KABUKICHŌ NEIGHBORHOOD - NIGHT

B. gets lost in a maze of winding streets behind Kabukichō, and it's dark, so she decides to go home and try another day.

INT. KITCHEN IN OLD HOUSE - NIGHT

B. sits at the kitchen table in her new house, drinking beer and eating cold tofu with soy sauce on it. Several empty beer bottles sit on the table in front of her.

She pulls out her notebook and pen and stares at the empty page. She rests her head on the table for a moment, seeming exhausted and a bit drunk, then sits up and writes --

INSERT - NOTEBOOK

Which reads:

"I'm now afraid that, no matter where I go or what I do, the film will always be somewhere else."

"Doppelgänger: a ghostly double of a living person, especially one that haunts its fleshy counterpart."

EXT. SHINJUKU - DAY

B. emerges from the subway onto the street
outside the station, where she is surrounded
on all sides by large shopping malls and tall
buildings covered in neon signs.

She follows the crowds to a wide intersection
with larger-than-life video advertisements
booming from lit-up facades.

She crosses to the other side and enters an
area with narrow streets full of people. The
buildings are covered with blinking neon and
pictures of smiling girls. There are pachinko
parlors and staircases that lead into dark
basements. Unsmiling men in suits guard the
entrances, where YOUNG GIRLS in short skirts,
with dyed hair, wearing lots of makeup beckon.

> YOUNG GIRLS
> (high-pitched shouting)
> Irasshaimase. Irasshai.
> Irasshaimase-e-e!

It is cold, and B. wishes she had gloves and a
warmer coat.

B. follows the map to the end of the dense,
urban part of Shinjuku and up a hill into a
residential area.

Around a bend, midway up the hill, she notices
a small Shinto temple tucked back from the
street, with bare dirt and a few trees in the
front garden. This is one of B.'s favorite
things about Japan -- the sacred spaces, the
way a neighborhood of skyscrapers will sud-
denly give way to an old wooden temple and
trees.

On the street in front of the temple, B. sees
a bag with a kitten's head poking out the
top. The bag is knotted shut so the kitten
can't get out, and the whole bag is writh-
ing, suggesting that there are more kittens
inside. B. looks around. The street is empty.

She carefully picks up the bag and carries it toward the temple.

EXT. SHINTO TEMPLE - DAY (CONTINUOUS ACTION)

B. KNOCKS at the door of a small house next to the temple.

After a moment, a WOMAN answers. She doesn't look the way B. imagines a priest would; she's a normal middle-aged woman with permed hair and glasses.

B. holds up the kittens. She points to them, then to the street, and makes a shrugging gesture. She hopes this somehow communicates that she found the cats on the street and doesn't know what to do with them.

The Woman smiles, takes the bag of cats, and sets them down outside the door.

> WOMAN
> O.K. O.K.

B. doesn't feel at all reassured and wonders if it was this woman who put the kittens into the bag in the first place. B. bows and smiles.

> B.
> Arigato gozaimasu.

The Woman closes the door. B. pauses for a moment, glancing at the bag of kittens, and then turns to leave. What else can she do?

EXT. RESIDENTIAL AREA OF SHINJUKU - DAY (CONTINUOUS ACTION)

B. continues up the hill, past a small area of shops, and down a side street, where she finds Takako's address.

It's an apartment on the upper level of a small two-story building with six units. Each apartment has a numbered door that opens onto a narrow balcony. The building faces a tiny yard with a small tree. On the other side of the yard is a large single-family home.

B. stands there for a moment, looking at the apartment. She now knows Takako lived in a tiny apartment in an old, quiet section of Shinjuku. Mentally, she adds that to the short list of things she knows about Takako, another bit of information that doesn't mean much.

She turns and walks back the way she came.

INT. INDIAN RESTAURANT - DAY

B. eats lunch in an otherwise empty Indian restaurant.

EXT. HOUSE IN RESIDENTIAL AREA OF SHINJUKU - DAY

A few weeks later, B. and one of Yuuko's friends, SHIRO, walk up to the single-family home next to Takako's apartment building and KNOCK.

> B.
> Do you think they'll know Takako?

Shiro nods and turns to the door as a MAN answers.

The two exchange bows and a few words in Japanese.

B. smiles and bows and tries to look simultane-ously friendly and grateful and apologetic.

The Man walks away from the door for a moment, and Shiro and B. silently exchange looks.

The Man comes back and says something to Shiro. Shiro smiles and bows, and B. does the same. They turn to go.

> SHIRO
> We can come back tomorrow.

> B.
> Why can't they just talk to us now?

Shiro shrugs.

 B.
Is that O.K. with you? To come back
tomorrow?

 SHIRO
Sure.

EXT. HOUSE IN RESIDENTIAL AREA OF SHINJUKU - DAY

They return the next day, and the LANDLORD, a
coiffed and made-up woman in her late sixties,
comes to the door. She says a few words to them
in Japanese and motions for them to enter.

 SHIRO
 (to B.)
We should leave our shoes outside.

Shiro and B. leave their shoes on the front
step and follow the Landlord into the house.

INT. LIVING ROOM - DAY (CONTINUOUS ACTION)

Shiro and B. sit on the floor across from the
Landlord at a low table. She says a few more
words in Japanese, and Shiro translates.

 SHIRO
She says she owns the apartment
building next door, where Takako
lived. She is happy to answer your
questions, but she doesn't want to
be filmed.

B. sets her camera equipment on the floor and
nods as if to say that's O.K.

B. hands a list of questions to Shiro. He takes
the list and, as far as she can tell, starts
at the top. He asks the Landlord a question in
Japanese, and she answers.

 SHIRO
 (in Japanese)
Thank you for taking the time to meet
with us. Could you please tell me
where Takako worked while she lived
here?

 LANDLORD
 (in Japanese)
When Takako first lived here, she
worked at a travel agency at Don
Quijote's, just up the street.
She worked there for a couple of
years. I think she liked it. Then,
when they closed the travel counter,
she lost her job and couldn't find
another one. She wrote letter after
letter apologizing for not paying
her rent and telling me about all
of the jobs she was applying for.
But I don't think she got any of
them . . .

Rather than translating for B., Shiro
scribbles notes onto the list and moves on,
asking the landlord another question.

 SHIRO
 (in Japanese)
So, how was she paying her rent?

The Landlord says something in Japanese,
stands up and goes into another room.

 B.
Where is she going?

 SHIRO
Takako wrote letters apologizing for
not being able to pay the rent. She's
going to show them to us.

The Landlord returns with a stack of papers,
which she hands to Shiro, explaining something
at length in Japanese.

 SHIRO
 (translating in English for B.)
Takako applied for a job at the Hard
Rock Café.

 B.
Did she get it?

Shiro shakes his head and focuses on listening to the Landlord, who continues to talk. Shiro scribbles notes.

The interview is over quickly. Shiro stands. He and B. bow and say thank you. The Landlord escorts them to the door.

EXT. HOUSE IN RESIDENTIAL AREA OF SHINJUKU - DAY

B. and Shiro exit the house, bowing to the Landlord and thanking her. She bows to them as she closes the front door. B. and Shiro pause on the front step to put their shoes on.

> SHIRO
> Do you wanna go somewhere and I can go over my notes?

> B.
> Yeah, that'd be good. While it's still fresh.

INT. ETHIOPIAN RESTAURANT - DAY

B. and Shiro sit in a booth at an Ethiopian restaurant, waiting for their food to arrive.

> B.
> . . . I don't get it either! She was all dressed and done up as though she expected to be on camera and then she said no?

> SHIRO
> Yeah. Maybe she imagined that she would say no, and then you would beg her to let you film her, and then she would reluctantly agree, which would seem more dignified than giving an easy yes.

B. throws up her hands in frustration.

> B.
> You're supposed to tell me this kind
> of thing!

> SHIRO
> Well, how am I supposed to know? It's
> your project. I was waiting for you
> to do something!

> B.
> But I didn't understand what she was
> saying! How am I supposed to know
> what the hell is going on unless you
> tell me?!

> SHIRO
> Sorry.

> B.
> It's done now. We can't go back
> there, can we?

Shiro shakes his head. They sit in silence for
a moment, then Shiro turns to his notes.

> SHIRO
> O.K., first question: How did
> Takako make her living? Let's see,
> Takako worked at a travel agency.
> It was just up the street, a counter
> inside Don Quijote's. But then the
> travel agency went bankrupt, and she
> was out of work and couldn't find
> another job. Remember, the landlord
> brought out that stack of letters
> from Takako, apologizing for not
> being able to pay the rent?

> B.
> Wait, so Takako was a travel agent at
> a place called Don Quijote's?

> SHIRO
> Yeah, it's up the street.

> B.
> It's called Don Quijote's?

 SHIRO
 Yeah.

 B.
 Can we go there?

 SHIRO
 Another day. I gotta get home after
 this.

 B.
 O.K.

 SHIRO
 (returns to his notes)
 Takako couldn't find a job, so the
 landlord said she thought Takako's
 parents were paying her rent. And
 then they came and got her and took
 her home.

B. nods.

 SHIRO
 O.K., second question you ask is
 how long she lived there. Answer:
 about three years. After she lost
 her job, she went back to Kagawa for
 a month -- that's where she's from --
 but she didn't like it, so she came
 back to Tokyo. Her old apartment was
 still available, so the landlord let
 her move back in. She said she gave
 Takako an old washing machine and
 stove and that she saw Takako out on
 the balcony scrubbing them until they
 looked like new. She said Takako was
 impeccably clean.

 B.
 Kagawa, where's that?

 SHIRO
 Right, the landlord gave me her
 parents' address. Actually it's in
 Tokushima, not Kagawa. Anyway, both
 are west of Tokyo, on Shikoku.

Shiro pauses and looks at B.

> SHIRO
> There are four main islands in Japan:
> there's Hokkaido to the north, then
> Honshu is the main island. Tokyo,
> Kyoto, Osaka, Kobe, and Hiroshima
> are all on Honshu. To the south and
> west, the smallest of the four main
> islands is Shikoku. That's where
> Takako was from. And then Kyushu is
> the island furthest to the west.
> There are lots of smaller islands,
> more than six thousand of them, but
> those four big islands make up most
> of Japan.

> B.
> I should know that.

Shiro looks at B. and decides not to comment.

> SHIRO
> Third question: What was her
> apartment like? She said it was a
> typical six-tatami apartment --
> that's like a small efficiency -- and
> that it was sparse, with only the bare
> necessities: TV, computer, stereo,
> bed. Here, you ask something like:
> what was she like, did she have any
> hobbies, to please describe Takako
> in her own words. The landlord said
> that when she first came to Tokyo,
> Takako was a nice girl. Very polite,
> very quiet, she came home early, kept
> to herself. She wasn't very social,
> didn't have a lot of friends. She was
> pretty, but she always wore jeans
> and tennis shoes, no makeup. She
> liked music. Yumi Matsutoya was her
> favorite. Then she says something
> about Takako maybe falling in love
> with some American guy? And that it
> didn't go well?

B.
Where did she get that information
from?

SHIRO
I don't know.

B.
I've heard about this romance from
other sources. A reporter from the
BBC tells everyone the same story
about Takako's failed romance with
an American guy.

SHIRO
(nods)
She said he was here.

B.
I'm sure he told the landlord the
same story.

While B. is talking, the food arrives. Shiro
looks at it.

B.
You use the bread like chopsticks.

B. demonstrates, tearing off a piece of injera
and using it to pick up some lentils.

B.
Yeah?

Shiro nods and starts to eat.

SHIRO
O.K., she says that after Takako came
back from Kagawa, she was different.
She was doing a lot of drugs --
well, "taking a lot of medicine,"
that's what the landlord said. She
kept the curtains closed, seemed
to be sleeping a lot, and spending
all her time on the internet. She
gained a lot of weight and her face
bloated up, "probably because of the
medicine," the landlord said.
(MORE)

169

 SHIRO (CONT'D)
She started having accidents. She
could never find her keys, she
fell down the stairs a lot, she was
covered in scars. The landlord said
she called the ambulance three times
and that the third time Takako stayed
in the hospital for a while. That's
when the landlord called Takako's
parents and said they needed to come
get her. Her father came and talked
to Takako, and she agreed to go home
at the end of October. The landlord
said she talked to Takako's father
after that, and he said Takako was
eating only Domino's pizza -- that's
random -- and that she'd be coming
to live with them at the end of
October. The landlord said Takako
packed everything and came to say
good-bye to her on October 30. At
that time, Takako said she was going
to the countryside, and the landlord
assumed that meant she was going to
her parents' house in Tokushima. But
she never showed up there. Takako's
father called in early November to
ask if the landlord knew where she
was. And then later, her father
called to say Takako was dead. He
said he was glad Takako hadn't died
in the apartment.

 B.
Wow, that's intense.

 SHIRO
 Yeah.

Both of them stop eating and lean back, taking
that in.

INT. KITCHEN IN OLD HOUSE - NIGHT

B. sits at the kitchen table in her house,
drinking a beer and staring at a blank page.
She writes --

INSERT - NOTEBOOK

Which reads:

> "The more I know about her, the less I
> understand. I know only that she was
> looking for something, but she never
> knew what."

EXT. STREET IN SHINJUKU NEAR DON QUIJOTE'S - DAY

A couple of days after the interview, B.
returns to Shinjuku to find the Don Quijote's
where Takako worked. It's on a corner just
a few blocks from her apartment, with a red
awning, a blinking yellow neon sign, and a
baffling array of brightly colored merchandise
that spills onto the sidewalk.

INT. DON QUIJOTE'S - DAY (CONTINUOUS ACTION)

Inside, the store is packed floor to ceil-
ing with chintz: costumes, stuffed animals,
vibrators, cosmetics. Large signs advertise
discounts. There is no visible reference to
Cervantes's Don Quixote, nor does it seem pos-
sible that a travel agency had been there. It's
like a kitschy ninety-nine-cents store.

B. wanders through cluttered aisles of loud,
sparkly things, staring at the people who work
there. She feels like she should ask some-
body a question, but she's afraid no one will
speak English. She leaves without talking to
anyone.

EXT. BUSINESS DISTRICT NEAR EBISU STATION - DAY

That same day, B. takes the train to Ebisu
Station to find the Morgan Stanley office
where, according to Takako's parents, the
alleged Douglas worked. She arrives at a tall,
modern building overlooking a central court-
yard filled with shops and modern sculptures.
B. follows a series of raised walkways to the
office.

INT. MORGAN STANLEY BUSINESS OFFICE - DAY
(CONTINUOUS ACTION)

B. approaches the RECEPTIONIST sitting at a
desk in front of the entrance to Morgan Stanley
offices.

> RECEPTIONIST
> Hello. How can I help you?

> B.
> Hi. I'm doing some research for a
> short piece about a Japanese woman
> who I've been told was friends with
> someone that worked here in two
> thousand. His name is Douglas -- I'm
> not sure if that's a first name or
> last -- but would it be possible to
> look at your records to see if he
> worked here?

The receptionist does some typing on her com-
puter and then excuses herself.

> RECEPTIONIST
> One moment, please.

She goes through the door to the main office
and returns a moment later with a NEW WOMAN.

> NEW WOMAN
> Excuse me, could you explain again
> what you are looking for?

> B.
> Yes. Sorry. I'm writing a short
> story based on a true story about a
> Japanese woman who lived in Tokyo.
> Her parents told me she was friends
> with an American man named Douglas
> who worked here. I'm just wondering
> if you could verify that. I don't
> know if Douglas is a first name or a
> last name, but he worked here in two
> thousand.

The new woman does some more typing, then both
women shake their heads.

NEW WOMAN
Sorry, there is no one named Douglas,
first name or last, listed in the
employee database.

B. stands there silently for a while. Either
these women are mistaken, or they're not tell-
ing her the truth, but B. has no way to insist
and nothing else to ask.

B.
O.K. Thanks so much for your help.

B. turns and leaves.

Afterward, B. sits in the courtyard of the office building, people watching, imagining Takako and Douglas meeting surreptitiously in one of the cafés, and trying to process the day's discoveries or lack thereof: she cannot confirm that Takako had a boyfriend who worked at Morgan Stanley, and it doesn't seem that she worked at a travel agency in Don Quijote's either. Everything seems to be getting murkier. Maybe Takako's parents and her landlord really didn't know anything about her. After all, that's what her parents said over and over to the cops in Minnesota—that they didn't know, that they were estranged. So what was really happening with Takako? In the absence of information, B.'s mind goes blank.

In 2003, the *Guardian* ran an article about black market borrowing in Japan. It said that in the first six months of that year more than 166,000 Japanese people—experts believe the real number could be closer to a million—had borrowed money from yakuza (members of organized crime syndicates) and loan sharks who often misrepresented the terms of their loans and sometimes charged more than 100 percent interest. Since many people couldn't pay back the initial loan, they ended up in a cycle of borrowing from one yakuza to pay another, increasing their debt exponentially. Loan sharks, and even some banks, endlessly harassed people and their families. Since life insurance policies in Japan pay out on suicides, some ended up killing themselves to pay off their debt. They saw no other way out.[2]

The landlord said she didn't know how Takako paid her rent after Don Quijote's closed its travel agency. She said she assumed Takako's parents were paying the rent, but maybe Takako borrowed money from yakuza, and the scars and bruises her landlord described, even her eventual suicide, were the result.

Takako's landlord didn't talk about this, but it's significant that Takako was twenty-eight years old when she died. There are plenty of jobs for youthful Japanese women to work as "office ladies," bringing tea and running errands, or in customer service, calling out to customers on the street—"Irasshaimase!" These low-paying, non-career-track jobs aren't meant to provide a living wage; they're simply a way for a woman to earn some pocket change until she gets married. It's assumed that, once married, a woman will quit her job to have children, since it's a full-time job to run a household, raise kids, and get them through school.[3]

Women who work in the sex industry, however, can make enough money to support themselves. It's an important safety net for many Japanese women who otherwise struggle to make ends meet with low-paying part-time and temporary jobs.[4] Many women purchase "alibis" from a service: the names and phone numbers of fake employers for them to give to their parents and landlords.[5] That way, they don't have to face anyone's judgment for working at a club, giving blow jobs while dressed as a nurse or travel agent or stuffed panda.

When Takako told her landlord she worked at the Don Quijote's travel agency, was it a cover?

Prior to 2001—the year Takako died—mental illness, including depression, was thought of as a rare condition in Japan and was hugely stigmatized. Outpatient treatment and the use of SSRIs were uncommon. Instead, most people with mental health issues were either untreated or hospitalized and given strong sedatives like benzodiazepines and barbiturates—the types of medications found in Takako's system during her autopsy.

In 2001, pharmaceutical companies introduced SSRIs to Japan and started a marketing campaign aimed at changing perceptions of depression and mental illness.[6] And things did start to change.

But the campaign and the changing attitudes focused on men—overworked salarymen who were burning out and committing suicide in epidemic proportions. Women were thought to suffer from a different category of depression, often classified with another name, such as "immature-type depression." It was taken less seriously and treated differently by psychiatrists.[7] It seems quite possible, in fact likely, that if Takako were suffering from anxiety or depression in 2001, she would have received treatment that involved a month or more in a hospital and medication that sedated her so much that her ability to function was compromised, that she fell down stairs and slept all day, as the landlady said she did after her "month away in the countryside." A euphemism for the psychiatric ward?

In light of this information, Berczeller's story about Takako—that she wanted to die in a place where she'd once been happy with her lover—feels even more unsatisfactory, like a lie that people repeat to avoid a darker, more difficult truth.

A psychiatrist named Anna Fels published an opinion piece titled "Great Betrayals" in the *New York Times*. A friend of hers had caught her husband in a long-term lie. In witnessing the aftermath of her friend's discovery, Fels had an insight about betrayal: the effect on the betrayed is more profound and difficult to deal with than the effect on the betrayer. Fels writes that, though the wrongdoer might suffer guilt, shame, and self-contempt, "they have the possibility of change going forward, and their sense of their own narrative, problematic though it may be, is intact. . . . But for the people who have been lied to, something more pervasive and disturbing occurs. . . . Insidiously, the new information disrupts their sense of their own past, undermining the veracity of their personal history."[8]

If Takako did go to Fargo to relive a moment from her affair with Douglas, perhaps it was because of that kind of pervasive, unshakeable doubt. Perhaps she wanted to circle back and sift through the wreckage of the past, reclaim her story, find a way back to her own life, a life that felt real.

In the courtyard outside Morgan Stanley, B. loops back to the feeling she got when she first read Takako's story and felt she knew intuitively what she was searching for: a way back into her own story. This feeling is like a North Star.

The Japanese novel *Snow Country*, by Yasunari Kawabata, tells the story of Komako, a geisha from a poor rural family who falls in love with her first client, a wealthy Tokyo dilettante. They have a tender, intimate connection at first, but the dilettante is married, and after a time, he begins to lose interest in Komako, favoring another woman in the village. As she gets older and her health begins to suffer from the excesses of geisha life, Komako stays attached to the dilettante, often sacrificing her dignity and real-life relationships to spend a few fleeting moments with him.

The French film *The Dreamlife of Angels* is a contemporary story in a similar vein. A young factory seamstress named Marie meets a rich boy who bails her out when she's caught shoplifting. He seems interested in her at first: he comes to her apartment to have sex with her, or they meet in out-of-the-way places; they even go on a trip to a beach house out of town. Marie distances herself from her friends and her old life. When the boy tires of her, she throws herself out a window.

The story of a woman from the lower class who has no hope of attaining a better life for herself until she captures the imagination of a wealthy ne'er-do-well is pervasive. The woman falls in love with the man, but after a time, he loses interest in her. The man goes on with his life, having lost nothing, but she is ruined.

Most of the time, women don't write this story. B. doesn't want to write this story, and that's one reason why, after her trip to Fargo, she set aside the film about Takako and started to work on something else. But here it is again—the possibility that this is Takako's story, at least in part. B. wants to understand why someone walks away from her own life. Maybe unrequited love and the trappings of class are one possible answer.

She tries to imagine the first scenes of this film.

FADE IN:

INT. TOKYO HOSTESS CLUB - NIGHT

DOUGLAS, a dilettante in his midthirties with
greasy black hair, thick glasses, and tanned
skin, sits with his coworkers and a group of
hostesses on a circular couch around a low cen-
tral table. Takako is among the hostesses; she
hangs back and watches the other women care-
fully, trying to follow their lead as they pour
drinks, light cigarettes, listen attentively
to everything that's said, and laugh at the
right moments.

One of the women, a BLONDE with a large afro,
brings a microphone to the group and flirt-
ingly hands it to the BOSS, a balding man in
his midfifties, dressed in a dark, expensive-
looking suit, encouraging him to sing a song.
The Boss tries to refuse, but the hostess
insists.

 BLONDE
 You must get us started. The fate of
 the evening is in your hands.

The Boss concedes and takes the microphone.
Everyone listens appreciatively as he SINGS
a heartfelt rendition of "We've Only Just
Begun" by the Carpenters.

During the song, the hostesses and stock
brokers pair off, leaving Douglas, Takako, and
the woman with the blond afro sitting alone.
The Blonde sits at the Boss's side, listening
attentively to his song.

Douglas and Takako awkwardly turn their atten-
tion to a large screen playing the 1982 movie
Cat People, closed-captioned. Takako gets up
and moves next to Douglas. Douglas turns to
look at Takako and smiles.

 DOUGLAS
 The original was good, but the best
 thing about this version is the
 theme song.

Takako nods and smiles at Douglas.

> DOUGLAS
> Bowie.

Takako nods and smiles, and then a look of recognition comes over her face.

> TAKAKO
> Bowie. Ah sokka -- David Bowie.
> I like.

> DOUGLAS
> Right.

He turns his attention back to the film. Takako holds up a bottle of whiskey.

> TAKAKO
> Suntory?

> DOUGLAS
> No, thanks.

They both turn to watch the film; the silence between them becomes awkward.

> TAKAKO
> I'm sorry. English, very little.

> DOUGLAS
> That's O.K.

> TAKAKO
> (in Japanese, rushed, as if
> suddenly thinking of something)
> I'll be right back.

Takako gets up and rushes across the bar.

Douglas waits uncomfortably among his coworkers, who are flirting with the hostesses. A moment later, Takako returns holding something that looks like a calculator.

> TAKAKO
> You, English. Here. I. Japanese.
> O.K.?

Takako hands Douglas the translator. He takes it and types something in English.

Takako reads the Japanese translation.

> TAKAKO
> (in Japanese)
> Do you like movies? Ah . . .
> (in English)
> Yes, I do.

Douglas takes the translator back from Takako and types a few more words.

> TAKAKO
> (in Japanese)
> What's your favorite movie?
> (in English)
> How in English?

> DOUGLAS
> Favorite movie.

> TAKAKO
> Favorite movie, desuka. Maybe I like
> Dancer in the Dark.

> DOUGLAS
> Really? Von Trier is such a
> misogynist.

Takako points to the translator.

> TAKAKO
> Sorry.

Douglas types into the translator and hands it to Takako.

> TAKAKO
> Ah sokka. Why. I like Björk.

Douglas nods.

> TAKAKO
> You. Favorite movie.

```
                    DOUGLAS
          Fargo, or maybe The Big Lebowski.
          Coen brothers. You ever seen their
          movies?

     Takako points to the translator.

                    TAKAKO
          Sorry.

                    DOUGLAS
          Fargo. Steve Buscemi. You know?

                    TAKAKO
          Ah, yes. Fargo. Steve Buscemi. I
          know, I know. I like.

     Takako takes the translator and starts to type
     another question.
```

Douglas and Takako start seeing each other secretly. They go to
dark, out-of-the-way places where they're unlikely to see anyone
they know. Once, they run into each other in a bar and pretend to
be strangers. The secrecy of the relationship makes it seem intimate,
something just between the two of them.

One day, Douglas visits Takako at her apartment. They spend the
day walking around the city; they visit a record store and a coffee
shop. While they're talking over coffee, Douglas reaches out and puts
his hand on Takako's leg for a moment. Everything stops.

After dark, they go into the Hustler store. They walk through
the aisles nonchalantly. At various moments, one of them points to
something exceptionally odd or funny, and they laugh silently, their
bodies quivering.

FADE IN:

INT. INDIAN RESTAURANT UNDERNEATH METRO
LINE - DAY

Douglas and Takako sit at the window of an
Indian restaurant, doing their best to eat a
large dosa with dignity. Takako tries with a
knife and fork.

> DOUGLAS
> (suddenly serious)
> I have something I need to tell you.

> TAKAKO
> O.K.

Douglas picks the translator up from the table
and types something into it. Takako reads it
out loud.

> TAKAKO
> (in Japanese)
> I am married.

Takako is silent for a moment.

> TAKAKO
> (in English)
> Ah. You are married.

Takako sets down the knife and fork, suddenly
not hungry. She puts the electronic translator
into her pocket and stares silently in front of
her, feeling a bit sick.

Douglas starts to stand up.

> DOUGLAS
> Should we go?

Takako nods and they leave the restaurant.

EXT. TOKYO STREET - DAY (CONTINUOUS ACTION)

Douglas and Takako walk down the street
together. They reach a corner and pause.

TAKAKO
My train.

She points in a direction, waves a tentative good-bye to Douglas, and walks toward her train.

Douglas follows her.

INT. SUBWAY STATION PLATFORM - DAY

Douglas boards the train and takes a seat behind Takako.

EXT. STAIRCASE TO TAKAKO'S APARTMENT - DAY

Douglas follows Takako as she mounts the staircase to her apartment. He follows her inside.

INT. TAKAKO'S APARTMENT - DAY (CONTINUOUS ACTION)

Douglas closes the front door behind him and walks toward the bathroom.

DOUGLAS
Just a minute.

Douglas rifles through the bottles in Takako's medicine cabinet. He finds and pockets a bottle of pills.

Walking back into the main room, Douglas approaches Takako. She takes a few steps backward and leans against the kitchen counter. Douglas leans his body into her. Takako turns away. Douglas takes a step back and looks into her eyes.

DOUGLAS
You O.K.?

Takako's body softens. She looks at Douglas and nods. Douglas takes Takako's hand and pulls her toward him.

Jana Larson

 DOUGLAS
 Come on.

She follows.

 FADE OUT.

After that day, Takako doesn't speak to Douglas for several months. She takes long walks through Shinjuku Gyoen, Kabukichō, and Yoyogi Park in Harajuku. She hopes people watching will soften the edge of her isolation, but everything feels empty and distant. People look tiny, surrounded by empty space. Their presence only makes the world feel emptier and more surreal.

FADE IN:

EXT. TOKYO PARK - DAY

One day, Takako sits down on a park bench and takes out her cell phone. She dials a number. After a few RINGS, Douglas's voice comes through, along with a CROWD OF PEOPLE LAUGHING in the background.

 DOUGLAS (O.S.)
 Moshi moshi. Ha! Don't make me come
 over there! Just a minute. Hello?

 TAKAKO
 (with forced cheeriness)
 Hello!

Takako takes a piece of paper out of her pocket. On it, she's written down some of the things she might say to him, but now, hearing his voice, scanning the list, nothing seems appropriate.

 DOUGLAS (O.S.)
 You there?

```
                    TAKAKO
         Yes. I'm sorry.
              [long silence]
         Good-bye. O.K.?

                    DOUGLAS (O.S.)
         O.K.
```

Takako continues to hold the phone to her ear
after Douglas hangs up. When a LOUD BEEPING
TONE comes over the line, she pulls the phone
away from her ear and presses the button to end
the call. The silence seems final.

```
                                   FADE OUT.
```

B. spends most of January wandering around Tokyo in the freezing
wind, without money, looking for a job. At first she has every confi-
dence she'll find one, but after several weeks of trying, she's had only
a few interviews and one offer, for a very low-paying job she doesn't
want, teaching English to kids an hour outside of Tokyo, in Chiba.
Then, toward the end of January, she gets an interview at one of the
big language schools in Japan.

```
FADE IN:

EXT. TOKYO BUSINESS DISTRICT - DAY

B. arrives outside the nondescript office
building on time, possibly early, wearing wool
trousers and a suit coat. She checks her hair
in the reflection of the glass door, arranges
her clothes, and goes inside.

INT. OFFICE BUILDING - DAY

B. takes the elevator to an upper floor.

The door opens onto a sea of tinted-glass
cubicles where people sit in front of comput-
ers, wearing headsets and TALKING ON THE PHONE.
```

As she enters, the HUMMING VOICES FALL QUIET, heads turn to look, and SEVERAL PEOPLE stand up quickly, looking embarrassed.

> SEVERAL PEOPLE
> Ohayo gozaima-a-a-s-u!

It occurs to B. that one of these people called her to set up the interview, and that seems strange, like she's seeing behind the curtain. This all happens in one expanded moment, then she's ushered quickly toward a conference room.

INT. CONFERENCE ROOM - DAY (CONTINUOUS ACTION)

STAN, a small, overweight man in his thirties, with manicured fingernails and permed hair, invites B. to sit down opposite him at the long table. John, an American man in his late twenties, wearing a suit and tie, sits next to Stan.

> STAN
> Hi. I'm Stan. This is John. He'll be observing the interview.

Stan motions towards John. B. waves hello.

> B.
> Hi, John.

> STAN
> It says here you are in a master's program in San Diego? And that you were teaching there?

B. is distracted, scanning Stan's face, trying to put her finger on what makes him look like an alien. She nods.

> B.
> Yes, I was teaching filmmaking as a graduate student, and then I was hired as an adjunct to teach English Composition, the required class for incoming freshmen.

B. decides that something about Stan is too
shiny; glossy as opposed to matte.

> STAN
> And you have experience teaching
> English as a second language?

B. nods.

> B.
> Yes, I lived in Spain and taught
> English there for a year. I studied
> for the TEFL certificate at the
> Cambridge School in Lisbon.

B. feels like the interview is going well. She
is composed and, she thinks, charming enough.

EXT. STREET IN TOKYO - DAY

The next day, as B. is walking on one of the
streets in Shinjuku, her PHONE RINGS.

> B.
> (talking into the phone)
> Moshi moshi.
> (pause)
> This is.
> (pause)
> I see. O.K. Thanks for letting me
> know.

B. hangs up the phone. She has suspected for
a while that she is putting off the wrong sig-
nals, that maybe things that work for her in
the U.S. don't work in Japan, but this call,
letting her know that she didn't get the job,
confirms it.

B. takes her notebook out of her bag and pulls
a copy of her resume out to look at it. She
flips through the pages of her notebook until
she finds the number she's looking for. She
enters it into her phone.

> B.
> (talking into the phone)
> Hi. May I speak with Stan, please?

 (pause)
 Hi Stan, we met yesterday for an
 interview . . .
 (pause)
 Yes, I'm hoping you'd be willing
 to share with me how you came to
 the decision not to hire me for the
 position. I'm looking at my resume,
 and I think my qualifications are
 pretty good. I'd appreciate any
 feedback you might have that would
 help me understand, to perform
 better at the next interview.
 (pause)
 Hello?

B. hangs up the phone and puts it back into her
pocket. Stan hanging up on her does nothing for
what's left of her confidence.

B. walks the streets of Shinjuku, pushed along by a certain kind of
restless hopelessness. The feeling she had on arrival, a kind of swim-
ming disorientation she attributed to exhaustion, has yet to go away.
She can find nothing solid, no vantage point from which to construct
a narrative that will hold up against the fluid pressure of experience.
Her body feels strange—gangly, large, unruly, amorphous. She feels
like a monster, adrift, alien.

INT. STARBUCKS - DAY

B. goes into the Starbucks in Shinjuku, orders
a coffee and takes a seat at a small table.

A woman with peroxide-orange hair, waiting at
the counter for coffee, catches her attention.
The woman is wearing thick pancake makeup, a
white fur coat and fur handbag, a light pink
dress, and shiny, black open-toed heels that
are much too big, so her toes, in their tan
nylon stockings, slide out the front, and
there's a gap of several inches in the heel.

The woman gets her coffee and moves away from
the counter, looking around for a place to
sit. She rolls her weight to the outside of her
feet strangely as she scans the room. Her gaze
falls on the chair opposite B. She shuffles
toward her as if she wants to share the table;
she stops in front of B. and opens her mouth,
but then she closes it and totters over to the
counter facing the street.

B. turns to watch as she sits down, heavy with
exhaustion. Almost immediately, the woman's
PHONE STARTS BUZZING and she is swept into
responding to messages and writing appoint-
ments in a small datebook. After a time, she
leaves her unfinished coffee and rushes off.

B. writes in her notebook --

INSERT - NOTEBOOK

Which reads:

> "If I were a prostitute in Shinjuku, it
> would be too much to even think about
> the meaning of my existence. The only
> thing that would matter is what other
> people thought I was worth. That would
> be my value."

FADE OUT.

B. starts to think the information the landlord gave her is all she's going to learn about Takako in Tokyo. This probably isn't true—she could probably have convinced Yuuko's friend Shiro to go with her to Don Quijote's to talk to some of the people there, and that might have helped her connect with some of Takako's friends. Maybe they would have known something about Douglas. She also could have tried going to the address in Yokohama where the landlord said Takako had lived before moving to Tokyo, asking questions about her there. And these two leads might have generated more. But after the difficulty of accomplishing the interview with the landlord—something that, on the face of it, seemed so easy—doing anything else feels enormously challenging in B.'s mind. She just wants to get out of Tokyo.

She decides it might be easier to connect with people in a quaint rural area. She starts to look for work on Shikoku, the island where Takako grew up. She thinks maybe she'll find Takako's parents, or others who knew Takako when she was young. She might finally glean some information about who she was, what she wanted, if not in Fargo, then at least in her life up to that point.

FADE IN:

INT. TOKYO STATION - DAY

A few days later, B. stands in the center of Tokyo Station. She has arranged an interview with MICHAEL GRENHAM, the owner of a language school in Takamatsu, a port city on Shikoku. B. wonders how she will ever find him in such a busy place but, right on time, an older man in a dark suit and overcoat approaches her. He's a fast-talking Kiwi in his sixties.

 GRENHAM
 Hello. Michael Grenham. Thanks for
 coming out here to meet with me.

B. and Grenham shake hands.

 GRENHAM
 I thought we could just head over
 there and have a quick chat.

B. follows him to an out-of-the-way area where there are tables and chairs.

 GRENHAM
 So, what brings you to Tokyo? Did you
 come here looking to teach?

 B.
 Actually, I came here to visit a
 friend. And now that I'm in Japan,
 I'd like to stay, and teach for
 a while, and do some research in
 Kagawa for a project. . . .

GRENHAM
Ah, yes. I came here twenty-five
years ago to sail. I think you'll
find that the inland sea is an
interesting place, lots of small
islands. . . .

During the interview, Grenham does most of the talking. B. learns that he is married to a Japanese woman, and spends a lot of time on his yacht. They talk for about fifteen minutes, and then he offers B. the job. She asks if she can have a day to think about it. He nods, apologizes for being in a rush, and runs back into the station to catch another train. B. wonders if he was in Tokyo for other business, or if he'd taken the train just to meet her.

That night, B. goes to see some friends from San Diego who are in town to play a rock show at a small club. At the show, she considers whether or not to leave Tokyo. She reviews her impressions from the month she's spent there—bleak, cold days; the bitter wind on her face; the light, thin and gray; always feeling cold and hungry; sometimes walking for hours to find restaurants—under streetcar lines, on winding back streets—listed as vegan-friendly in *Lonely Planet Tokyo*.

She considers leaving Japan all together, but something holds her there.

In his performance piece *Swimming to Cambodia,* Spalding Gray talks about being unable to leave Thailand until he had what he called "the perfect moment." He had just finished shooting *The Killing Fields* and felt like he hadn't experienced something essential. So he floated around the country for a while, headed to the beach, smoked some pot, and waited. He didn't know what he was looking for. He only knew he felt incomplete; he hadn't yet done what needed to be done. And then, one day, swimming out beyond the break in the Indian Ocean, out further in the ocean than he'd ever been before, it did happen. He explains the moment:

[The shore] was so far away I felt this enormous disconnection from Mother Earth. Suddenly there was no time and there was no fear. . . . It was just one big ocean. My body had blended with the ocean. And there was just this round, smiling ear-to-ear pumpkin head perceiver on top, bobbing up and down. And up the perceiver would go up with the waves, then down it would go, and it could have been in the middle of the Indian Ocean, because it could see no land. And then the waves would take the perceiver up to where it could look down this great wall of water. . . . I don't know how long this went on. It was all very out of time.

B. doesn't know if she would call whatever she's looking for a perfect moment. She has an image in her mind—something like a doorway, a hole from this world to another, like the mirrors in Cocteau's *Orphée*. She'll know it when she sees it; she'll feel something like "ah, yes, this," and because of that, she'll know that it's time for her to leave. Until then, she thinks maybe she should keep moving. That's the only way to find it, whatever it is.

After the show, she and her friends stay out all night with a couple of young, trendy Tokyoites who take them to restaurants and bars and karaoke. B. gets home around 8 a.m. and sleeps for most of the day, missing a few other job interviews and letting the decision make itself. When she gets up, she calls Michael Grenham and accepts the job in Kagawa. They agree she'll start in two weeks.

That night she goes to a party at the apartment of one of Yuuko's friends. Everyone's very nice, but there's very little English spoken at the party, so B. stands around smiling for a while, then takes the train back to her place.

B. leaves Tokyo on January 31. She stays until the last possible day, not because there is anything for her there, but because she has paid rent through the end of the month, and even if the accommodations are cold and uncomfortable and lonely, she is living on credit cards, literally borrowing time in Japan. These days count.

On her way to her new job in Takamatsu, B. stops in Kyoto to see a friend, Owen, who is in Kyoto for six months on a Japan–U.S. Friendship Fellowship.

FADE IN:

EXT. KYOTO STATION - DAY

B. stands at the entrance to Kyoto Station, watching the crowds walking out of the station and on the surrounding streets. She notices that many of the women seem to be wearing high-heeled black boots and walking in a pigeon-toed shuffle, taking tiny steps, their arms dangling loosely at their sides. B. thinks it makes them look a bit puppetlike. She finds herself staring, mesmerized.

She doesn't wait long before OWEN rounds the corner, pushing his bicycle, out of breath. Owen is tall and skinny, with blond, curly hair and sparkly blue eyes. As usual, he's wearing all white, with a tan puffy coat and a giant smile. B. relaxes immediately upon seeing him: a friend. Owen gives B. a giant hug.

> OWEN
> Oh my god. Look at your suitcase!

> B.
> I know, I know. I brought all my
> video gear. It's super heavy.

> OWEN
> I had this crazy idea I'd give you a
> ride on my bike. That's O.K., we'll
> walk.

B. follows behind Owen as they navigate the sidewalks of a modern urban area, then turn down a narrow street into a neighborhood with traditional wooden houses and lovely rusted signs.

Owen lives behind one of the old wooden houses, through a small courtyard and up a flight of rickety stairs.

INT. OWEN'S APARTMENT - DAY (CONTINUOUS ACTION)

Owen's one-room apartment has the cool efficiency you would find in an airplane or boat: there's a small futon on the floor, and a low table; the bathroom is made from a single piece of molded plastic that forms a sink, shower, and toilet. They drop off B.'s suitcase and go back out to find something to eat.

EXT. KYOTO STREET - LATE AFTERNOON

B. points to a woman walking in the strange puppet shuffle she noticed at the train station.

> B.
> What's up with that?

Owen LAUGHS.

> OWEN
> It's supposed to be cute.

> B.
> No way.

Owen LAUGHS again.

> OWEN
> I know, it's not really my thing.
> Although, I've been here so long
> that things that weren't really
> my thing are starting to become
> more . . . attractive, I guess.

Owen and B. were friends during graduate school. From the moment Owen arrived in San Diego he seemed to understand he was there to build an art career, and that if he wanted to do that, he had to meet all the right people and get all the right grants and fellowships. He was good at it. B., in comparison, was a mess, full of doubt, getting everything wrong. They're both in Japan, but that's where their similarities end. He is there on a fellowship, fully connected and supported,

studying Japanese aesthetic forms, giving talks at universities, and meeting other scholars and academics. B. is winging it through Japan, without any connections or cash, looking for information about a dead woman, or a gateway to another world.

They eat dinner at a vegan restaurant not far from Owen's house. It's clearly for foreigners and expats, complete with a shelf of Lonely Planet guidebooks. That night, B. pushes Owen's laundry into a corner and sleeps on top of it, underneath Owen's puffy down coat.

EXT. TRAIL UP MOUNT DAIMONJI - DAY

The next morning, Owen takes B. on a hike up Mount Daimonji to visit a temple called Nanzen-ji. It's cold and windy hiking up the mountain, and B.'s wool coat and sweater aren't adequate. Still, it is lovely, with small shrines dotting the path. B. delights in the small Buddhas on the shrines, each surrounded by flowers and incense, wearing tiny knitted caps and sweaters.

On their hike down, it starts to snow. B.'s teeth start to chatter, so they run back into town.

INT. BAR - NIGHT

Later that night, they meet up with two of Owen's friends at a bar. Both of them are artists, and both are paid to look after Owen during his fellowship.

EXT. BAR - NIGHT

B. and Owen leave the bar and walk down the street together.

 B.
I can't believe you even have people who are paid to be your friends while you're here.

 OWEN
 I know. I don't know what I would do
 without them. It's weird; I've never
 felt so isolated before. Sometimes,
 sitting alone in that little
 apartment -- it's surreal.

EXT./INT. BUS THROUGH MOUNTAINS - DAY

The next day, B. and Owen take a bus through
the countryside. Outside the bus window, the
farm fields and wooden buildings are covered
in snow.

EXT. OHARA VILLAGE - DAY

B. and Owen walk through the narrow, winding
streets of a small rural village in the moun-
tains, lined with traditional wooden-frame
buildings and old temples.

 B.
 I think this might be the most
 beautiful place I've ever seen.

INT. TATAMI VIEWING PLATFORM, HOSEN-IN GARDEN -
DAY

Owen and B. sit in a large screened-in plat-
form, with a tatami floor and timber columns,
in front of an elaborate Japanese garden
with rocks, streams, and ancient, twisted
pines, their large branches resting on wooden
supports.

A woman dressed in kimono brings them matcha
tea and mochi filled with sweet bean paste.

B. takes a sip of tea. She watches her breath
hang in the air and the steam rise from
the cup.

 OWEN
 Careful, this tea is like crack
 cocaine. Just a few sips or you'll
 be sorry.

B. looks out at the garden.

 B.
 This is amazing.

 OWEN
 Yeah, it's considered a minor
 temple, but I think it's my
 favorite. It's one of the few places
 where the garden is maybe even more
 spectacular in the winter.

 B. nods and takes another sip of tea.

 OWEN
 It's also a good example of a
 garden that, like so many here,
 isn't meant to be walked through
 but viewed from a specific vantage
 point. Even within this room,
 there's an optimal place to sit for
 viewing the garden, and the people
 with the highest rank traditionally
 sit there. Radiating outward from
 that spot, the quality of the view,
 and the social standing of the
 viewers, drops off.

 Owen and B. stand up and start to experiment,
 walking around and comparing the view from
 different places in the room.

B. enjoys being in Kyoto with Owen. He's teaching B. about Japanese culture by teaching her how to look at art, explaining how Japanese aesthetic forms—the temples, the architecture, the gardens—are representations of cultural forms. Owen says that even though the viewing platform is no longer used formally in the way he describes, when a group of Japanese people sit together, they arrange themselves in a way that reflects the social hierarchy. To B., this makes Japanese culture sound like the military: every gesture and interaction is formal, constantly referring to and reinforcing the social structure in which the participants are enmeshed.

EXT. NARA, JAPAN - DAY

The next day, B. and Owen go to Nara, the
eighth-century capital of Japan. They stand
in the courtyard in front of a large wooden
temple, Todai-ji, which houses Daibutsu, the
largest bronze statue of the Buddha in the
world. Small tame deer with clipped antlers
roam about, begging for the deer crackers sold
at souvenir stands dotting the grounds.

> OWEN
> You could buy some crackers to
> feed the deer, if you want. They are
> supposedly the messengers of God.
> I don't really understand what that
> means, though.

> B.
> Yeah, what is "God" in Buddhism?
> Nature?

> OWEN
> Possibly, since Japanese Buddhism
> is connected to Shinto, which is
> basically the worship -- for lack of a
> better term -- of ancestors, spirits,
> and an animating force that exists
> inside of all things. That force is
> good; it's called kami. There is an
> evil force, too, caused by demons
> and evil spirits. Basically, my
> understanding is that Shinto is about
> cultivating the good spirits and
> chasing away the evil ones. The deer
> must be the embodiment of the good.

Owen and B. move closer to a Japanese family in
order to watch the two young children feeding a
deer some crackers. The deer is very gentle.

EXT. YOSHIDA-JINJA SHRINE - LATE AFTERNOON

Later they visit Yoshida-jinja, a large Shinto
shrine, for Setsubun, a festival to burn off
all the bad luck and devils that accumulate
during the year.

B. and Owen stand by as people burn paper
talismans and ogre masks in a fifteen-foot
bonfire carefully tended by firefighters in
shiny silver suits.

Later they buy toasted soybeans from a small
stand and throw them at men in ogre masks,
joining in with a CROWD that is chanting:

> CROWD
> Oni-wa-soto, fuku-wa-uchi.
> [Out with the devils, in with good
> luck.]

A Girl Walks Home Alone at Night is an independent Iranian film about a twenty-something woman who is a vampire, wears a chador instead of a cape, and rides a skateboard. She lives alone in a place called Bad City, where she preys on junkies and drug dealers but takes pity on children and prostitutes. One night, she stalks a young man who has taken MDMA and is wandering around lost. She appears suddenly behind him but, instead of becoming afraid, he hugs her. When he feels how cold she is, he gives her his jacket. The girl takes him home, and they listen to records. She doesn't kill him. Instead, they fall in love.

This story about a renegade vampire in a chador, killing men who don't behave and sparing those who do, gives some insight into why a woman would make a film about a monster. It's the kind of film that comes about when there isn't a way to imagine a woman as powerful and self-possessed within the context of her society. The writer, then, creates a being that lives outside of that society; just how far outside is an indicator of the level of oppression within.

Maybe that's why most demons in Japanese stories are women. It's the only form in which women can access the power they need to resolve the conflicts that vexed them in life. If there is a demon living inside of B., perhaps she is there in order to resolve something, so that she can move on to another realm.

INT. OWEN'S APARTMENT - NIGHT

Owen and B. walk in the door to Owen's apart-
ment. B. sits down on the floor. Owen takes off
his coat.

> B.
> Could I put your coat on? I'm
> freezing.

Owen hands B. his coat.

> OWEN
> You don't look so good.

> B.
> I don't feel good. I think I might
> just go to sleep, if that's O.K.
> with you.

> OWEN
> Sure. Can I make you a cup of tea?

> B.
> That would be lovely. Thank you.

B. heads over to the corner and pushes Owen's
laundry into a heap. She lays down on top of
it, pulling Owen's coat over her.

EXT. SITES AROUND KYOTO - SERIES OF SHOTS

The next day, they visit Sanjūsangen-do,
a temple with one thousand and one golden
bodhisattva statues.

And the Kyoto National Museum, where B. falls
in love with the room full of old maps and
illustrated scrolls.

They also visit Kiyomizu-dera, a temple with
a small area devoted to the god of love. Two
stones are placed a short distance from each
other, and visitors walk from one to the other
with their eyes closed. If they make it, their
hopes for love will come true. B. misses, just
barely.

INT. OWEN'S APARTMENT - NIGHT

At Owen's place, B. goes to sleep early again, exhausted and trembling.

INT. OWEN'S APARTMENT - MORNING

When she wakes up, she is sick: flushed and sneezing.

EXT. SITES AROUND KYOTO - SERIES OF SHOTS

Even so, she and Owen visit Chion-in, a temple where there are CHANTING MONKS and a garden of rocks and chrysanthemums meant to represent the descent from the heavens.

They visit Shōren-in, a temple that houses a famous painting made of gold and a picture-window bamboo garden.

They eat a traditional lunch of cold tofu and vegetables at the temple.

Then they go to an exhibition of work by Yayoi Kusama, a Japanese artist who became famous in New York in the sixties for her psyche-delic sculptures: obsessive dots and patterns superimposed on everyday objects. B. goes into an installation by Kusama: a small room that only one person can enter at a time. It's dark except for colored lights that seem to spring from the void above, below, and all around the viewer. Mirrored walls make the room appear to extend forever in all directions. B. walks on a dark plank to a platform where she takes in the infinity of tiny lights. It feels like being inside the Milky Way or suspended in a strange, floating oblivion. It's lovely.

INT. OWEN'S APARTMENT - NIGHT

When they get back to Owen's apartment, B. is stricken with a horrible fever, chills, sweats, chattering teeth, and delirium. Owen, unsure what to do, sits at his little table and tries to work while B. tries to sleep.

Occasionally, he checks on her or brings her a
cup of tea.

 FADE TO BLACK.

FADE IN:

EXT. TAKAMATSU TRAIN STATION - DAY

B. arrives at the Takamatsu train station.
She gets off the train, pulling her suitcase
after her onto the platform. Two men approach
her and introduce themselves: CHAD is a shy,
pimply Korean American guy who looks at B. from
under a shelf of greasy black hair; ROBERT is a
fleshy, affable, red-headed Brit.

 ROBERT
 Michael sent us to collect you. Good
 thing, too. You'll need help with
 that.

Robert grabs hold of B.'s suitcase and starts
to wheel it toward the exit.

EXT./INT. STREET IN FRONT OF TAKAMATSU
STATION - DAY (CONTINUOUS ACTION)

They lead her to a tiny car, into which
the three of them barely manage to fit her
suitcase.

 ROBERT
 Wow, sorry. Yeah, Japanese cars are
 much smaller than American ones.
 We'll manage, though.

B. crams into the backseat, legs sideways.

 ROBERT
 You O.K. back there? It's not a long
 drive.

 B.
 Yeah, thanks. I'm O.K.

Robert and Chad get into the car, and they
drive away.

EXT./INT. LANGUAGE SCHOOL - DAY

B. and Chad follow behind Robert, who pulls B.'s suitcase up a few stairs into the language school, an aging two-story building. They leave the suitcase in the corner of a small, tiled waiting room, and Robert motions for B. to enter the office. Robert waits at the door.

INT. OFFICE - DAY (CONTINOUS ACTION)

Inside the office, a gruff secretary named Muranaka-san gives B. some paperwork to fill out.

INT. LANGUAGE SCHOOL - DAY (CONTINOUS ACTION)

Then Robert leads B. up a long, steep staircase to the second floor, where he introduces her to the other teachers, standing in the hallway between classes.

 ROBERT
 This is my wife, Kim.

B. extends her hand to Kim, who has a kind face, sensible shoes, and a sleek black page-boy haircut.

 ROBERT
 Alastair, from South Africa.

ALASTAIR is in his sixties, awkward and angular with an energetic handshake.

 ROBERT
 And Anne. She's from Canada, and
 she's been here . . . almost two
 years now?

ANNE is a thin, mousy-haired woman in her midforties with a pinched face and an aura of tension. She nods as she shakes B's hand.

 ANNE
 Yes, I've been here longer than
 anyone.

 ROBERT
 Anne lives in a great two-bedroom
 apartment. You'll be staying with
 her until we can find you another
 place.

Anne nods in affirmation with a pained look.

 B.
 Thanks for offering your place while
 I get settled.

Anne nods again with an aggrieved smile.

INT. STARBUCKS - DAY

B. goes to a nearby Starbucks to wait for
Anne to finish class. She pushes her suitcase
into a corner and takes out her notebook. She
writes --

INSERT - NOTEBOOK

Which reads:

 "I'm surprised that the majority of
 teachers at the school are older.
 Everyone is so nice, and yet I have the
 ominous sense of being welcomed to my
 doom. They all seem lonely, desperate
 to talk to someone. It feels a bit like
 Sartre's No Exit: some try to escape;
 some try to make the best of it; both
 fail."

INT. RESTAURANT - NIGHT

Later that night, B. goes out to dinner with
Chad, Robert, and Kim, and her intuition is
confirmed.

 CHAD
 Once the novelty wears off, it's
 just unpleasant here. I'm freezing
 and sick all the time, and my
 apartment is infested with giant
 centipedes that bite me while I
 sleep.

Chad pulls up his sleeve, revealing a giant welt.

> B.
> Oh my god! That's awful! Can't you
> get an exterminator or something?

Chad shrugs and gives B. a look of resignation.

> ROBERT
> Kim and I feel a bit like we're doing
> time.

Robert turns to Kim for confirmation, and she nods.

> ROBERT
> We all do, I think. We're all staying
> here just so we can come away with
> something -- money, a sense of
> accomplishment. . . . Alastair
> is trying to finish writing a
> novel. . . .

> FADE OUT.

That night, B. dreams about the teachers, each showing her ways they've found to be less miserable. When she wakes, she writes, "I think perhaps I've arrived in hell."

Woman in the Dunes (Suna no onna) is a 1964 film by Hiroshi Teshigahara based on a novel of the same title by Kobo Abe, who also wrote the screenplay for the film. It tells the story of a man who goes bug collecting in the desert. He goes farther and farther out, distractedly following some specimen, and misses the last bus home. The villagers in a nearby settlement offer him a place to stay for the night, and he accepts. They bring him to a house at the bottom of a large pit in the sand. The man uses a rope ladder to climb into the hole, where he's greeted by the woman who lives there. She is kind, beautiful, and hospitable. She shows him to a room, where he promptly falls asleep. When he wakes in the morning, ready to leave, the ladder is gone. He calls out desperately, and eventually, some of

the villagers come to the edge of the pit. They refuse to replace the ladder and tell him he must stay there to help the woman dig sand to maintain the pit. Overnight he's become a captive.

At first the man refuses to work. He makes a scene and takes the woman hostage, demanding to be freed. But the villagers withhold water from them until they are near death, and he has no choice but to set her free. Meanwhile, the pit has nearly filled with sand. He and the woman start to dig. They shovel sand into baskets at the ends of ropes that villagers hoist up, empty, and throw back down. At night, the woman cooks for the man and dotes on him, and they become lovers. Cut in between the dramatic black-and-white scenes of the film are images of the never-ending movement of sand: sand snaking across endless dunes, sifting in through the thatch of the roof, covering the surfaces inside the house, mixing with sweat on their bodies, sucking away heat and moisture, making clothes so unbearable that the two of them walk around naked. It gives the viewer the dizzying sensation of both entrapment and sensuous rapture.

The apartment where B. stays with Anne isn't at the bottom of a pit, but it is freezing and damp. While B. is there, she stays in bed most of the time, watching her breath turn into steam that hangs in the air for a moment, then dissipates. She's still sick, but that's only part of the reason for her malaise. Anne lives in fear of mold and gets upset whenever B. takes a shower or makes a cup of tea, which is what she does most of the time. Anne has a very specific routine to mitigate moisture. It involves squeegees and towels and fans. B. tries her best to adhere to the routine, but Anne still follows her around, turning on fans and opening vents in her wake, as if B.'s presence alone generates an insupportable amount of moisture.

Anne is also terrified of catching B.'s cold. She puts out clean hand towels in both the bathroom and kitchen and points them out: "This is your towel, and this is my towel. Please don't touch my towel." Still, B. senses Anne watching her, following behind her to disinfect whatever she touches. So most of the time B. hides in her room, reading under her blankets or doing silent yoga. Occasionally Anne will call out to B., as if to check on her, and then B. will hold her breath, pretending to be asleep.

Trapped in this small room, B. starts to unwind from the struggle and delirium of her first five weeks in Japan, and the gravity of her financial situation sinks in. She is completely out of money. Her credit card is maxed out. She's borrowed money from both her parents. Her trip from Tokyo to Takamatsu, the rent at Anne's apartment, and the food she is now eating are all paid for by an advance from the school, against pay for work she is not yet doing. Her journal is full of lists and calculations tracking these expenditures, her descent into a pit she might never dig herself out of. She realizes that, unwittingly, she's becoming trapped here. She doesn't have enough money to get back to the airport in Tokyo. She could leave immediately upon receiving her first paycheck. That way she wouldn't miss the last possible date to catch the return flight on the plane ticket she has. Since her paychecks will be only about two thousand dollars a month, hardly enough to cover expenses, it might be months before she can save up to buy another one. She doesn't want to leave before she is ready, but she doesn't want to end up stuck here like the rest of the teachers either.

Realizing this gives B. a sense of urgency. She feels like she'd better learn what she can about Takako now, in case she decides to cut and run.

She rides her bike to the international center in town (I-PAL, an acronym formed from the Japanese words for love, information, and friendship) and posts a small ad for a Japanese-English translator interested in offering translation services in exchange for English classes.

While she's there, she uses the computers to figure out how to take the train to Awa-Ikeda, the largest town near one of the two possible Konishi addresses she got from Takako's landlord.

FADE IN:

INT. JAPAN RAIL (JR) TRAIN - DAY

B. rides a JR train with a single car into the countryside. For most of the trip, she's the only person on the train apart from the DRIVER, who gestures and yells continually.[9]

Before he opens the door, he points at it and
shouts at the top of his lungs:

> DRIVER
> Sharyo teishi ichi, yoshi!

Before he closes it, he points again and shouts:

> DRIVER
> Repita, yoshi!

It's an odd spectacle B. has noticed on other
trains, but it's made odder by the fact that,
on this train, there are only the two of them.
B. wishes she could tell the guy to relax.

EXT. DOWNTOWN AWA-IKEDA - DAY

Awa-Ikeda is nothing more than a train sta-
tion and a few closed shops in a tiny downtown
area surrounded by countryside. B. walks
down the one street in town, empty but for one
young girl who seems to actively ignore her.
B. decides against asking the girl for direc-
tions and returns to the train station, at a
loss for what to do.

INT. AWA-IKEDA TRAIN STATION - DAY

B. goes into the station office to ask about
a bus to Hakuchi-Ikubo, the area where the
Konishis might live.

> B.
> Hakuchi-Ikubo? Bus? Hakuchi-Ikubo.

B. holds up a piece of paper with the Konishis'
address on it to the STATION ATTENDANT, an
elderly woman who stands behind a long coun-
ter, the sole person in the station. She speaks
no English but pantomimes that B. should fol-
low her.

INT. AWA-IKEDA BUS STATION - DAY (CONTINUOUS
ACTION)

They walk a few doors down to the bus station
and together manage to ask the man at the ticket
counter about a bus, but there isn't one.

INT. AWA-IKEDA TRAIN STATION - DAY

Back in her office at the train station, the Station Attendant takes the Konishis' address from B. and looks it up in an atlas. The Konishi name has been clearly printed in the atlas next to a dot on the map. The woman shows it to B.

> STATION ATTENDANT
> Ko-ni-shi. Hai.

It's such a small town that the map lists the name of each resident. The woman motions to B. to follow her and locks the office door behind them.

EXT. BEHIND AWA-IKEDA TRAIN STATION - DAY
(CONTINUOUS ACTION)

B. follows the Station Attendant out to a small car parked behind the station. The woman opens the car door to get in, motioning to B. to do the same. B. tentatively opens the car door.

> STATION ATTENDANT
> (nodding emphatically)
> Hai. Hai. Hakuchi-Ikubo.

B. gets into the car and the two drive off.

EXT./INT. CAR DRIVING THROUGH SHIKOKU
COUNTRYSIDE - DAY

They drive through hilly, forested country-side, over a bridge, past the Hakuchi post office, which the woman slows down to point out.

> STATION ATTENDANT
> Ha-ku-chi.

And up a narrow road with switchbacks. They come to a river with a small bridge, and the woman pulls the car onto the side of the road.

EXT. HAKUCHI-IKUBO - DAY (CONTINUOUS ACTION)

The Station Attendant gets out, and B. fol-
lows her. She points to the Konishi name on the
mailbox.

> STATION ATTENDANT
> Ko-ni-shi.

And then to a small, traditional house set back
from the road, next to the river.

> STATION ATTENDANT
> Konishi. Hai.

A woman is standing on the street in front of
the neighboring house. The Station Attendant
approaches her and starts a conversation.

While they talk, B. pulls out her video camera
and films the house and their conversation.
The woman from the station turns to B., holding
up her crossed forearms.

> STATION ATTENDANT
> Ee-yay.

This means no. Given the context and her tone,
B. surmises that the Konishis aren't there.

The woman from the station takes out her cell
phone and calls someone. She says a few words
to the WOMAN ON PHONE and then hands it to B.

> WOMAN ON PHONE (O.S.)
> Hello. I am the daughter of the woman
> from the train station?

> B.
> Oh. Hello. Please tell your mother
> thank you for driving me out here.

> WOMAN ON PHONE (O.S.)
> Yes. O.K. She would like to know if
> there is a message you would like to
> leave for the Konishi family.

 B.
 Yes, please. I would like to talk
 to them about Takako. I am writing a
 short piece about her. If they would
 please call me at 087-834-3342 to
 set up a time to talk, I would be
 grateful. Thank you.

 WOMAN ON PHONE (O.S.)
 O.K. Give the phone back to my
 mother, please. I'll tell her.

B. hands the phone back to the Station
Attendant. She says a few more words, hangs
up, and says something to the woman B. pre-
sumes is the Konishis' neighbor. They both
turn to look at B., seeming to regard her with
confusion for a moment, and then the woman
from the station shrugs and gets into her car.
B. gets in, too, and they do a U-turn, driving
back the way they came.

EXT. AWA-IKEDA STATION - DAY

When they get to the station, the woman unlocks
the door and they go inside.

INT. AWA-IKEDA STATION - DAY

B. buys a return ticket to Takamatsu from her
and sits down to wait for the train. She takes
out her notebook and writes --

INSERT - NOTEBOOK

Which reads:

 "Chief Keena was right: Takako grew
 up in the countryside. In a small
 house surrounded by hills, next to a
 stream."

 FADE OUT.

B.'s first week in Takamatsu, she is in training. This means she goes to
classes with other teachers, watches them teach, teaches while being

observed, and meets some of the students. It's unclear what classes B. will be teaching; nobody seems to know. She has a lot of free time, which she spends riding one of Alastair's bicycles around Takamatsu, using the library and computers in the I-PAL, and avoiding Anne at home by pretending to sleep.

On Friday, Alastair asks B. if she wants to have lunch and go for a bike ride over the weekend. She accepts.

FADE IN:

EXT. TAKAMATSU CITY STREET - DAY

At noon, B. rides her bicycle to Alastair's flat.

INT. ALASTAIR'S KITCHEN - DAY

B. sits in the kitchen, drinking a cup of tea and chatting with Alastair while he makes lunch.

> ALASTAIR
> . . . I was a fruit farmer in
> Rhodesia. And I fought in the
> Rhodesian Bush War.

> B.
> That's insane!

> ALASTAIR
> It was. I spent years living in the
> wilderness like some crazed prophet,
> starving to death, my clothes in
> tatters, lying around in pits
> shooting at people and being shot at.

> B.
> Oh my god. I cannot imagine.

> ALASTAIR
> Neither can I, anymore. It was a
> different life, really. . . .
> (MORE)

211

ALASTAIR (CONT'D)
Afterwards, I moved to South Africa
and got a job running a plantation.
Oranges mostly. I married the owner.
She was a beautiful woman. Very
beautiful. And educated. But, she
did not know how to run a plantation.
I don't think a woman can really
understand what's involved in a
large-scale operation like that
unless she's really done the work
like I have. But she could not just
let me run things. As a result, the
marriage fell apart. I got involved
with a young woman. My wife married
my best friend. Left me without a
rand. Went out of her way to make my
life a hell in every way she could
think of.

B. is looking into her cup of tea, listening to
Alastair. When he pauses she looks up.

B.
Sounds very complicated.

ALASTAIR
You can say that again. Women are
complicated.

Alastair LAUGHS and turns to the stove, pull-
ing a noodle out of a pot of boiling water and
putting it in his mouth.

ALASTAIR
Al dente. Perfect.

Alastair picks up the pot of water and drains
it over a colander in the sink.

EXT. STREETS OF TAKAMATSU - DAY

After lunch, Alastair and B. ride their bikes
to a lighthouse on a wide promenade and go into
a nearby restaurant for a drink.

INT. RESTAURANT ON PIER - DAY

They sit at a table in a restaurant made almost entirely of windows that look out over the inland sea.

A waiter brings them each a drink. Alastair and B. both take out their wallets to pay, but Alastair insists.

> ALASTAIR
> This is on me. You can take me out for a drink when you start to get paid.

> B.
> Deal. Thank you.

Alastair pays the waiter.

> ALASTAIR
> Have you been to Italy?

B. shakes her head.

> ALASTAIR
> It's wonderful. Before I came to Japan, I was teaching English there. It was a great job, really just talking to people all day. The Italians are great conversationalists. . . . And the food, oh my god, the food is the best in the world. You would love Italy. I had a nice flat -- small but nice -- and a girlfriend. Beautiful and much younger than me. And that was fine at first, it was a casual thing, but then she got serious. I needed time to think, and to finish this novel I've been working on. So I came here to get some space and focus on my work.

At this point, Alastair pauses. It sounds to B. like he regrets the decision.

Jana Larson

> ALASTAIR
> I thought I would stay for a couple
> of years. I've only been here for
> five months and . . . I don't want
> to scare you . . . but it's a hell.

He pauses and falls silent.

> ALASTAIR
> At least I won't get into any trouble
> here. I'm not attracted to the
> women. Are you? Attracted to the
> men, I mean? Can you see yourself
> with one of them?

> B.
> Yeah, I think so. I guess I haven't
> thought about it . . .

B. turns to look out the window at a chain of
small islands with mist hanging over them.

> B.
> The islands are beautiful, aren't
> they?

Alastair turns to look out the window.

> ALASTAIR
> Yes, gorgeous . . .

They watch the mist slowly rising and falling
around the islands.

> ALASTAIR
> How is staying with Anne?

B. shrugs.

> B.
> I don't know. She seems to be
> obsessed with fighting mold and
> moisture. It's a little tough to
> deal with.

Alastair nods.

 ALASTAIR
 I can imagine. A few months ago, Anne
 was on vacation in Thailand when the
 tsunami hit. She barely survived.
 It's a crazy story. You should get
 her to tell you about it sometime.

B. nods, knowing she'll never ask Anne about it
or anything else.

 ALASTAIR
 I think Anne really wants to go home,
 but she doesn't have the money to
 leave. That's why she's become so
 impossibly unpleasant.

B. nods. She tries to regard Anne with more
compassion. It doesn't work.

 FADE OUT.

Later that day, B. goes to the I-PAL and sees that she's received an
email from a woman named Akemi:

Hello,
 My name is Akemi Saito. I'm from Tadotsu-chō, Nakatado-
gun in Kagawa prefecture.
 How have you been enjoying your stay in Kagawa?
 I was born and brought up here, and I'm a full-blooded
Japanese woman.
 I'm writing to you because I found your advertisement on the
bulletin board at I-PAL Kagawa.
 I'm quite interested in what you have been trying to accom-
plish, that is, an English documentary film on Kagawa, my home.
 I have a bachelor's degree in Anglo-American Studies at
university.
 I have been recently working as an English teacher, sightseeing
guide interpreter, and translator.

I also have the rudimentary certificate of System Administration, and I have been working as a web designer, system administrator, and programmer occasionally.

If you feel I have sufficient skill to help you with your work, please let me know.

All the best,

Akemi Saito

B. emails Akemi immediately, trying not to sound overly enthusiastic or desperate. They arrange to meet the following week at a restaurant near the pier.

```
FADE IN:

INT. RESTAURANT - DAY

AKEMI is in her late twenties, maybe thirty,
with long black hair, a rectangular face, and
penetrating brown eyes. She sits across from
B. at a table in a restaurant, lost in thought.

                    AKEMI
          This story you're trying to
          tell. . . . If nothing else, I
          think I might be able to help you
          understand Takako, since we're from
          the same town and would have been
          the same age. You see, it's a very
          common longing of young people to
          live alone in an apartment in Tokyo.
          It's the modern sickness of young
          people, who fear the obscurity of
          disappearing in rural places. I,
          too, lived alone in Tokyo. I shared
          many of Takako's experiences --
          of schizophrenia, searching for
          something, wanting to die . . .

B. tries to write everything Akemi says into
her notebook.
```

 AKEMI
 Living in Tokyo was difficult. I
 had a scholarship to study at Tokyo
 University, but it was difficult
 to make friends, and afterward I
 couldn't find a job.

Akemi pauses to allow B. to catch up with
her note taking. B. finishes writing, then
looks up.

 B.
 Why do you think it was so difficult
 for you in Tokyo?

 AKEMI
 There is serious discrimination
 in Tokyo against people from the
 countryside. There's a different set
 of rules in Tokyo, foreign to anyone
 who didn't grow up there. Someone
 like me, from Kagawa, is just as
 foreign as someone like you. There's
 also serious discrimination against
 women, made worse by the recession.
 It's difficult to get a job and
 make enough to live on. Without
 connections, you get temporary jobs,
 where you have no power and make very
 little money. Eventually, I came
 home to live with my parents.

Akemi trails off. It's clear there is some-
thing more -- devastating, perhaps -- that
she's not saying. B. feels a palpable sense
of regret or maybe failure, and she lets the
silence hang in the air for a moment. Akemi
doesn't fill the space. Instead, she looks
at B. with a smile.

 AKEMI
 We could talk about music. Who are
 your preferred musical artists?

 B.
 Currently?

 AKEMI
 Sure. I mean, for me there is no
 "currently." There is only Bowie.
 Did you know that I helped to arrange
 and promote his last tour in Japan?

 B.
 Wow, that's cool.

 AKEMI
 Once, I flew all the way to London
 just for a concert. Afterward, I
 went backstage and met Bowie, and
 his son Duncan was there too.

 B.
 Zowie Bowie?

B. inserts this to try to seem "with it." Akemi
shakes her head.

 AKEMI
 He prefers to be called Duncan. He
 and I are close. I still correspond
 with them both. Duncan writes to me.
 I think he thinks of me, too. . . .
 But I don't know if anything will
 happen with that.

 B.
 I love David Bowie too. I think my
 favorite record is . . . maybe
 "Changes"?

As soon as she says this, she's aware of how
ridiculous it sounds. She means to say they
have Bowie in common, but clearly they don't,
not really. Akemi lives or dies for Bowie,
knows every song. B. has loved Bowie since
her teens but has never seen him in concert.

Akemi shakes her head.

 AKEMI
"Changes" wasn't really an album.
Changesonebowie was a compilation
of his best hits released in 1976.
"Changes" was a song on Hunky Dory,
which came out in 1971.

 B.
That's what I mean: Hunky Dory. And
also Ziggy Stardust.

 AKEMI
Both great records.

They turn to quietly eating their lunch.

 AKEMI
I am very busy, but I am willing
to help you with your project
whenever I can. Send me a copy of
the police report and any other
information you have about the case
so I can familiarize myself with
Takako's story. I'll search for any
information that might have appeared
about her in Japan.

 B.
Oh my goodness. Thank you! You are a
dream come true.

Akemi nods and continues to eat her lunch.

 FADE OUT.

That night, B. dreams she's at a Bowie concert, hanging out with him
backstage. It's the Ziggy Stardust version of Bowie, and they try on
makeup and clothes together before the concert starts. But B. doesn't
see the concert. When Bowie goes onstage, she's kidnapped by aliens,
who lock her in a school while they eat cake.

REEL 7

At the end of February, the academy moves B. to a city called Tokushima about fifty miles to the east. Instead of teaching in a school, she drives a car rented from the academy—paid for with a sum borrowed against her salary—to neighboring towns and gives classes to workers in factories and office buildings.

She lives alone on the fourth floor of a large cement building called Hamanosaki Mansion. The apartment has five rooms: two bedrooms with tatami floors, and a bathroom, living room, and kitchen with brown linoleum floors. It's completely empty except for one puce, legless Naugahyde armchair, a television and VCR that sit on the floor in front of the chair, and a thin futon that she lays on the bedroom floor at night and hangs outside during the day. B. inherited these things from an American guy who quit suddenly, leaving her all of his classes. It's like he stepped out of the wrapping of his life and she stepped in.

The outer wall of the apartment comprises two sets of sliding glass doors that open onto a long, narrow balcony overlooking a winding road and a cement canal that eventually makes its way to the sea. Her students tell her that, during hurricane season, the canal sometimes fills with a wall of water that rushes inland, cresting the cement barrier and washing over the roads. That's why all the buildings along the canal are made of thick cement block, held up by large pilings, and empty on the ground floor. A "mansion," here, is a cement dwelling built to withstand disasters.

B. finds an old bicycle in a junk shop that feels like someone's garage. She falls in love with the old man who sits there all day, moving his stool from place to place, following the sun. She loves his toothless grin and his soiled blue coveralls, and she waves to him whenever she passes. She wishes there were something else she could buy from him, but there's not.

She rides her bike a lot, to the small grocery store near her house, to the used clothing store a few blocks away, along the river toward

the center of town, where she sometimes rides or walks through the covered arcades where clothing and electronics and housewares are sold. She can't afford to buy anything, but she doesn't want anything, except maybe a warmer coat.

She also rides to a Zen temple near her apartment. It's not a tourist spot, just an everyday temple with a small congregation. She likes it because of the cemetery on the temple grounds, with densely packed gravestones and a stone pathway that continues through the graveyard up a slope, through a bit of forest lined with small shrines, to a small clearing with an old wooden temple. She parks her bike and walks up the path to the temple many times, loving the beauty of it, but always unsure whether she is trespassing or not. She goes to meditate in the temple once or twice, but the priest doesn't speak English and insists that she sit in a specific posture that causes a sharp pain in her knee. Whenever the priest walks away, she microadjusts the knee almost imperceptibly to relieve the pressure, but the priest always notices and returns to push her knee back. She stops meditating there.

On most days, she rides to Mount Bizan, which is more like a tall hill than a mountain, and climbs to the top. Toward the end of March, she meets a smiling old man who shows her a tree-lined path that cuts up the side of the mountain. B. starts to see him on the trail a lot after that. He speaks no English but cheerfully joins her and points out the shrines and small temples along the way. In the silent pantomime of gestures and smiles, a camaraderie develops. He becomes B.'s closest friend.

One day, the smiling old man insists she go with him into the cement building at the top of the mountain, where the cable car ends. It's a monument to something, maybe peace. Inside the concrete structure, a man who speaks English is expecting them. He says, "Hello. Mr. Tanizaki has told me about you. He wonders, what is your name? Why are you in Japan? Are you married? How long will you be staying here?" The man pauses after each question so B. can answer. He relays the information to Mr. Tanizaki.

Afterward, Tanizaki-san leads B. out to a plaza overlooking Tokushima, where a group of old men in climbing gear are chatting and taking in the view. Tanizaki-san presents B. to each of them, and she bows. "Hajime mashite."

After that day, the camaraderie is gone. Whenever B. sees Tanizaki-san on the path, he gives her a distant wave and walks off in another direction. Something—the basic information about her life, the sound of her voice, the way she greeted his friends, the fact that she is in Japan indefinitely—must have broken the spell. She imagines his disappointment, that she is somehow less interesting than he had hoped, or less—something.

B. is torn between her idea of the perfect film and the film it's possible to make. The gap between them seems to widen continually. She begins to feel that the only way to make the film is to incorporate her life in Tokushima into it. She imagines Takako watching her from a far-off afterworld that looks like an editing room. There, Takako reviews all of the footage B. has shot—of the test scenes and rehearsals with the actors, the interviews in Fargo, and the landscape in Japan—and sends comments to B. via text message. These scenes are intercut with scenes B. will shoot in Japan, and the image of a woman walking through a snowy landscape, as if she is in a dream or visiting from the perfect film that will never be made.

```
FADE IN:

EXT. FROZEN LAKE, MINNESOTA - DAY

A woman is walking in a vast, open landscape in
a snowstorm. Wind whips across a frozen lake,
blowing the snow into swirls that occasionally
obscure her from view. A closeup reveals that
the woman is B., a white woman with long brown
hair, in her thirties, thin with an athletic
build, wearing cords, combat boots, a puffy
down jacket, and a wool hat.

She carries her video camera back to a car
that's waiting on the side of the road. B. gets
in, and the car starts to drive slowly along
the lake as she leans her camera out the win-
dow, filming a long tracking shot of snow
billowing across the lake.
```

INT. APARTMENT IN TOKUSHIMA - DAY

B. is asleep on the floor of a nearly empty
Japanese apartment. The sliding door to the
balcony is open, and pages from a police report
blow about, becoming a disordered mess. A
television on the floor plays the film <u>Good
Men, Good Women</u>, by Hou Hsiao-hsien, and the
LOW MUSIC AND DIALOGUE of the film are inter-
mittently drowned out by the SOUNDS OF PASSING
CARS.

ON THE TV SCREEN

A woman dances provocatively, standing on a
twin bed in a small bedroom TO MUSIC PLAYING ON
THE RADIO. A disco ball twirls over her head. A
man stands into the frame, holding a flashlight
to the disco ball and spinning it. He puts on a
spikey red wig and grabs the woman's hands and
they LAUGH and dance together. The disco ball
falls from the ceiling and they collapse into
a FIT OF LAUGHTER, holding each other.

BACK TO SCENE

A CELL PHONE RINGS, and B. wakes and
answers it.

 B.
 Moshi moshi. Yes, sorry! On my way!

B. sits up quickly, gathers the pages of the
police report together, and puts them into a
bag along with a notebook.

She quickly brushes her teeth at the kitchen
sink and rushes out the door.

INT. EMPTY GYMNASIUM - DAY

B. sits on the floor of an empty basketball
court, watching two actors, an American Man
and a JAPANESE WOMAN, rehearse a scene. The man
has his arms around the woman, who stares off
as if through a window.

B. holds up a notebook and reads a line from it.

 B.
I waited for you at the hotel, but
you didn't come.

 JAPANESE WOMAN
I waited for you at the hotel, but
you didn't come.

B.'s CELL PHONE BUZZES, and she pauses to
read a message that pops up on the screen from
"TAKAKO."

ON THE CELL PHONE SCREEN

The text message reads:

 "The internal conflict is the real
 issue. How to show that?"

BACK TO SCENE

B. stands up and walks toward the actors.

 B.
That's the feeling, but maybe
nothing is said. You're with your
lover. You want to make him happy.
But you're split between being with
him and living your own life. Do you
know what I mean by that?

The Japanese Woman nods her head.

 B.
 (continuing)
It's a love story, but you wish you
could be both in love and outside of
love at the same time. That's the
split, and then there's the desire
to be whole again. Have you ever felt
that?

The Japanese Woman stares at B. without
comprehension.

B. pauses and looks at the actors, at a loss
for words.

 B.
Let's skip ahead. You're sitting on
the floor.

The Japanese Woman sits on the floor.

B. points to the American Man.

 B.
You're sitting on the edge of the
bed, using your laptop.

The American Man moves to a chair and opens an
imaginary laptop.

B. turns to the Japanese Woman.

 B.
You approach him and put your hands
on him. You try to make him want you.

The Japanese Woman approaches the American Man
and leans into him.

 B.
Can you stay a little longer?

 JAPANESE WOMAN
Can you stay a little longer?

B.'s CELL PHONE BUZZES, and she reads the
message as she walks toward the actors.

ON THE CELL PHONE SCREEN

The text message reads:

 "Same problem. We don't see the real
 conflict. She doesn't know how to get
 what she really wants."

BACK TO SCENE

B. stops in front of the actors and puts her
phone away.

 B.
 (to the Japanese Woman)
Yes, that's good . . .

EXT. STREET WITH SHOPS, TOKUSHIMA - DAY

B. walks through the rain down the street of
a small town. The rain turns to sleet, and she
ducks into a grocery store.

INT. APARTMENT IN TOKUSHIMA - DAY

Back at her apartment, an espresso pot boils
over and B. pours herself a cup of coffee. She
picks up a package of donuts and carries them
over to a puce vinyl chair without legs. She
spreads the police report out in front of her
on the floor and reads it as she eats donuts
and sips coffee.

She locates a phone number in the report and
uses her cell phone to place the call. The
PHONE RINGS. No one picks up.

 FADE OUT.

B. decides that at the end of the film, Takako will travel to North
Dakota. She will wait in the hotel in Bismarck for a few days, writing
letters, waiting for someone or something that never appears. Then
her life will seem to open up in a small way. She'll buy a couple of
bottles of champagne and go out in search of a scenic place where
she can celebrate the start of something new. It will start to snow,
shooting stars will fly across the sky, and she'll experience a feeling
of hope—that life will be different somehow. For B., this is the most
important moment in the film: when Takako lets go and a space
opens up for life to renew itself, for her to go on.

 Later, this idea of space will dominate B.'s thinking. She'll begin
to wonder if it is not the film but the ending of the film that is impor-
tant. If it's not a film at all but a performance, in which she as the
director sits in an editing room and sifts through the footage she
shot in Fargo and Japan. Takako confers with her via text message.
And together they edit the film down to a single image that also dis-
appears, until all that remains is an empty, white screen or empty,
glowing monitors. Maybe it's a performance that would take a month

or more in a gallery. Maybe it would go on in perpetuity: when one film disappeared, all the footage would reappear, and she and Takako would begin again, and through another set of decisions, a different film would start to take shape before it, too, would disappear. And so it would become like a purgatory or bardo realm, where she and Takako sift through the remnants of the past trying to make sense of it, transform it into something meaningful. And in every case they wind up at zero, only to begin again. In some ways, B. is already living in this realm, searching for a way through to the other side, to whatever comes next. Perhaps the point of this bardo is to end up at a version of zero that feels right, complete, good enough. How will she know when she gets there?

```
FADE IN:

INT. B.'S APARTMENT - EVENING

In the middle of March, Akemi visits B. at
her apartment. They eat dinner sitting on the
floor at a low table.

                AKEMI
          I've done some research into
          Takako's story. There was no news
          coverage of Takako's death in
          Japan. But I have come up with my own
          theory: it's quite common for young
          people in Japan to find each other
          in suicide chat rooms and make plans
          to commit suicide together. My best
          guess is that Takako made a suicide
          pact with someone and flew to North
          Dakota to fulfill it, but whoever
          she made it with didn't show up. I
          think that's why Takako waited at
          the hotel for a few days.
                (MORE)
```

> AKEMI (CONT'D)
> Either the others didn't show up,
> or she ended up in the wrong place,
> and by the time she got to the right
> place, the others were already gone,
> or dead, though this is less likely,
> since no other Japanese people
> turned up dead in North Dakota that
> November. Correct?

> B.
> Not that I know of.

B. is silent and considers this possibility.

> AKEMI
> Or maybe Takako's boyfriend Douglas
> wanted to get rid of her, so he lured
> her to North Dakota under false
> pretenses and then left her stranded
> there with no means of getting home,
> knowing her only option would be
> suicide.

> B.
> Whoa. That casts the boyfriend theory
> in a new and more sinister light.

B. considers these ideas through the lens of a theory of her own: that Takako's story is like a Rorschach test. She wonders if Akemi ever spent time in suicide chat rooms, or if she was once jilted by a lover and felt like her only option was death.

As B. is thinking this over, she considers another option: What if Takako arranged to meet up with someone in a suicide chat room and did find that person in North Dakota? What if there were two people at the hotel in Bismarck, and that's why there were conflicting descriptions of Takako? What if the woman in Bismarck who didn't speak English very well was one person, and the woman chatting to the guy at the front desk in Fargo was another? Maybe there were two bottles of champagne in Detroit Lakes because there were two women out there under the stars, waiting to die. What if Takako drank

the champagne, walked out of that forest, flew somewhere else, and disappeared? Her suicide note and the cremains her parents brought back to Japan proved her death, allowing her family, who would have been complicit in this plot, to collect insurance money and end whatever trouble Takako might have gotten herself into. What if Takako flew to Singapore and started over?

INT. B'S APARTMENT - EVENING (CONTINUOUS ACTION)

Akemi interrupts B.'s line of thought.

> AKEMI
> I've figured out who Takako's parents are. They live in an apartment not far from my parents' house in Marugame. I think I must have attended high school with Takako, though I don't remember her.

> B.
> Really? Let's go over there and see if they'll talk to us.

Akemi shakes her head.

> AKEMI
> No. We have to find the right people to make the introduction.

> B.
> Like who?

> AKEMI
> Someone respected in the community, like a teacher or an elected official.

> B.
> I'm a teacher.

Akemi shakes her head.

> B.
> I don't know anyone who might be respected by the Konishis.

> AKEMI
> You have to try to meet someone.
> Otherwise, they won't talk to you.
>
> B.
> Seriously?
>
> Akemi nods.
>
> FADE OUT.

Moving to Tokushima and starting to work hasn't improved B.'s financial situation. Apartments in Japan come unfurnished, without appliances. So Pete, the head teacher at the school where she works, took her shopping so she could buy a refrigerator, a stove, and a washing machine with another loan from the school. This pushed her further into the hole. Now, after payment is held back on her debt and on the rent for her car and apartment, there's not enough left in her paycheck to live on. She always runs out of money before the end of the month, and there are always a few days when she drinks green tea and eats rice with soy sauce or plain udon soup from a shop that sells noodles for about a dollar. At the beginning of the month, B. fills her notebook with fantasy calculations that have her saving enough to leave by August or even July, with enough money to travel to Burma or Laos or China or India. But by the end of the month, it's clear that she's saved nothing and that she'll be stuck in Japan until at least December.

This thought fills her with despair. She writes, "Something is happening to me. I don't know what. I cried yesterday when I woke up. And I cried myself to sleep—or rather, crying kept me awake. Loud sobs and wave upon wave of sorrow. I don't feel the urge to go out or do anything. And anyway, I can't because I'm so broke. Flipping through the calendar on my phone, the months seem interminable, months of solitude and loneliness."

B. spends a lot of time driving to factories and office buildings to teach. At first, she drives an old, bright orange Daihatsu Kei truck, a miniature pickup from Grenham's farm. She loves this truck, and she especially loves how seeing her in it sends her students into

peals of uncontrollable laughter. It seems the car a person drives is an important indicator of status, and the Kei truck places B. squarely at the bottom of the pile. For some reason this pleases her. It's like a small act of rebellion in a culture with few opportunities for dissent. Later, Pete will bring over a tiny, white car for her to drive, equally old, but sad instead of funny, or so she gathers. By that time, B. will have accepted her status as an outsider and gone beyond caring what anyone thinks.

She teaches Monday through Friday. Wednesdays and Fridays are twelve-hour days, but on the others, she teaches for just two or three hours in the evening. For the most part, her interactions with her students are supposed to be scripted. She's been instructed to follow a textbook written by Grenham, but she tries to engage her students in conversation as much as possible. Not just because she's lonely (and for the most part the students are lonely too), but because in general, Japanese people have already studied English grammar for several years in school; they just need to practice speaking it. Mostly this means being O.K. with making mistakes, gaining confidence and fluency. It actually helps that B. doesn't speak Japanese because it means her students have to speak English with her. At first, they think she's feigning ignorance. To test her, they say things that are so provocative she'd have to respond if she understood, then they carefully monitor her face. This probably would have made her laugh if she had any idea what they were saying—they laugh, anyway—but she doesn't, and in the end, the students finally believe her.

She tells her students she wants to learn more about Japanese culture and that it's up to them to be her teachers. This is true, but she also wants them to feel like they can talk about their lives without sharing things that would make them uncomfortable. She writes down a few items from these conversations that seem relevant to Takako's story: the favorite color of most Japanese people is white, which is also the color of death; Japanese words do not have concrete meanings and are highly dependent on context; Minnesota is famous in Japan for UFO sightings; if a woman is traveling alone, it can only mean she intends to commit suicide.

This last one comes up during a lesson with a married couple who are two of her favorite pupils. One day she explains to them

that she's having difficulty making hotel reservations. Whenever she calls a ryokan to ask if they have a vacancy, it seems like they do until they ask, "For how many?" And she replies, "Hitori desu." One. Then the person at the hotel invariably replies, "Ah so desu ne. Chotto muzukashii desu." The first sentence means, "Oh, I see." The second means, "That's a little difficult," which she always takes to mean that the receptionist needs to check on something. She waits on the phone, thinking that in a moment they'll come back with a definitive yes or no. But that doesn't happen. Instead, there is some confusion, and then the receptionist hangs up the phone. She explains all of this to her students, who laugh and tell her about the Japanese perception of women traveling alone—that they mean to commit suicide.

What they don't explain—perhaps because to them it's self-evident—is that "chotto muzukashii" effectively means "no." Because apparently—though she could be wrong about this—Japanese people almost never state anything directly. If she goes into a store and asks for a Sprite, for example, instead of saying, "Sorry, we don't have Sprite," the storekeeper inhales through her teeth to make a hissing sound, makes a kind of wincing expression, and says, "Chotto muzukashii." That's a little difficult. Because she doesn't have any Sprite, and perhaps to come right out and say so would be too definitive and thus—indelicate? B. never figures this out while she's in Japan. She's like the proverbial bull in a china shop.

During one lesson, her students try to explain the concept of wabi-sabi, which they say has something to do with seeing beauty in decay and imperfection and accepting the inherent sadness of all things. In another, she learns that the cherry blossom is the unofficial Japanese national flower because the blooms are so fleeting. They say something like, "This is the samurai way, to have a great life for a short period of time and die when you're young, without regret." B. wonders if anyone really wants that.

Most of the time, B. is alone in her empty apartment doing one of four things: rereading the same information about Takako's case, taking notes on ideas for a screenplay she can shoot in Japan, reading one of three books she has with her (Beauvoir's *Second Sex*, Camus's

The Myth of Sisyphus, and Cortázar's *Blow-Up and Other Stories*), or watching rented VHS tapes of old Hollywood films, films that are old enough to have never been dubbed in Japanese (*The Maltese Falcon, Singin' in the Rain, The Great Escape*). She spends nearly eight months alone in that empty apartment. How can she describe the effect of so much solitude?

In a sense, the isolation is deliberate. In San Diego, she was always thinking, *I want to end all of this. I want to get away from all of this. All of this.* What did she mean by that?

Things are not better in Japan. On the drive to and from her classes in the more remote parts of the island, she often stops to look at the sea. One day, she finds a hidden veranda in a tangle of brush near the water. It looks like it was once part of a park that is now abandoned and overgrown. As she walks toward the veranda, an albino peacock suddenly appears. It's as if the peacock has been transported from whatever remote past the veranda belonged to. Normally, this would have thrilled her, but on this day, B. turns, runs back to her truck, and drives off, heart pounding.

It doesn't matter what she finds or where she goes; B. sees only emptiness. Sometimes she feels like a vast cave that emptiness howls through, hollowing it out from within.

FADE IN:

EXT. STREET IN FRONT OF HAMANOSAKI MANSION – EARLY MORNING

At the end of March, B. gets up at 5 a.m. for a day trip with PETE and his wife, YUKI. She waits on the street in front of her apartment building; Pete and Yuki arrive in a small car, and she gets in.

EXT./INT. SMALL CAR DRIVING ON SHIKOKU COASTLINE – DAY

They drive along the coast toward Cape Muroto, where they plan to meet up with Pete's friend Stacey, who is walking the Shikoku pilgrimage.

PETE

People come from all over the world
to walk the Shikoku pilgrimage.
It's a seven-hundred-and-fifty-
mile route to visit the eighty-eight
Buddhist temples that ring the
island. Pilgrims traditionally
carry a walking stick and wear white
clothes and a cone-shaped straw hat.
It takes anywhere from thirty to
ninety days to complete the journey
on foot, so many people take tour
buses or drive, but Stacey is going
on foot and one hundred percent
traditional.

B.

That's hard-core.

PETE

Yeah. He's committed to walking every
inch of the route. And the place
we're meeting him today is pretty
remote. There are long stretches
of several days between temples out
here, so he's been a little miserable
lately. That's why we're driving
out. To bring him sandwiches and
keep him company for a bit. Anyway,
Cape Muroto, where we're meeting
him, is near the cave where Kukai,
the patriarch of Japanese Shingon
Buddhism, attained enlightenment
when a star flew into his mouth.

B.

That's a cool image. I wonder if
that's what enlightenment feels
like.

PETE

No idea.

B.

Me either.

B. turns to look out the window at the coast. Rocks made from layers of sediment have been heaved by a great force so the layers are perpendicular to the earth. It's breathtaking.

EXT. ROCKY OUTCROPPING ON THE COAST - DAY

The car pulls off the road in the middle of nowhere. Stacey is waiting for them, perched on an outcropping of rocks looking out at the sea. He is tall and lanky, with short blond hair and a ruddy complexion. His face lights up as they get out of the car; he walks toward them, gives Pete and Yuki, then B., a big hug.

Pete and Yuki return to the car to pull out a picnic basket.

B. and Stacey find a comfortable place to sit on the rocks.

> B.
> Pete says you guys are friends from home?

> STACEY
> Yeah, from Bozeman. That's where Pete and I grew up and went to college. I'm still living there, working as a reporter for the newspaper. Anyway, my dad just died. I decided to walk the pilgrimage as a way to say good-bye to him. And I guess to figure out what I'm supposed to do now that I have to become a grown-up.

He says all of this with disarming, almost childlike candor.

> B.
> I'm so sorry for your loss.

> STACEY
> Thanks.

They sit in silence for a moment, looking out at the sea.

 B.
 Well, you definitely have some space
 out here to reflect.

 STACEY
 (laughing)
 That is for sure.

 Pete and Yuki arrive to the rocks carrying
 a picnic basket, pull out a large sandwich
 and give it to Stacey. Stacey beams from ear
 to ear.

 STACEY
 Oh my god. Look at that sandwich.
 I've never seen anything so
 spectacular in all of my life.
 Except maybe this Laundromat I found
 a couple of days ago in the middle of
 nowhere . . .

B. watches Stacey closely, noting how the simplest things make him
happy: a sandwich, laundry facilities. She remembers that feeling—
the joy of being a traveler. She thinks perhaps she'll drive out and
walk with Stacey again on another day.

 FADE IN:

 EXT. TOKUSHIMA CENTRAL PARK - DAY

 In early April, the cherry trees start to
 blossom.

 One Sunday afternoon, B. goes out riding her
 bicycle and notices that the central park is
 full of people sitting on blankets under the
 branches.

 She gets off her bike and pushes it through the
 park.

Jana Larson

There are a few groups that look like students, and maybe a couple of families, but mostly people are dressed in work uniforms or suits, gathered with their coworkers, drinking alcohol, eating snacks, chatting and laughing together, or looking up at the blossoms.

A group of salarymen, MR. INAMOTO, MR. HONDA, AND MR. HIROAKA, sitting on a blanket under a tree, call out to her, motioning that she should sit down with them. She wheels her bike over to them.

> MR. INAMOTO
> (slurring but very polite)
> Hello. I'm Mr. Inamoto. This is Mr. Honda and Mr. Hiraoka. We'd like very much if you would join our viewing party.

> MR. HONDA
> May we please give you a little drink?

The three of them collapse into a FIT OF HYSTERIA. With effort, Mr. Honda pulls himself together enough to hold up a bottle of alcohol for her consideration. Mr. Hiraoka finds and holds up a glass. This sends them into another round of LAUGHTER.

If B. had to guess, she'd say these are the top executives at a local company, out to prove they can have a good time. They are drunk.

> B.
> Oh, thank you, but no. Nothing to drink. It's too early in the day for me.

> MR. INAMOTO
> You must sit down with us, just for a short time.

> MR. HIROAKA
> (parroting Mr. Inamoto)
> Yes, please, sit, for a short time.

 B.
 Just for a minute.

B. sets her bike on a kickstand and tentatively
sits down on the corner of their blanket.

The three men seem suddenly hushed with terror.

Mr. Inamoto summons up the courage to speak
to her.

 MR. INAMOTO
 You speak English very well.

 B.
 Yes. I'm an American.

 MR. INAMOTO
 (turning to the others)
 Ah, Amerika-jin, desu ne.

The other two nod appreciatively at this bit of
information.

 MR. HONDA AND MR. HIRAOKA
 (in unison)
 Amerika-jin. Ah souka.

 MR. INAMOTO
 What brings you to Tokushima? Are
 you here for a visit?

 B.
 I'm living here right now. I teach
 English at businesses in the area.

 MR. INAMOTO
 Ah, teacher. I see.
 (to the other men)
 Eigo kyoshi. Teacher.

 MR. HONDA AND MR. HIRAOKA
 (in unison)
 Ah. Eigo kyoshi, teacher, desu ne.

The three men nod and fall into a brief
silence. B. starts to get up to leave, but
Mr. Inamoto motions for her to stay.

 MR. INAMOTO
 No, no, no, you must join us. Sakura
 viewing is not complete without
 Mount Bizan. You will be our guest.

 MR. HONDA AND MR. HIRAOKA
 (in unison)
 Yes. Please. You must come with us.

 B. nods.

 B.
 Sure. Why not?

The men are thrilled. They leave their blanket
under the tree and start to walk. B. pushes her
bicycle.

The walking seems to have a sobering effect,
and quiet falls over the group.

EXT. PATH UP MOUNT BIZAN - EVENING

The path up Mount Bizan is lit with lanterns and
scattered with small tables for the occasion.
It's getting dark as they begin to climb, and
the sakura blossoms glow in the lantern light.

When they reach the top, they stand together
and look out at the lights of the city, and
beyond, to the black of the sea. The view is
stunning. It is almost a magical moment.

 FADE OUT.

B. continues to write a screenplay in which she appears on-screen as
the director, and Takako sends comments to her via fax and text mes-
sage, helping to shape the story.

 B. considers various structures for the film, musical structures
like strophic form, medley, rondo. She thinks perhaps she could
do something similar to what Marguerite Duras does in her book
Emily L.: Two lovers sit next to each other at the bar of the hotel
where they're staying and together invent a story about a couple sit-
ting nearby. As they weave the story about the other couple, they

reveal aspects of their own relationship, the good and bad times and the roles they played in each. B. is very attracted to this idea, and for a while it seems like the answer she's been looking for. But she doesn't know who would play the two couples, or if there would be couples at all. She still doesn't know what Takako's story is.

She circles back to the idea that Takako is like a blank slate, a stranger who arrives in a small town with no past, no history. She goes there to meet somebody, but when he doesn't show, she decides to start her life over again. Takako has always been molded by the people around her, and now she wants to write her own story. She mails suicide notes to friends and family as a way to cut ties with her past. B. is drawn to this idea, but she's not sure how it would fit within a film structured like *Emily L*. Perhaps B. would sit at a hotel bar watching another couple that could be Takako and Douglas as Takako narrates their quasi-fictional story via text message.

After watching *The Maltese Falcon* for the third time, B. starts to wonder if Douglas was a dangerous man and Takako was running from him. She thinks this could be why Takako's parents were reluctant to admit to any ties with her, or give any information about Douglas. Perhaps Takako sent the suicide note to protect them, so they wouldn't come looking for her. Maybe both Douglas and Takako were outlaws who, in the end, betrayed each other.

But what continues to confound B. about Takako is that, like every character in every story, fiction or nonfiction, she could only have been doing what she thought was necessary under the given circumstances. And B. cannot figure out what circumstances could have brought Takako to Bismarck, North Dakota, searching for something connected to the movie *Fargo*. Neither in truth, nor in fiction, does that make sense to her.

In April, Henri emails B. saying he'd like to visit. Though in some ways B. went to Japan to get away from him, she has continued to communicate with him by phone and email. He's aware that B. has time off during Golden Week—a week with four national holidays—and he wonders if that would be a good time to visit. B. agrees, then finds herself spiraling into a bout of sleepless anxiety. As usual, the specter of Henri makes her feel nauseated and stunned.

She writes, "I must be insane. I live my life in some kind of dream world, totally preoccupied with ideas and fantasies of my own creation. I can't explain why something captivates me or becomes the object of my obsessive musings. Fantasies and obsessions just appear to me, whole, and that's all. Rarely do I have the ability to see them objectively. When I do, the fantasy is over. It occurs to me now I have confused this kind of fantastical obsession for love."

FADE IN:

INT. OSAKA AIRPORT - DAY

B. stands in a crowd in front of a gate at the
Osaka airport. She hangs toward the back,
unsure if she should stay or run.

Henri comes through the doors at the gate and
scans the crowd until he finally sees B., par-
tially hidden behind a man in front of her. He
frowns. B. wonders if he can read her mind.

She steps out from behind the man, smiles,
walks up to Henri, and gives him a hug.

 B.
 Hi. You must be exhausted. I have
 some leftover adzuki beans and
 pumpkin with me. I thought you might
 be hungry. Vegan is strangely
 impossible in Japan.

 HENRI
 Oh, thanks. I'm starving. I'll eat
 when we get to the hotel.

The two of them start walking together toward
the luggage carousel, the strangeness between
them already dissipating.

In some ways, the ten days they spend together are amazing. They stay at the Ritz in Osaka, visit everything in Kyoto, and spend a few

days at a monastery in Koyasan, a Buddhist mountain sanctuary with more than one hundred temples, a cedar forest filled with stone monuments and gravestones, and young monks in training clacking through the streets in high wooden shoes and ceremonial robes.

INT. DIVE BAR/VEGAN RESTAURANT IN KYOTO - NIGHT

One night, B. and Henri go to her favorite vegan place in Kyoto and sit at the end of the bar. It's a dive bar just over the river from central Kyoto, dark and grimy and full of locals, owned by a Japanese woman in her forties who stands behind the bar. She looks kind of punk rock, with long, straight, unkempt black hair and black eyeliner, in a grungy black T-shirt, jeans, and motorcycle boots.

B. holds up two fingers to the woman.

 B.
 Food please. For two.

The woman nods and goes out the back door.

 HENRI
 Wow. Your Japanese is totally
 impressive.

 B.
 (laughs)
 I know.

The woman makes several trips inside, carrying Crock-Pots that she sets on a counter behind the bar.

B. is fascinated by the bar owner. She seems to have figured out how to live outside the Japanese system, the thing she always imagined Takako wanted but couldn't figure out. B. wonders if the woman has a rich family or maybe inherited the bar from a grandparent. It's like she's created an alternate reality inside the trappings of an old-school dive bar in Japan.

INT. DIVE BAR/VEGAN RESTAURANT IN KYOTO - NIGHT

The woman takes out two plates and starts
scooping food from the Crock-Pots onto them.

As they wait for their dinner, B. is suddenly
overcome with sadness and starts to SOB. Henri
sits next to her silently, waiting for her to
stop crying.

When she winds down, he points to a basket of
kittens sitting on the counter behind the bar.

Several of them appear to be sick, and the bar
owner keeps picking them up and wiping their
butts with a bar towel, then setting the towel
back down on the counter next to their plates
of food. It's shocking and fascinating and
distracts B. from her sadness.

 FADE OUT.

After Henri leaves, B. decides to stay in Japan and push through the
loneliness and culture shock to continue writing the script for her
film, which she titles *Self-Portrait with Double*. The film will depict
the last days of Takako's life: she'll move out of her apartment in
Shinjuku, stay in a Tokyo hotel with Douglas for a few days, then fly
to Fargo. B. plans to shoot the scenes in her apartment as a series
of rehearsals with actors. She will appear in the film as the director,
a filmmaker who is in Japan trying to make sense of Takako's story.
Japan will be a character in the film, as seen through the eyes of the
director in between rehearsals.

The one thing that never changes is the first image of the film: a
woman alone, unattached, floating in whiteness. She appears out of
nowhere like an alien and just as easily disappears back into the void.
B. imagines this effect might be created by shooting an actor in front
of the glass doors of her apartment and bringing her into and out of
focus. The white is the blown-out sky in the background, the oblivion
created by racking focus.

B.'s clarity and energy for this project lasts for a few days or a
week and then starts to flag. She begins to ruminate. She still doesn't

know what Takako wanted. She writes this doubt into the script as the director's main dilemma, but this doesn't satisfy her. She can't see the point of writing a film about a woman who was totally dependent on an American man named Douglas and then, when he disappeared, walked off into the cold, empty woods to die under the stars, maybe searching for something, maybe not. She doesn't want to make this film, and so when the doubt surfaces again, all progress stops. She decides that if she can't answer this question, she can't make the film.

She writes about Jean Rouch, the ethnographic filmmaker whose work came out of a philosophy of resistance and gave rise to the French New Wave. Rouch refused to film people as victims; he viewed his work as a playful collaboration with his "subjects" that would create a feeling of hope. He felt strongly that there was not only no point in telling a story that portrayed someone as a bug under a glass—a victim with no exit—but that there was a kind of violence to that. Every story needed to offer a way out, something that shimmered with hope. Even Camus, in *The Myth of Sisyphus*, came to the same conclusion. His absurd character realizes there is no point to existence but decides to live anyway.

B. considers how Simone de Beauvoir, in *The Second Sex*, says women often take refuge in fantasies of annihilation or transcendence rather than face the fact that the world is closed to them. B. decides that perhaps Takako's plan to find the money from the movie *Fargo* is an absurd form of resistance. The final scene, in which Takako goes out into the woods, will be like the final scene of *Thelma and Louise*: she realizes she can't go back to living her previous life, so instead, she goes out in a blaze of glory. B. doesn't know how she'll make that final scene in the woods seem like a blaze of glory. Maybe the stars shooting across the sky as she slips into unconsciousness can be manipulated to give that effect.

But even as she considers ways to make that work, another kind of despair corrodes her resolve. She wants to write a screenplay, but she knows it will take months or even years. Then she'll have to shoot the film itself, which will likely take another handful of months. And that's the most optimistic timeline, not a realistic one. It doesn't take into account the fact that she has a job and can't get out of bed most

of the time. And that's the real problem: she can feel the amount of time she has left in Japan contracting. Whereas a month or two before there were days when she liked her life and felt optimistic about what she might accomplish, now she wakes up every morning in despair, full of anxiety, wanting with every fiber of her being to go home.

With this in mind, she abandons the idea of writing a script and decides instead to try to create a composite portrait of a possible Takako using the handful of women she knows in Japan. She starts with Akemi and makes an appointment to visit her in Marugame.

FADE IN:

EXT./INT. CAR DRIVING ON ROAD LEADING INTO
MARUGAME - DAY

As B. drives into Marugame, she finds the
town itself bleaker than she had imagined, a
homogenous sprawl of large supermarkets and
convenience stores dotting a featureless road
that circles the island.

EXT. RESIDENTIAL AREA OF MARUGAME - DAY

Akemi and her family live in a small, single-
family home on a hillside, in a cluster of
similar homes. Akemi opens the front door as
B. pulls into the driveway.

INT. AKEMI'S LIVING ROOM - DAY

B. sits on the floor at a low table, drinking
tea with Akemi in her living room. Her video
camera sits on a tripod next to her, filming
Akemi's face. AKEMI'S MOTHER, a pretty woman
with dyed red hair, peeks in.

> AKEMI'S MOTHER
> Just saying hello. I'm so happy you
> and Akemi have become friends.

B. turns the camera to shoot Akemi's mom.

 B.
 Oh, hello, nice to meet you.

B. starts to stand up for a more formal greet-
ing, but Akemi's mother motions for her to stay
seated.

 AKEMI'S MOTHER
 Please, sit. I'm running away now.
 Just a quick hello. O.K.?

B. nods and turns the camera back to Akemi.

 AKEMI
 She's working. She has a beauty shop
 in the back of the house. I help her
 in the shop sometimes.

 B.
 Doing hair?

 AKEMI
 No. Bookkeeping. I help my dad,
 too. I'm trying to figure out how to
 save his business. He got into some
 trouble playing pachinko . . .

Akemi trails off, and her face drops. B. stays
quiet and lets the camera roll. Just when the
conversation seems to have taken a dark turn,
Akemi smiles.

 AKEMI
 I've met someone! A guy who plays
 games with me at the local arcade.
 He's short, and he makes false teeth
 for a living. I am spending too
 much time at the arcade, playing an
 online game. But I've made some new
 friends there, so that is good. And
 this guy is cute.

 B.
 Akemi! That is so great! I'm so glad
 you've met someone nice.

 AKEMI
 That's why I haven't called you for
 so long. I've been busy!

Akemi is beaming as she shares her news. She
seems transformed by this crush. They sip
their tea.

EXT. LONG, STEEP STAIRWAY LEADING TO KONPIRA
SHRINE - DAY

Akemi and B. ascend an impossible number of
steps to get to Konpira Shrine, one of the
oldest and best-preserved Shinto shrines
in Japan.

EXT. GROUNDS OF KONPIRA SHRINE - DAY

The shrine sits on top of the hill, alongside
the oldest Kabuki theater in Japan. They take
photographs out front and visit the sites.

EXT. LONG, STEEP STAIRWAY LEADING TO KONPIRA
SHRINE - DAY

They then descend the stairs and go into a café
in a scenic shopping area on the hillside below
the shrine.

INT. DIMLY LIT CAFÉ - DAY

There, they drink tea in a small, dark room
with hundreds of scrolls covered in Chinese
characters hanging from the ceiling, a fitting
location to write a letter to Takako's par-
ents, which is the main reason for B's visit.

Convincing Akemi to write the letter has been difficult. She clearly
doesn't think it's a good idea and has found numerous ways to
stall. Mostly, she has continued to insist that if B. really wants the
Konishis to talk to her, she needs to find the right person to make
the introduction. B. hasn't found "the right person," and now she just
wants to go home. So Akemi has reluctantly agreed.

INT. DIMLY LIT CAFÉ - DAY (CONTINUOUS ACTION)

B. sets up her camera on a tripod and hands
Akemi the draft of the letter she has writ-
ten. Akemi looks the letter over and shakes her
head. B. was prepared for this and takes out a
notebook and pen, handing them to Akemi.

Akemi starts to write a new letter from
scratch. She reads each sentence out loud
after she writes it.

> AKEMI
> Dear Mr. and Mrs. Konishi.
> Please excuse me for writing a
> letter suddenly like this. I am an
> artist from the United States but
> now live in Tokushima, where I teach
> English. I read about your daughter
> Takako three or four years ago in the
> newspaper. I was very sorry about
> what happened to Takako, and I would
> like to make a piece of artwork for
> her. I came here to Shikoku to learn
> more about her. Two years ago I went
> to North Dakota and interviewed the
> people who spoke with Takako while
> she was there. They said she was very
> polite and seemed to really want to
> get to Fargo, but they didn't know
> why. Maybe you don't know why she
> went to North Dakota either, but I am
> hoping you will meet with me and tell
> me more about her -- whatever comes
> to mind. Thank you sincerely.

Akemi looks at B. for affirmation.

> AKEMI
> Does that sound good?

> B.
> Sure. I trust you know best what the
> letter should sound like. You'll add
> my phone number and address so they
> can contact me?

> AKEMI
> Yes, of course. Did you bring
> the stationery I told you
> to get?

B. nods and pulls out stationery, matching
envelopes, and a package of stamps, and hands
them to Akemi. Akemi takes them and starts to
rewrite the letter in Japanese using her best
calligraphy.

EXT. ARCADE IN MARUGAME - DAY

B. parks her car outside what looks like
a small dive bar, and she and Akemi go
inside.

INT. ARCADE IN MARUGAME - DAY

It's dark inside the arcade, full of
games with maybe a dozen people playing
them. Akemi introduces B. to a handful of
her friends -- none of them seem to be the
guy -- and then leads B. over to the game
she's obsessed with.

> AKEMI
> You should try it. But beware.
> It's addictive.

> B.
> I couldn't be worse at video games
> if I tried. Keeps me from becoming
> obsessed.

> AKEMI
> We'll see.

B. tries her hand at the game while Akemi
SHOUTS INSTRUCTIONS, but she fails to properly
execute any of the moves.

Finally, B. hands the controls over to Akemi
and shoots some video of her playing.

EXT. ARCADE IN MARUGAME - DAY

Afterward Akemi walks B. to her car. B. gets
in, STARTS THE ENGINE and waves to Akemi,
watching as she disappears into the arcade,
probably to wait for her new boyfriend to
show up.

 FADE OUT.

Soon after, Ms. Akiyama, B.'s most unassuming and conscientious
student at a local soda-bottling plant, invites her to go fishing.
Ms. Akiyama's parents fish for a living, and she wants B. to have a
chance to go out on the sea. B. asks if it would be O.K. to videotape
parts of the day, and Ms. Akiyama agrees.

FADE IN:

EXT. HOUSE NEAR SEASHORE - BEFORE SUNRISE

The family is standing outside in the dark,
waiting for B., as she drives up to their
house.

EXT. SEASHORE - BEFORE SUNRISE (CONTINUOUS
ACTION)

They all walk across the road to a small wooden
boat on the shore. B. and MS. AKIYAMA get in,
and her parents push the boat out, join them
inside, and start to row out to sea.

EXT. SMALL WOODEN BOAT AT SEA - BEFORE SUNRISE
(CONTINUOUS ACTION)

B. takes out her camera and starts to film,
though it's still quite dark out. MRS. AKIYAMA
stands at the front of the boat, all muscle and
bone. Mr. Akiyama stops rowing once they're a
ways off from the shore. Mrs. Akiyama hoists
a net off the ground and throws it out to
sea, then pulls it back in like a machine.

Her gnarled fingers fit perfectly around the edges of the net. She grabs the largest fish and throws them into a bucket, tosses everything else overboard, and sends the net out again. Mr. Akiyama rows and occasionally rushes to the bow to assist, then rushes back to the stern. B. and Ms. Akiyama do the only helpful thing they can: try to stay out of the way.

The Akiyamas row to different spots and repeat the process until the sun is well-established in the sky.

Then Mr. Akiyama rows to a cement landing on the shore. A few men in coveralls and rubber boots meet them and help to haul the buckets of fish from the boat onto the landing.

INT. LARGE WAREHOUSE - DAY

The Akiyamas set their modest catch on the floor of a large warehouse next to other sea creatures, all laid out in neat rows.

B. walks along the rows, filming the fish and other aquatic animals.

A MAN WITH A MEGAPHONE STARTS AN AUCTION, standing on a wooden crate and calling out as a few men in the crowd subtly raise two fingers to indicate their willingness to purchase.

B. closely monitors the Akiyamas' reactions to the prices they get for the fish, but their faces betray neither happiness nor regret.

INT. CEMENT LANDING - DAY

After the auction, they all get back into the boat and row toward home.

EXT. SEASHORE - DAY

Mrs. Akiyama pulls the boat onto shore, and they all get out and return to the Akiyamas' house.

EXT. SMALL GROUPING OF HOUSES NEAR THE SHORE - DAY

Now that it's light, B. sees that the Akiyamas live in a traditional Japanese house in a grouping of maybe twenty houses looking out over the sea.

> MS. AKIYAMA
> Will you stay to have lunch with us?

> B.
> Yes, I would like that. Thank you.

Mrs. Akiyama motions for B. to enter the house.

INT. AKIYAMAS' HOUSE - DAY

Inside, B. shoots video of the interior of the house, which feels like the cabin of a boat, with everything hanging in nets on rusty nails pounded into the walls and ceiling.

Mrs. Akiyama prepares fish, rice, and pickle for lunch. As she cooks, she smiles at B. and her camera politely and asks questions, using Ms. Akiyama as a reluctant translator.

> MS. AKIYAMA
> She wants to know what you normally eat.

> B.
> Mostly rice, vegetables, and tofu. But I like fish a lot.

B. listens closely as Ms. Akiyama translates for her mom. Mrs. Akiyama looks at B. and nods. Mr. Akiyama sits nearby, away from the camera, but also listening with interest. Mrs. Akiyama asks another question for Ms. Akiyama to translate.

> MS. AKIYAMA
> What is your house like? Do you live with your family?

 B.
 No. I've been living in California.
 My family lives in Minnesota.
 California has beaches and lots of
 people. Minnesota has lots of lakes
 but no ocean. It's in the north, so
 it's very cold in the winter and hot
 like Japan in the summer. My family
 lives in a house about ten miles
 outside the city.

Again, B. waits while Ms. Akiyama translates for
Mrs. Akiyama, who then asks another question.

 MS. AKIYAMA
 Do you drive a car at home?

 B.
 I have a pickup truck.

Mrs. Akiyama listens to the translation and
asks another question, but Ms. Akiyama refuses
to translate.

 MS. AKIYAMA
 (with mild embarrassment)
 I'm sorry. My parents have never
 seen a foreigner before, so they're
 very curious about you.

B. looks over at Mrs. Akiyama and smiles, sud-
denly uncomfortable.

INT. AKIYAMAS' HOUSE - LATE AFTERNOON

After lunch, Mrs. Akiyama clears the table and
brings out a pot of tea. B. accepts the tea and
takes a sip. The Akiyamas then sip their tea,
watching B. closely.

 B.
 Thank you. I've really enjoyed
 today. I should get going before
 it gets dark.

Ms. Akiyama translates for her mom, who
replies.

```
                MS. AKIYAMA
            She says that you don't need to go.
            You could stay the night. It might
            be fun.

        B. sets down her cup of tea and looks at the
        Akiyamas, all three of them smiling at her.
        She realizes with regret that she has already
        overstayed.

                      B.
            That does sound fun, thank you. But I
            really need to get home.

        B. stands up and gathers her camera and tripod
        as Ms. Akiyama translates. B. smiles and bows
        to the Akiyamas as she moves toward the door.

                      B.
                  (bowing)
            Thank you, again. Thank you so much.

        The three Akiyamas stand next to the door, bow-
        ing to her as she leaves.

                                        FADE OUT.
```

Back at her apartment, B. reviews her footage. She doesn't see how the portraits of Akemi and Ms. Akiyama have anything to do with Takako, but she decides to continue and see if a film starts to take shape.

B. asks another of her students if she's willing to be filmed for the project. She is B.'s only private student. She's young and gorgeous and often shows up to lessons on a Ducati in full leather. She is a mother and has shown B. photographs of her children and her wedding. At the wedding, she is dressed in kimono, and her hair and makeup are done in traditional style. In the photos with her kids, her hair is pulled back in a ponytail and she wears jeans and a cardigan sweater. That's what interests B.—how this woman puts on and takes off her various personas so completely, as if she is multiple people inhabiting the same body. But the woman doesn't want to participate in B.'s film.

B. asks another student, a chemist. She is unmarried and lives alone and likes to play tennis in her free time. She jokes around with

her coworkers in class—all men—but she doesn't go out drinking with them after work. She seems lonely. She also declines to participate.

Each of the students B. asks to participate in the film declines, even her three favorite office ladies, the women who wear the same blue uniform every day and joyfully perform tasks like sweeping and making coffee. Ms. Nakahara, the oldest of the three, talks incessantly about Tom Cruise and writes imaginary dialogues with him in all of her homework assignments. One day she asks B. who her favorite actor is, and B. stupidly tells the truth: either Marcello Mastroianni or Toshiro Mifune. The woman looks at B. like she's crazy, and B. explains that they're actors from the sixties who are now dead. After a long pause, B. says she also likes Johnny Depp, and that satisfies Ms. Nakahara. From then on, Ms. Nakahara focuses on writing sentences that compare the two actors, illustrating how Cruise is superior to Depp. She also writes dialogues between the two and enlists B. and the other office ladies to enact them. As they perform the dialogues, it's all they can do to keep from collapsing into fits of hysterical laughter. B. wishes she had thought to say she liked Steve Buscemi, but it doesn't matter, since she can't convince any of the office ladies to participate in her film.

After she has exhausted her few connections, she wonders if perhaps she can convince strangers to perform in the film. She asks her student Tanaka-san for help. He's an engineer and is B.'s friend mostly because he is Chinese, so he is almost as lonely as she is. He's short, with thick glasses and a shiny bald spot he attempts to cover by combing a few loose strands over the top. B. asks Tanaka-san to take her to a "snack," a cheaper version of a hostess club, to sing karaoke and talk to some of the girls who work there.

```
FADE IN:

EXT. RED-LIGHT DISTRICT OF TOKUSHIMA - NIGHT

B. walks up the street into the red-light
district of Tokushima.
```

Young men with elaborate peroxide hairdos
parade back and forth in front of build-
ing entrances, where a few young women in
short skirts and lots of makeup CALL OUT to
passersby.

TANANKA-SAN is waiting for her in front of
a nondescript office building with tinted
windows.

> B.
> (laughing as she approaches)
> Hi. Thanks for doing this.

Tanaka-san nods, seeming a little nervous.
He turns and walks toward the entrance of the
building.

> TANAKA-SAN
> This is where we're going.

INT. SNACK CLUB - NIGHT

It's early when they arrive, and they're the
only customers, so five or six of the HOSTESSES
come to sit with them.

B. orders a Coke. Tanaka-san gets a beer and
tells the Hostesses to buy themselves a drink
too. Two of the Hostesses bring the drinks
over, and they all sit and chat. Mostly they
shower B. with compliments.

> HOSTESSES
> (in Japanese; a cacophony of voices)
> Wow. You are so beautiful. You must be
> very intelligent too. A teacher! You
> must've traveled a lot, yes? Oh, you
> speak Japanese. You're so impressive!

They say all of this to Tanaka-san, who trans-
lates, laughing as he does.

> TANAKA-SAN
> (laughing, to B.)
> You are so beautiful.
> (in Japanese, to Hostesses)
> She's my English teacher.

 (laughing, to B.)
 Oh, you are so intelligent.
 (pause, listening to Hostesses)
 They think your Japanese is
 impressive. You haven't spoken
 any Japanese, have you?

It's embarrassing. Somehow B. thought that,
being a woman, she would be spared this kind of
treatment, but she's the paying client, so she
gets all the compliments.

 B.
 Let's sing karaoke, O.K.?

Tanaka-san nods.

 B.
 (loudly, to everyone)
 Karaoke? Yes? O.K.! Karaoke!

 TANAKA-SAN
 (mockingly)
 Oh, more Japanese! Impressive!

One of the Hostesses goes to fetch the micro-
phone and brings it back to the table.
Tanaka-san takes the microphone and starts
to SING a throaty emotional ballad he's obvi-
ously spent quite a bit of time rehearsing.
The Hostesses at the table listen as if spell-
bound. B. flips through the songbook looking
for something she knows.

Tanaka-san hands B. the microphone. She takes
it and stands up on the bench and SINGS Pat
Benatar's "Love Is a Battlefield." She sings
it loudly and somewhat badly, straining at the
high notes.

Afterward, the Hostesses shower her with com-
pliments, but Tanaka-san, who apparently takes
karaoke very seriously, looks a bit disturbed.

By this point, a few other groups have arrived,
and so most of the Hostesses migrate to
other tables to mingle with the new guests.
One HOSTESS stays with B. and Tanaka-san.

She's pretty, with dyed red hair and a tinge of
sadness at her edges.

> B.
> (to Tanaka-san)
> Will you ask her a few questions
> for me?

He agrees.

> B.
> Ask her about her plans for the
> future. Does she have any hopes and
> dreams?

> TANAKA-SAN
> (shaking his head)
> I won't ask her that. Come up with
> something else.

B. thinks for a moment.

> B.
> O.K., ask her to imagine she's
> telling a story about a woman who sets
> out on a journey, searching for
> something. Ask her to invent that
> story. What would this woman be like,
> and what would she be looking for?

Tanaka-san shoots B. a look that says "no way."

> TANAKA-SAN
> (in Japanese, to the Hostess)
> Bring us another round of drinks.
> And I'd like to sing another song.

He opens the songbook and soon starts to
PERFORM another love song.

When he's done singing, B. has finished her Coke.

> TANAKA-SAN
> I think we're finished here.

B. doesn't back down.

> B.
> Ask her my question.

He refuses.

> TANAKA-SAN
> Maybe we can come back another time.
> (in Japanese, to the Hostess)
> You can bring us the check.

B. pays the bill, which comes to something
like one hundred dollars for a few beers, a few
Cokes, and some snack mix. This makes B. even
more furious.

EXT. STREET IN RED-LIGHT DISTRICT - NIGHT

Once outside the club, B. starts in with him.

> B.
> What is wrong with you? I'm buying
> your drinks so you'll ask these
> ladies questions for me, and then you
> refuse to do it! What's up with that?

Tanaka-san is also furious.

> TANAKA-SAN
> What you are asking is impossible!
> If you want Asian people to do
> something, you have to be very
> specific about what you expect from
> them. They can't invent stories
> or imagine the future. That's too
> difficult.

B. throws her hands up in frustration.

> B.
> How do you know? Just because it's
> difficult for you doesn't mean all
> "Asian people" lack imagination.
> Why couldn't you just ask? I didn't
> need you to approve of my question,
> or edit it. Just to ask what I was
> telling you to ask! That's all you
> needed to do!

Tanaka-san shakes his head and walks away,
leaving B. standing on the street.

FADE OUT.

As summer arrives, B.'s circumstances and mental state become even bleaker. The academy has assigned more classes to her, so she's working almost all the time now for the same amount of money. It's hot and humid, the rains have begun, and the air is oppressive. B. lives on the fourth floor with giant south-facing windows that soak up the heat. She has one fan and no air-conditioning, so being inside is unbearable, but so is being outside. She's waiting for the tidal wave warnings to begin. She's started to dream of people running for their lives as large tidal waves pummel the town, leaving a trail of destruction in their wake. This in and of itself seems like good reason to leave.

Her brain cleaves in two and does battle with itself. The emotional part of her has collapsed in despair and is ready to go home, but the taskmaster refuses to leave until something is accomplished. She can't decide, and this further slackens progress. She starts to search for tickets home, but it's peak season, and even the cheapest flights cost more than a thousand dollars. Some days she tries to convince herself she's exactly where she needs to be to get the film done; she just needs to buckle down and write something. Other days she lies in bed staring at the ceiling, steeping in misery.

She has expressed this dilemma to friends via email, hoping someone will perceive her desperation and tell her to come home. Instead, they all advise her to stay in Japan a while longer, at least until she figures out how to finish the film. Except for Henri, who writes, "Keep in mind that you shouldn't stay just for the sake of staying. You should stay to accomplish what you wanted to accomplish. So it might be a good idea to make an explicit plan of attack, i.e., I am going to shoot this on this day, edit this on this day, etc. You can always change it. But without a game plan, months might go by without making headway."

Too true. But hell if she can make a game plan.

B. circles around to the idea of making a film like Godard's *Numéro deux*. She will set up her apartment like a film studio, with monitors and computers, and play some of the video she's shot in Japan on the monitors while she, as the director, and Takako, via text message, tell the story. It's not a bad idea, and it might work, but she can't see how even this "simple" film will take less than a few months, if not years, to make. And she'll need money she doesn't have. She can't even afford to buy a table and chair, much less video monitors. So the wheel of despair continues to turn.

She starts to think about making a film about the pilgrimage in Shikoku, an eighty-eight-minute film consisting of a one-minute vignette about each temple on the pilgrimage. She doesn't know why she's even contemplating this, except that it's the only film she can imagine being able to make at this point. But she has spent a lot of time hanging around the temples in Tokushima, and for the most part they leave her unenthralled. The only thing she finds somewhat interesting about them is the chanting. Each temple has its own chant, and busloads of elderly pilgrims arrive and stand in front of them chanting and ringing bells in unison. It's a haunting and resonant sound. The chanting asks the patron saint of the temple for a certain kind of deliverance, which is perhaps what draws her to it— she, too, is desperately wishing for something to intervene and yank her from this hell. Still, an eighty-eight-minute film about chanting doesn't seem worth the trouble.

At the end of June, Benjamin, a cinematographer B. met in Tokyo, flies to Shikoku on a whim to meet up with her. He has a day off from shooting the documentary he's working on and wants to see something of Japan beyond Tokyo.

```
FADE IN:

EXT./INT. TOKUSHIMA AIRPORT - DAY

B. stands outside, leaning against her car,
as BENJAMIN, a very tall, skinny, unshaven
and smiley man approaches her and gives her
a big hug.
```

 B.
You are so insane! I can't believe
you flew down here for a few hours.

 BENJAMIN
Well, I want to see more than just
Tokyo while I'm here. This is my
opportunity.

 B.
So they flew you to Japan a second
time. This project must have a lot of
money!

 BENJAMIN
We're being very frugal while we're
here.

They get into her car. Benjamin's knees are
almost up to his ears.

 B.
Sorry. Small car.

 BENJAMIN
I'm used to it.

 B.
I was thinking we could go to see
one of the nansho -- the perilous
temples, they call them -- on the
Shikoku pilgrimage? Something
I've been wanting to check out
but haven't yet.

 BENJAMIN
Sure. I'm up for anything.

 B.
Cool. Sorry to be selfish and take
you to something I haven't seen
yet . . .

 BENJAMIN
No, that's awesome.

B. pulls a book out of the back seat, opens it
to a marked page and reads from it.

> B.
> (reading)
> "Shōzan-ji, the Temple of the
> Burning Mountain. Legend has it
> that Kōbō-Daishi" --
> (an aside, not in book)
> that's the patriarch of Shingon
> Buddhism --
> (reading again)
> "subdued the fiery dragon of this
> mountain who was causing great
> damage to life and property in the
> area. As the Daishi ascended the
> mountain, flames threatened to
> engulf him, but he extinguished them
> by forming the Mudrā of the Turning
> Wheel of the Dharma with the aid of
> Kokūzō Bosatusu, and finally sealed
> the dragon in a cave, carving two
> images to guard it.
> (to Benjamin, no longer reading)
> Maybe that's what makes it perilous:
> the dragon might escape again.
> Or maybe it's that the temple is
> located at . .
> (reading again)
> . . . "two thousand, six hundred and
> forty feet above sea level."[10]

> BENJAMIN
> I'm in.

> B.
> Awesome. Hope the dragon stays in
> the cave while we're there.

B. sets the book down and starts the car. They
drive off.

EXT. STEEP WOODED PATH LEADING TO SHŌZAN-JI – DAY

B. and Benjamin start their ascent. On their way up, Benjamin stops to shoot photographs and short videos of people and trees.

They meet a small cadre of pilgrims coming down from the temple. One of them, a YOUNG MAN, steps forward to address them.

> YOUNG MAN
> Hello. Have you two been here before?

> BENJAMIN
> First time.

> YOUNG MAN
> We're wondering: Would you like someone to show you around the temple?

B. smiles as she shakes her head and tries to hurry Benjamin forward; by now, she's learned that a lot of homeless people dress in the white garb of pilgrims in order to work various cons. But Benjamin hangs back. He seems inclined to take up the offer and, after further observation, B. also intuits the man's sincerity.

> BENJAMIN
> That would be nice. Thank you.

The Young Man and a few of his friends turn around to accompany B. and Benjamin up the hill to the temple.

> YOUNG MAN
> I've walked the pilgrimage many times now. I started walking over a year ago, and after the first time, I felt different. I didn't want to go back to living the same life, so I decided to walk it a second time. At first I was alone but, eventually, I met a group of other people doing the same thing.
> (MORE)

> YOUNG MAN (CONT'D)
> Together, we walk the loop around
> the island again and again.

He gestures to his friends, and they smile.
The language barrier prevents the pilgrim from
expressing himself fully, but it seems he's
found whatever he was looking for. Finding it
hasn't helped him figure out what to do next,
though, so he just keeps walking. B. is moved
by his story.

They get to the top of the hill and walk
together through the temple complex, the Young
Man pointing out sites, mostly to Benjamin.

B. gets caught up in the moment and completely
loses track of time. Suddenly, she realizes
she's going to be late for class. She rushes
up to Benjamin and grabs his arm with a look
of panic on her face.

> B.
> Oh my god! We've gotta go now! I'm
> so sorry! I totally lost track. I'm
> going to be very late to class!
> (to the Young Man)
> Thank you so much. You have been so
> kind to us. I wish you all the best
> on your journey.

As they are leaving, the Young Man grins
beatifically and gives them a gift, a small
talisman. He puts it into Benjamin's hand and
bows to them both.

Then B. and Benjamin run down the hill to her
car, and together they speed off to the factory
where B. has class.

On the drive, it occurs to B. that the young man found whatever he
had been searching for just a few miles from Takako's hometown. He
put everything down to search, and maybe that's why he succeeded.
He didn't have to go far; it was the setting aside that was important.

And once he let everything go, he didn't see any reason to pick it back up again.

That night, when she gets home, she writes, "Nothing is more terrifying or unapproachable than emptiness, but maybe if the mind has a form to inhabit, it can learn to let go."

At the end of July, Pete, Yuki, and Stacey invite B. to go along with them on a visit to the island of Naoshima. Stacey has finished the pilgrimage, and he wants to visit something there before he goes home.

Naoshima used to be a remote fishing island in the Seto Inland Sea, but now it's an art destination with several museums and hotels designed by famous architects. Visitors have to travel to and from the island via ferry, usually staying for a few days to take in the sights and the beaches. The four of them would have liked to have done this, but they have little money and only one day. They board the ferry at 4:00 a.m., and Yuki goes over a carefully planned itinerary that includes everything she thinks they can see before the last ferry returns to the mainland.

```
FADE IN:

INT. BENESSE HOUSE - DAY

At the first museum, Benesse House, Pete,
Yuki, Stacey, and B. pause before Bruce
Nauman's 100 Live and Die, a wall of blinking
neon that pairs fifty words -- "play," "come,"
"suck," "know," "fail," "eat," "sleep" -- with
the phrases "and live," or "and die." Phrases
like "RUN AND DIE," "STAY AND LIVE," "LOVE AND
DIE," "PISS AND LIVE," "THINK AND DIE," "PAY
AND LIVE" blink rhythmically in yellow, white,
blue, green, and red neon. It's a mesmerizing
reminder that everything, glorious or shitty,
ends in death.
```

> PETE
> (laughing, to B.)
> This is one of the most popular
> backdrops for wedding ceremonies
> in Japan.

Yuki looks at B. and nods.

> YUKI
> It's true.

> B.
> (laughing)
> What! Why?

> PETE
> Yuki?

Yuki shrugs and laughs, as if to say no expla-
nation is possible. They all move on.

In another gallery, B. stands contemplating a
series of minimalist photographs of the hori-
zon line at sea by Hiroshi Sugimoto.

Yuki, Pete, and Stacey jog up to her.

> YUKI
> We have to go. We are already behind
> schedule.

Stacey grabs B.'s hand and pulls her along.
B. follows reluctantly.

Further along, B. stops in front of Jonathan
Borofsky's Chattering Men, three tall mechani-
cal statues. The others continue to speed walk
ahead. B. doesn't follow, staying to look at
the sculptures. Moments later, Pete loops back
and prods her forward.

INT. CHICHU ART MUSEUM - DAY

They enter the famous Chichu museum, which
houses several of Monet's giant Water Lilies,
each carefully lit using only natural light.
B. walks into one of the galleries, rapt. In
the soft light the lilies seem to float off
the canvases.

Yuki looks at her watch and enters behind her.
She holds up three fingers to B.

> YUKI
> Seriously, three minutes. I'm sorry
> we don't have more time, but we need
> to hurry if we're going to catch the
> bus to the village. It's on the other
> side of the island.

B. nods to indicate that she understands.

> B.
> O.K. I'm right behind you.

B. starts to walk backwards slowly toward the
exit, taking in the Monet paintings for a few
more moments.

EXT. HONMURA VILLAGE - DAY

When they get off the bus, it's raining.
They walk quickly through a traditional-
looking village with narrow, winding streets
and wooden houses. A small café with seat-
ing that spills into the street is full of
young, arty internationals drinking coffee.
But they move quickly past, up a hill toward
Minamidera, a structure built on the former
site of a Buddhist temple, designed by the
famous Japanese architect Tadao Ando.

> STACEY
> (to B.)
> I'm sorry we have to rush, but this
> is totally worth it. You'll see.

EXT. MINAMIDERA - DAY

They join a small crowd waiting outside
Minamidera in the rain, pressing against
the outer wall in an attempt to keep dry. But
the rain cascades off the roof and BOUNCES
OFF THE CONCRETE, and everyone gets soaked.

Backside of the Moon, the installation by James Turrell inside Minamidera, is what they're waiting to see. B. thinks about the piece she most associates with Turrell—though it's actually a piece by his fellow Light and Space artist Robert Irwin titled $1^o2^o3^o4^o$—at the Museum of Contemporary Art San Diego. A friend had taken her to the museum to see the piece with an enthusiasm similar to Stacey's. She remembers standing in front of three rectangles cut from a large picture window looking out on the ocean. That was the piece—the holes in the window. At the time, it didn't seem like anything to get excited about, and while B. tried to seem interested, she silently wondered how much the artist was paid to ruin a very expensive window. She's curious to see what Turrell has done to Ando's temple.

EXT. MINAMIDERA - DAY (CONTINUOUS ACTION)

A GUARD wearing black appears at the entrance.

> GUARD
> (in Japanese)
> O.K. One at a time, please. Thank you.

> YUKI
> Go on. He takes us in one at a time.

Stacey follows the Guard inside.

After a moment, the Guard returns and offers his arm to B. She takes hold of it and goes into the temple.

INT. MINAMIDERA - DAY (CONTINUOUS ACTION)

The interior of the temple is quiet and totally dark. THE CAMERA CONTINUES TO ROLL, SHOOTING THE DARKNESS.

The Guard leads B. through the black space of the temple. We hear the even rhythm of their FOOTSTEPS and the sound of B.'s BREATHING as she concentrates, trying to feel into the space in front of her.

Finally, the Guard stops and B. KNOCKS into
a solid shape that feels like a wooden church
pew. B. extends one hand to touch it as the
Guard sits her down.

> STACEY
> (whispering)
> Hello.

> B.
> (whispering)
> Hello.

We hear the RAIN FALLING outside, the
PATTERING on the roof, the STREAMING onto
the pavement from the roof and gutters.

The Guard returns, leading someone else inside,
across the floor, to a bench. We hear the quiet
FOOTSTEPS of the Guard as he retreats, then
returns again with another person. And another.
Until finally it is quiet and there seem to be
about thirty people sitting inside, BREATHING
together, waiting in the dark for what will hap-
pen next.

Once in a while, we hear someone SHIFT OR CLEAR
THEIR THROAT, but mostly it's silent.

B. is aware of the feeling of her bones on the hard pew; the warm
damp of clothes against her skin; the tightness in her throat; the slow
rising and falling of her chest. She feels Stacey's arm touching hers;
her heart beating. She continues to pay attention, to wait for some-
thing to happen. Her mind starts to drift, to float in the darkness.

She thinks maybe she sees something—a colored light, very
faint, maybe red or orange; it slips in and out of her perception like
the spots she sees when she closes her eyes, only now her eyes are
open and she doesn't know if the light is real or in her mind. When
it's there, she watches it. When it vanishes, her mind flows into the
dark.

She begins to notice that the light is connected to the beating of
her heart; when it beats, the light gets brighter; when it relaxes, the

light goes out. Her mind starts to merge with this rhythm—systole, diastole, systole, diastole.

Slowly the pulse of light disconnects from the beat of her heart and becomes more consistently present. She watches it closely.

INT. MINAMIDERA - DAY (CONTINUOUS ACTION)

A dim rectangle of light glows in the distance, growing in intensity to a brighter hue: yellow instead of orange.

Two dark silhouettes stand slowly into the frame. Holding each other, one tentative step after another, they start to traverse the expanse between the pews and the rectangle.

They arrive to the light. They reach out, try to grasp it, then turn to go.

The rectangle is empty again, the light pulsing in its frame, becoming lighter.

The silhouette of a young man stands into the frame. He slides out one foot, then the other, groping his way across the dark floor.

A group of hunched, unsteady, aged women totter out behind him, holding each other up as one with a cane taps out the course in front of them. They move in concert, like ancient sisters.

Another young couple, maybe Pete and Yuki, stands and goes in hesitating steps, holding onto each other to cross the space.

Stacey stands up, too, and moves across the floor toward the rectangle.

Several figures stand in front of the light, their arms outstretched, waving and undulating as if trying to grasp it.

One by one, they turn and exit the frame.

Then B. is alone, her form imperceptible in the dark. We hear her BREATHING IN AND OUT.

The constant THRUM OF RAIN on the roof slows
and gives way to the HUM OF SILENCE. B. remains
still, transfixed by the light.

She stands up slowly and reaches her hands out
in front of her. Except for the distant rect-
angle, the blackness is total. Tentatively,
she puts one foot out in front of her. Then
another. The CAMERA TRACKS WITH HER as she
advances through the dark. Moving like this,
it's a long way to the light.

When she arrives to the rectangle, it has
dimmed, appears bluish. Her outline is visible
against the pale shape which is now more
absence than presence, a hole cut in the wall;
the light seems to emanate from a shaft. She
reaches her hand into the space, but there is
nothing to touch. She looks down searchingly,
as if wanting to descend, tunnel below to the
source of the light.

She stands and turns toward the exit. The
CAMERA FIXES ON THE DOORWAY AND MOVES SLOWLY
TOWARD IT. B. enters the frame and walks at a
deliberate pace toward the brightness outside.
The CAMERA TRACKS TOWARD the bright doorway
until the frame is overtaken by white.

EXT. OUTSIDE MINAMIDERA - DAY (CONTINUOUS
ACTION)

The particles of light in the blown-out frame
reconfigure into the form of B., standing
outside the temple. Sun glistens on the wet
surfaces of leaves and pavement around her.
B. turns her head, taking in the scene, her
eyes adjusting to the brightness. She smiles
to herself. FREEZE FRAME.

 FADE OUT.

 THE END

NOTES

1. This *is* a true story. The events described in this book took place between 2001 and 2005 in Minnesota, North Dakota, California, and Japan. In some instances, I took creative license with setting, chronology, and dialogue. With the exception of Takako Konishi and Chief Keena, who appear in the news article published at the beginning of the book, the names have been changed. When referenced in the essay sections of the book, artists, writers, and film-makers are referred to by their real names.

Reel 1.
1. Some of the visual elements of this scene reference *8½*, directed by Federico Fellini (1963; New York: Janus Films, Criterion Collection, 2001), DVD.

2. The adaptation is based on the story of Yuki-Onna as it appears in Lafcadio Hearn, *Kwaidan: Stories and Studies of Strange Things* (New York: Houghton Mifflin, 1904).

3. These scenes are adapted from an unfinished screenplay by Jana Larson and Katinka Galanos, "The Snow Woman" (unpublished manuscript, 2001), typescript.

Reel 2.
1. Several years after the film came out, in a short documentary on the *Fargo* DVD, the Coen brothers admitted that *Fargo* was a fiction. But that was *after* Takako's trip to Fargo (*Minnesota Nice*, directed by Jeffrey Schwarz [2003; Santa Monica, CA: MGM Home Entertainment], DVD).

2. The Coen brothers identified the 1986 murder of Helle Crafts as the inspiration for the "wood chipper scene." This was the case of a Danish airline stewardess who was murdered by her American husband, Richard Crafts, in Connecticut. The story got a lot of press because Crafts disposed of his wife's body by putting it through a wood chipper he parked on a bridge over the Housatonic River during a snowstorm. For a long time, the police were unable to charge Crafts for the murder because they couldn't issue a death certificate without the body. Divers searched the river for remains and eventually found one tooth. A judge ruled that the tooth was sufficient evidence for a death certificate, and Crafts was charged with murder, but it took three more years to convict him. Aside from the one chilling scene in which Grimsrud puts Showalter through a wood chipper, there doesn't seem to be much else related to the Crafts murder in the film. For more about the Crafts case, see "Richard B. Crafts," Murderpedia, Encyclopedia of Murderers, http://murderpedia.org /male.C/c/crafts-richard.htm.

3. Mike O'Rourke, "Reaction to 'Fargo' Nomination," *Brainerd Dispatch*, February 11, 1997.

4. *Minnesota Nice*, dir. Schwarz.

5. A story in the *New York Times* that recounts the famous 1963 case of
T. Eugene Thompson, who hired a hit man to kill his wife, reports that many
Minnesotans believed this case was the inspiration for the movie *Fargo*.
However, the Coen brothers said they had never heard of Thompson's case.
(Sam Roberts, "T. Eugene Thompson Dies at 88; Crime Stunned St. Paul," *New
York Times*, September 5, 2015.)

The 1972 kidnapping of Virginia Piper also shares several details with
the kidnapping in the film: a woman was kidnapped from her home by two
masked men, a million-dollar ransom was paid and never recovered, and two
bumbling local criminals were later identified as the kidnappers but were never
convicted. (William Swanson, "More Than Forty Years Later, the Virginia Piper
Kidnapping Remains Shrouded in Mystery," *MinnPost*, July 28, 2015, www
.minnpost.com/mnopedia/2015/07/more-forty-years-later-virginia-piper
-kidnapping-remains-shrouded-mystery.)

6. The camera wasn't rolling during this conversation, so some of it is quoted
from the statement "Lisa" (alias) gave to police as recorded in the Minnesota
Bureau of Criminal Apprehension Report of Investigation, 2001-481.

7. "Stu Carlson and Cort Baumler" (aliases of Bismarck, North Dakota,
police officers) in a videotaped conversation with the author, February 2003.

8. "Jamie Harmon" (alias of Bismarck, North Dakota, police officer) in a
videotaped conversation with the author, February 2003.

9. "Donald Keller" (alias) in a videotaped conversation with the author,
February 2003.

10. Ernest Jones, *Sigmund Freud: Life and Work*, vol. 2, *Years of Maturity:
1901–1919* (London: Hogarth Press, 1955), 421. In a footnote Jones gives the
original German, "Was will das Weib?"

In her book *The Bonds of Love*, psychoanalyst Jessica Benjamin tries to
answer this question. She writes about the desire for a different kind of relation-
ship between self and other, a desire for mutuality or *attunement*. It's actually a
desire to feel real, to feel that "I am the doer who does, I am the author of my
acts" (21). She writes that Simone de Beauvoir had the insight: "that woman
functions as man's primary other, his opposite—playing nature to his reason,
immanence to his transcendence, primordial oneness to his individuated
separateness, and object to his subject" (7). Benjamin posits the theory of inter-
subjectivity, the desire for attunement, as an alternative to this duality, and to
what Hegel saw as the inevitable struggle for power (31-32).

According to Benjamin, the only way to feel real is to meet the world and
others as an equal. Only then can a person be at ease with experience, act out of
curiosity or responsiveness rather than need or anxiety. When equality breaks
down, one feels neither connected to the world, nor free when alone. Instead,
she writes, "a person feels that aloneness is only possible by obliterating the
intrusive other, that attunement is only possible by surrendering to the other"
(28). This desire for a space in which one can live in the world and with others

outside the struggle for either domination or submission, she says, is what the writer Milan Kundera called the realm of co-feeling, "the ability to share feelings and intentions without demanding control, to experience sameness without obliterating difference" (48).

The desire to connect rather than control or submit. The desire to feel real because one is seen on one's own terms, given the space and freedom to be. Perhaps the paradox of this desire is that one cannot achieve it alone; it requires the presence of another, an equal. Without the equal other, one is adrift, alienated, directionless, powerless; one feels she is disappearing, invisible.

Reel 3.

1. This scene is influenced by the opening scene of *L'eclisse,* directed by Michelangelo Antonioni (1962; New York: Janus Films, Criterion Collection, 2005), DVD.

2. *Biospheria: An Environmental Opera,* music by Anthony Burr, dir. Steve Ausbury. University of California, San Diego, March 15–18, 2001. It's unclear why there were only five planets orbiting around the sun and moon in this scene.

3. The discussion of the film *Hiroshima mon amour,* directed by Alain Resnais (1959; New York: Janus Films, Criterion Collection, 2003) DVD, is influenced and informed by viewing the film, reading the screenplay by Marguerite Duras, and reading James Monaco's essay about the film, which appears as the third chapter in his book *Alain Resnais.*

4. James Monaco, "False Documentary," *Alain Resnais* (New York: Oxford University Press, 1979), 34.

5. Monaco, 34.

6. Marguerite Duras, *Hiroshima Mon Amour* (New York: Grove Press, 1961), 15–18.

7. Monaco, 43.

8. Monaco, 37.

9. Duras, 9.

Reel 4.

1. Julio Cortázar, "The Distances," *Blow-Up and Other Stories* (New York: Pantheon Books. 1985), 18.

2. Wikipedia, s.v. "Julio Cortázar," last modified March 17, 2020, 18:22, https://en.wikipedia.org/wiki/Julio_Cortázar.

3. Cortázar, "The Distances," 20.

4. This scene is based on two films: (1) *After Life,* directed by Hirokazu Kore-eda (1998; New York: New Yorker Video, 2000), DVD. The film is shot in an institutional-looking brick building that could be a school or a hospital. At the beginning of the film, a group of people enter and are interviewed one at a time by the "staff." It becomes clear this is a way station, a brief purgatory between one life and the next, where the goal is for each of the newly deceased to select one memory from this (now previous) life to carry with them to the

next. In this scene, Takako could be played by Erika Oda, the star of *After Life,* and Death by Tilda Swinton. (2) *Orphée,* directed by Jean Cocteau (1950; New York: Janus Films, Criterion Collection, 2011), DVD. Death, a dark-haired femme fatale in sunglasses played by María Casares, drives a black Rolls-Royce across the border between life and death.

5. Caroline Wyatt, "'Paris Syndrome' Strikes Japanese," *BBC News, Paris,* December 20, 2006, http://news.bbc.co.uk/2/hi/6197921.stm.

6. Wikipedia, s.v. "Paris Syndrome," last modified March 11, 2020, 14:27, https://en.wikipedia.org/wiki/Paris_syndrome.

7. Wikipedia, s.v. "Stendhal Syndrome," last modified March 13, 2020, 16:56, https://en.wikipedia.org/wiki/Stendhal_syndrome; quote from Stendhal, *Naples and Florence: A Journey from Milan to Reggio,* 1817, quoted in *Interfaces of Performance,* ed. Maria Chatzichristodoulou, Janis Jefferies, and Rachel Zerihan (Burlington, VT: Ashgate, 2009), 196.

8. *Blow-Up,* directed by Michelangelo Antonioni (1966; Burbank, CA: Warner Home Video, 2004), DVD.

9. Cortázar, "Blow-Up," *Blow-Up and Other Stories* (New York: Pantheon Books, 1985), 116.

10. Cortázar , "Blow-Up," 131.

11. *Vagabond,* directed by Agnès Varda (1985; New York: Janus Films, Criterion Collection, 2000), https://www.criterionchannel.com/videos/vagabond.

12. *Vagabond: Remembrances,* directed by Agnès Varda (2003; New York: Janus Films, Criterion Collection), https://www.criterionchannel.com/videos/remembrances.

13. Edited statement "Cabbie" gave to police as recorded in the Minnesota Bureau of Criminal Apprehension Report of Investigation, 2001-481.

14. The full medical report is not public record and was not included in the police report; only the summary findings of the autopsy were included.

15. *This Is a True Story,* directed by Paul Berczeller (2003), http://www.berczeller.com/?project=this-is-a-true-story.

16. Jamie Harmon (alias of Bismarck, North Dakota, police officer) in a videotaped conversation with the author, February 2003.

17. Peter Stark, "Frozen Alive," *Outside,* January 1997, http://www.outsideonline.com/2152131/freezing-death.

18. Space Weather, "What's Up in Space—November 12, 2001," http://www.spaceweather.com/archive.php?view=1&day=12&month=11&year=2001; Space Weather, "Aurora Gallery, November 5-6, 2001," http://www.spaceweather.com/aurora/gallery_06nov01_page3.html.

19. I originally found this information on the Centers for Disease Control and Prevention website, http://cdc.gov, but the webpage is no longer available. See Ken Zafren and Ingrid T. Lim, "Hypothermia: A Cold Weather Hazard," *Relias Media,* November 1, 2005, https://www.reliasmedia.com/articles/82980-hypothermia-a-cold-weather-hazard.

Reel 5.

1. I wrote these notes during a class with Eileen Myles. They likely represent a mixture of my own thoughts and points from Myles's lecture.

2. This section of voiceover, and indeed this entire short script, draws from Cortázar, "The Distances," 17–27.

3. Thomas F. Oltmanns and Brendan A. Maher, *Delusional Beliefs* (New York: Wiley, 1988), 20.

4. Oltmanns, 78.

5. Oltmanns, 49–50.

6. Oltmanns, 38–40.

7. *Wanda,* directed by Barbara Loden (1971; Bardene International Films; Parlour Pictures, 2006), DVD.

8. "The Mike Douglas Show—Loden, Lennon, Ono," *The Mike Douglas Show,* February 15, 1972, 12:35, https://www.youtube.com/watch?v =PtBuOTWoRpw@feature=youtu.be.

9. Quoted in Kate Taylor, "Driven by Fierce Visions of Independence," *New York Times,* August 29, 2010, https://www.nytimes.com/2010/08/29/movies /29wanda.html.

10. Quoted in Taylor, "Fierce Visions."

11. Taylor, "Fierce Visions."

12. Taylor, "Fierce Visions."

13. McCandlish Phillips, "Barbara Loden Speaks of the World of 'Wanda,'" *New York Times,* March 11, 1971, 32, https://www.nytimes.com/1971/03/11 /archives/barbara-loden-speaks-of-the-world-of-wanda.html.

14. Marguerite Duras and Elia Kazan, "Conversation on *Wanda* by Barbara Loden," *Cinema Comparat/ive Cinema* 4, no. 8 (2016), 12–13 (originally published in *Cahiers du Cinéma,* December 1980).

15. Marion Meade, "Lights! Camera! Women!" *New York Times,* April 25, 1971, quoted in "For Wanda," by Bérénice Reynaud, *Senses of Cinema* 22 (October 3, 2002), http://sensesofcinema.com/2002/feature-articles/wanda.

Reel 6.

1. Shelley R. Adler, *Sleep Paralysis: Night-mares, Nocebos, and the Mind-Body Connection* (New Brunswick, NJ: Rutgers University Press, 2011), 8–26; Wikipedia, s.v. "night hag," last modified February 28, 2020, 14:38, https:// en.wikipedia.org/wiki/Night_hag.

2. Justin McCurry, "Loan Sharks Fuel Japan's Suicide Rise," *Guardian,* August 16, 2003, https://www.theguardian.com/world/2003/aug/17/japan .justinmccurry.

3. This is changing now, and many women are entering the workforce in Japan, but see the following for a discussion of the state of Japan's culture around work at the time of Takako's death: Karen A. Shire, "Gendered Organization and Workplace Culture in Japanese Customer Services," *Social Science Japan Journal* 3, no. 1 (2000): 37–58.

4. Gabriele Koch, "The Libidinal Economy of the Japanese Sex Industry: Sexual Politics and Female Labor" (PhD diss., University of Michigan, 2014), 133–136, https://deepblue.lib.umich.edu/bitstream/handle/2027.42/110490/gabikoch_1.pdf?sequence=1.

5. Nicholas D. Kristof, "In Japan, Alibis Are an Industry," *New York Times*, July 11, 1999, https://www.nytimes.com/1999/07/11/weekinreview/in-japan-alibis-are-an-industry.html.

6. Ethan Watters, *Crazy Like Us: The Globalization of the American Psyche* (New York: Free Press, 2010), 192.

7. Junko Kitanaka, *Depression in Japan: Psychiatric Cures for a Society in Distress* (Princeton, NJ: Princeton University Press, 2012), 144–49.

8. Anna Fels, "Great Betrayals," *New York Times*, October 5, 2013, https://www.nytimes.com/2013/10/06/opinion/sunday/great-betrayals.html.

9. Alice Gordenker, "JR Gestures," *Japan Times*, October 21, 2008, https://www.japantimes.co.jp/news/2008/10/21/reference/jr-gestures.

Reel 7.

1. Bishop Taisen Miyata, *A Henro Pilgrimage Guide to the 88 Temples of Shikoku Island Japan* (Los Angeles, CA: Koyasan Buddhist Temple, 2006), 55.

SELECTED BIBLIOGRAPHY

This is not a full list of the works and sources consulted, but only the books and films most vital to the shape of the book in its current form.

Adler, Shelley R. *Sleep Paralysis: Night-mares, Nocebos, and the Mind-Body Connection.* New Brunswick, NJ: Rutgers University Press, 2011.

Amirpour, Ana Lily, dir. *A Girl Walks Home Alone at Night.* Los Angeles, CA: SpectreVision, 2014.

Antonioni, Michelangelo, dir. *L'eclisse.* 1962; New York: Janus Films, Criterion Collection, 2005. DVD.

——. *Blow-Up.* 1966; Burbank, CA: Warner Home Video, 2004. DVD.

Beauvoir, Simone de. *The Second Sex.* London: Vintage Books, 1997.

Benjamin, Jessica. *The Bonds of Love: Psychoanalysis, Feminism, and the Problem of Domination.* New York: Pantheon, 1988.

Berczellar, Paul, dir. *This Is a True Story.* 2003. http://www.berczeller.com /?project=this-is-a-true-story.

Camus, Albert. *The Myth of Sisyphus and Other Essays.* New York: First Vintage International, 1991.

Cocteau, Jean, dir. *Orphée.* 1950; New York: Janus Films, Criterion Collection, 2011. DVD.

Coen, Joel, and Ethan Coen, dirs. *Fargo.* 1996; Santa Monica, CA: MGM Home Entertainment, 2003. DVD.

Coen, Joel, Ethan Coen, and Frances McDormand. Interview by Charlie Rose. "A Look into 'Fargo,' with the Filmmakers—the Coen Brothers—and Actor Frances McDormand." *Charlie Rose,* March 10, 1997. https://charlierose.com /videos/618.

Cortázar, Julio. *Blow-Up and Other Stories.* New York: Pantheon Books, 1985.

Demme, Jonathan, dir. *Spalding Gray's Swimming to Cambodia.* 1987; Irvine, CA: Lorimar Home Video, 1996. VHS.

Duras, Marguerite. *Hiroshima Mon Amour.* New York: Grove Press, 1961.

——. *Emily L.* New York: Pantheon Books, 1990.

Fellini, Federico, dir. *8 ½.* 1963; New York: Janus Films, Criterion Collection, 2001. DVD.

——. *Nights of Cabiria.* 1957; New York: Janus Films, Criterion Collection, 1999. DVD.

Gherardi, Paul, Eric Jaeche, and Dave Bjerga. *Report of Investigation, 2001-481.* Saint Paul, MN: Minnesota Bureau of Criminal Apprehension, November 16, 2001.

Godard, Jean-Luc, dir. *Eloge de l'amour.* 2001; New York: Manhattan Pictures International, 2002.

——. *Numéro deux.* 1975; Paris: Sonimage, 1976.

Goeke, Paul. *Report of Investigation, Case No. 0017826*. Detroit Lakes, MN: Detroit Lakes Police Department, November 16, 2001.

Hearn, Lafcadio. *Kwaidan: Stories and Studies of Strange Things*. New York: Houghton Mifflin, 1904.

Hsiao-hsien, Hou, dir. *Good Men, Good Women*. 1995; New York: Winstar TV & Video, 2001. DVD.

Kar-wai, Wong, dir. *Happy Together*. 1997; New York: Kino Video, 2004. DVD.

Kawabata, Yasunari. *Snow Country and Thousand Cranes*. New York: Penguin Books, 1986.

Kore-eda, Hirokazu, dir. *After Life*. 1998; New York: New Yorker Video, 2000. DVD.

Loden, Barbara, dir. *Wanda*. Bardene International Films, 1971; Parlour Pictures, 2006. DVD.

Marker, Chris, dir. *Sans Soleil*. 1983; Burbank, CA: Warner Home Video, 2003.

Monaco, James. "False Documentary." *Alain Resnais*. New York: Oxford University Press, 1979.

Oltmanns, Thomas F., and Brendan A. Maher. *Delusional Beliefs*. New York: Wiley, 1988.

Resnais, Alain, dir. *Hiroshima mon amour*. 1959; New York: Janus Films, Criterion Collection, 2003. DVD.

———. *Night and Fog*. 1955; New York: Janus Films, Criterion Collection, 2003. DVD.

Rouch, Jean, dir. *Jaguar*. 1967; Paris: Les Films de la Pléiade, 1967.

Schwarz, Jeffrey, dir. *Minnesota Nice*. 2003; Santa Monica, CA: MGM Home Entertainment, 2003. DVD.

Sinclair, Joan. *Pink Box: Inside Japan's Sex Clubs*. Singapore: Harry N. Abrams, 2006.

Stark, Peter. "Frozen Alive." *Outside*, January 1997. http://www.outsideonline.com/2152131/freezing-death.

Teshigahra, Hiroshi, dir. *Woman in the Dunes*. 1964; Tokyo: Toho Co. Ltd., 1964.

Turrell, James. *Backside of the Moon*. 1999; Installation, Art House Project, Naoshima, Japan.

Varda, Agnès, dir. *Vagabond*. 1985; New York: Janus Films, Criterion Collection, 2000. https://www.criterionchannel.com/videos/vagabond.

Winter, Deena. "Coroner Unable to Find Cause of Death of Japanese Woman." *Bismarck Tribune*, January 7, 2002.

Zonca, Erick, dir. *Dreamlife of Angels*. 1998; Culver City, CA: Columbia TriStar Home Video, 1999. DVD.

ACKNOWLEDGMENTS

Deepest gratitude to my teachers and friends for their vital insights and assistance: Patricia Weaver Francisco, Dena DeCola, Lizzie Davis, Josh Ostergaard, Laura Flynn, Katinka Galanos, Uli Armstrong, Jim Smith, Yutaka Sho, Eriko Saeki, and so many others.

A heartfelt thanks to everyone I met and interviewed for this project, especially Steve Kilde, Cody Trom, Jesse Hellman, Kelvin Keena, Marty Solman, and Leon Kohler, who were so helpful and kind to me.

Thank you to the Minnesota State Arts Board and the Princess Grace Foundation for their support of this project when it was a film, and to Coffee House Press for bringing it into the world as a book.

Coffee House Press began as a small letterpress operation in 1972 and has grown into an internationally renowned nonprofit publisher of literary fiction, essay, poetry, and other work that doesn't fit neatly into genre categories.

Coffee House is both a publisher and an arts organization. Through our *Books in Action* program and publications, we've become inter-disciplinary collaborators and incubators for new work and audience experiences. Our vision for the future is one where a publisher is a catalyst and connector.

LITERATURE
is not the same thing as
PUBLISHING

FUNDER ACKNOWLEDGMENTS

Coffee House Press is an internationally renowned independent book publisher and arts nonprofit based in Minneapolis, MN; through its literary publications and *Books in Action* program, Coffee House acts as a catalyst and connector—between authors and readers, ideas and resources, creativity and community, inspiration and action.

Coffee House Press books are made possible through the generous support of grants and donations from corporations, state and federal grant programs, family foundations, and the many individuals who believe in the transformational power of literature. This activity is made possible by the voters of Minnesota through a Minnesota State Arts Board Operating Support grant, thanks to the legislative appropriation from the Arts and Cultural Heritage Fund. Coffee House also receives major operating support from the Amazon Literary Partnership, Jerome Foundation, McKnight Foundation, Target Foundation, and the National Endowment for the Arts (NEA). To find out more about how NEA grants impact individuals and communities, visit www.arts.gov.

Coffee House Press receives additional support from the Elmer L. & Eleanor J. Andersen Foundation; the David & Mary Anderson Family Foundation; Bookmobile; Dorsey & Whitney LLP; Foundation Technologies; Fredrikson & Byron, P.A.; the Fringe Foundation; Kenneth Koch Literary Estate; the Matching Grant Program Fund of the Minneapolis Foundation; Mr. Pancks' Fund in memory of Graham Kimpton; the Schwab Charitable Fund; Schwegman, Lundberg & Woessner, P.A.; the Silicon Valley Community Foundation; and the U.S. Bank Foundation.

THE PUBLISHER'S CIRCLE OF COFFEE HOUSE PRESS

Publisher's Circle members make significant contributions to Coffee House Press's annual giving campaign. Understanding that a strong financial base is necessary for the press to meet the challenges and opportunities that arise each year, this group plays a crucial part in the success of Coffee House's mission.

Recent Publisher's Circle members include many anonymous donors, Patricia A. Beithon, the E. Thomas Binger & Rebecca Rand Fund of the Minneapolis Foundation, Andrew Brantingham, Dave & Kelli Cloutier, Louise Copeland, Jane Dalrymple-Hollo & Stephen Parlato, Mary Ebert & Paul Stembler, Kaywin Feldman & Jim Lutz, Chris Fischbach & Katie Dublinski, Sally French, Jocelyn Hale & Glenn Miller, the Rehael Fund-Roger Hale/Nor Hall of the Minneapolis Foundation, Randy Hartten & Ron Lotz, Dylan Hicks & Nina Hale, William Hardacker, Randall Heath, Jeffrey Hom, Carl & Heidi Horsch, the Amy L. Hubbard & Geoffrey J. Kehoe Fund, Kenneth & Susan Kahn, Stephen & Isabel Keating, Julia Klein, the Kenneth Koch Literary Estate, Cinda Kornblum, Jennifer Kwon Dobbs & Stefan Liess, the Lambert Family Foundation, the Lenfestey Family Foundation, Joy Linsday Crow, Sarah Lutman & Rob Rudolph, the Carol & Aaron Mack Charitable Fund of the Minneapolis Foundation, George & Olga Mack, Joshua Mack & Ron Warren, Gillian McCain, Malcolm S. McDermid & Katie Windle, Mary & Malcolm McDermid, Sjur Midness & Briar Andresen, Daniel N. Smith III & Maureen Millea Smith, Peter Nelson & Jennifer Swenson, Enrique & Jennifer Olivarez, Alan Polsky, Robin Preble, Alexis Scott, Ruth Stricker Dayton, Jeffrey Sugerman & Sarah Schultz, Nan G. Swid, Kenneth Thorp in memory of Allan Kornblum & Rochelle Ratner, Patricia Tilton, Stu Wilson & Melissa Barker, Warren D. Woessner & Iris C. Freeman, and Margaret Wurtele.

For more information about the Publisher's Circle and other ways to support Coffee House Press books, authors, and activities, please visit www.coffeehousepress.org/pages/donate or contact us at info@coffeehousepress.org.

JANA LARSON holds an MFA in creative nonfiction writing from Hamline University, where she studied with Barrie Jean Borich (*My Lesbian Husband*), Patricia Weaver Francisco (*Telling: A Memoir of Rape and Recovery*), and Jim Moore (*Lightning at Dinner*); an MFA in filmmaking from the University of California, San Diego; and a BA in anthropology from the University of California, Santa Cruz. As a filmmaker, she has received awards from the Princess Grace Foundation and the Minnesota State Arts Board and shown her work at festivals and the Walker Art Center. She lives in Minneapolis, Minnesota.

Reel Bay was designed by Bookmobile Design & Digital Publisher Services. Text is set in Arno Pro.